Interdisciplinary Arts

Integrating Dance, Theatre, and Visual Arts

Suzanne Ostersmith, MFA

Gonzaga University

Kathleen Jeffs, DPhil

Gonzaga University

HUMAN KINETICS

Library of Congress Cataloging-in-Publication Data

Names: Ostersmith, Suzanne, 1967- author. | Jeffs, Kathleen, 1981- author.
Title: Interdisciplinary arts : integrating dance, theatre, and visual arts
 / Suzanne Ostersmith, MFA, Gonzaga University, Kathleen Jeffs, DPhil,
 Gonzaga University.
Description: Champaign, IL : Human Kinetics, Inc., [2023] | Includes
 bibliographical references and index.
Identifiers: LCCN 2021047387 (print) | LCCN 2021047388 (ebook) | ISBN
 9781492599876 (paperback) | ISBN 9781492599883 (epub) | ISBN
 9781492599906 (pdf)
Subjects: LCSH: Interdisciplinary approach in education. | Art--Study and
 teaching. | Theater--Study and teaching. | Dance--Study and teaching.
Classification: LCC LB2361 .O88 2023 (print) | LCC LB2361 (ebook) | DDC
 707.1--dc23/eng/20220124
LC record available at https://lccn.loc.gov/2021047387
LC ebook record available at https://lccn.loc.gov/2021047388

ISBN: 978-1-4925-9987-6 (print)

Acquisitions Editor: Bethany J. Bentley; **Managing Editor:** Anna Lan Seaman; **Copyeditor:** Marissa Wold Uhrina; **Proofreader:** Pamela Johnson; **Indexer:** Rebecca L. McCorkle; **Permissions Manager:** Dalene Reeder; **Senior Graphic Designer:** Nancy Rasmus; **Cover Designer:** Jennifer Gibas; **Art Director:** Keri Evans; **Cover Design Specialist:** Susan Rothermel Allen; **Photograph (cover):** Human Kinetics, Inc. / **Illustrator:** Jennifer Gibas; **Photographs (interior):** © Gonzaga University, unless otherwise noted; **Photo Production Manager:** Jason Allen; **Senior Art Manager:** Kelly Hendren; **Illustrations:** © Suzanne Ostersmith, unless otherwise noted; pp. 6, 8, 11, 13, 17-19, 22, 25-27, 42, 100, 122, 152 © Human Kinetics; **Printer:** Versa Press

Printed in the United States of America 10 9 8 7 6 5 4 3 2 1

The paper in this book is certified under a sustainable forestry program.

Human Kinetics
1607 N. Market Street
Champaign, IL 61820
USA

United States and International
Website: **US.HumanKinetics.com**
Email: info@hkusa.com
Phone: 1-800-747-4457

Canada
Website: **Canada.HumanKinetics.com**
Email: info@hkcanada.com

E8145

Tell us what you think!
Human Kinetics would love to hear what we can do to improve the customer experience. Use this QR code to take our brief survey.

CONTENTS

PREFACE

Welcome to your journey into the arts! By studying interdisciplinary arts, you explore creative and innovative thinking and problem solving. The purpose of this textbook is to introduce you, the student, to interdisciplinary arts as the integration of arts concepts drawn from the separate but related disciplines of theatre, dance, and visual arts as well as to create original works that bring those concepts together for the purposes of innovation. Using strategies and terminology from multiple areas of artistic practice enriches your perspective not only as an artist but also as a thinker and communicator.

Acting, directing, design, and technical skills all work together to form the theatre arts, just as choreography and Western and non-Western styles interrelate dynamically within a range of dance forms. Painting, sculpture, and digital media communicate meaning through art in a variety of modes, yet all create visual messaging within cultures. Drawing from these multiple fields gives you tools to create new forms of art and communication and to use those forms to inspire others and solve problems.

While interdisciplinary study is not a new concept (it has been a course of study at the university level as far back as the 1930s), it still provides a less tidy definition than that of a single discipline (Ulbricht 2005), and scholars continue to debate the terminology. Many resources exist to learn more about the field's history such as *The Oxford Handbook of Interdisciplinarity* (Frodeman et al. 2017).

While it is critical to gain a grasp of a discipline's unique concepts and vocabulary, it is important for an artist to break free of the separation commonly found among university departments. For a time, students telling their families something like "I am minoring in biology" or another familiar field of study would have put their families at ease, whereas newer subjects such as interdisciplinary arts might leave families bewildered. Yet the future lies in being able to work across and within multiple subjects. The danger of working in isolation is obvious, where the ideas from other fields are not considered (Sternberg 2008). The full scope of any problem can only be seen in relationship to other problems like it, and it is helpful to understand how other fields have solved those related problems. No matter how hard you work, if you do so all by yourself, you risk developing tunnel vision. For you, today's students, being able to articulate the value of thinking interdisciplinarily engages you in the market of ideas that characterizes the 21st-century artistic landscape and marketplace.

This book and the exercises within it will help you address questions such as the following:

- How can I look past the first solution to find the right one for the situation?
- Is it possible to train myself to be creative?
- What tools can I use to engage my full physical instrument to communicate?
- How can I use emotion to express when I dance rather than just focus on visual shapes my body makes?
- Why, when I paint, do I feel tension in my shoulders and does my mark making become tight?
- How can I better articulate how my study of the arts informs my decision-making in other fields?
- How can the arts help me get a job in my chosen field?

By the end of this textbook, the reader will be able to move past limiting thoughts such as the following:

I am not creative.

I am not an artist.

Don't ask me to dance, act, or draw.

The writers of this book work across the sometimes disparate worlds of theatre, dance, and visual arts. With experience in dance, choreography, visual arts, theatre history, acting, directing, dramaturgy, and arts administration, we live and communicate in each of those worlds. As a result, our experiences in each discipline naturally inform our work in the others. In the world of academia, even today, areas of study are in departments, often isolated. Yet we know that innovative thinking comes from breaking through barriers to look at things in new ways. Leveraging experience in professional and educational settings, this approach also draws on ideas such as the acting theories of Stanislavski, the movement work of Laban and Bartenieff, concepts of multiple intelligences developed by Gardner, and looking at art in innovative ways such as intuitive painting and visual thinking strategies (Housen and Yenawine, n.d.). Over the years, the authors of this book have attended countless hours of training, synthesizing these various approaches into a teaching style that is interdisciplinary at its core.

You are invited to join in this journey of discovery, to learn about your own expressive capabilities that might not yet be fully integrated into your life. You might think of yourself as a creative person, or you might have the view that you are not creative. Take some time now, before you begin to delve into this book, to brainstorm ways that you express creativity in your life. Do you enjoy cooking, merging new flavors, and experimenting in the kitchen? Do you enjoy colors and spend time carefully selecting paint and items as you decorate your room? In nature do you enjoy the sound of birds or appreciate the growing of plants in your garden? Perhaps you are athletic and express your inner strength through outward acts of proficiency in a sport. In the journal on HK*Propel*, or better yet, beginning an interdisciplinary arts journal with an entry on this topic, briefly list a few areas where you might have underlying wells of creativity that can be a resource for creative expression.

Organization of Contents

Chapter 1 defines the field of interdisciplinary arts and how instructors and students can benefit from making these exploratory and creative connections, specifically through a structured warm-up. In chapters 2 through 4, you will be introduced to each of the art forms: theatre, dance, and visual arts. These chapters include concepts for the art form as well as theory that is used specifically for a course in this field. Each chapter has exercises that develop your physical knowledge of the potential of the art form. If you have a background or passion for other areas such as music or film, you are encouraged to bring those elements into your work in the exercises. Opportunities for reflection and discussion are given in each chapter to help you ground your knowledge and deepen your skills. The goal of this work is to bring all skills to play with each problem, assignment, or puzzle as you innovate and explore each art form.

In chapters 5 through 7 the art forms integrate through the development of performance art presentations. These activities are to deepen the knowledge and understanding of each art form and how they relate to each other. Chapter 5 brings together poetry, performance, and movement as you create a performance piece merging dance and theatre. Chapter 6 unites the physical medium of fabric with movement concepts to create a dance work that incorporates a piece of visual art you have created. Chapter 7 invites you to enter the mask-making craft as well as to write an original monologue to explore the connections between visual arts and theatre. With each of these chapters, you gain a better understanding of each art form by developing skills drawn from two or more areas of interdisciplinary arts.

Chapters 8 and 9 invite you to put into practice what you have learned. It pains any course instructor to think that the knowledge and experiences gained in a course only live during

the semester or quarter, and then the course is never to be thought of again. Knowledge is cumulative. Experiences are cumulative. These chapters impart to you a better understanding of how this thinking can be used in other settings. Chapter 8 engages your multiple intelligences to combine all three art forms into a synthesis project that engages with another field of study. Perhaps this is your major or minor or another subject that interests you, such as science or the natural world. Chapter 9 is an investigation into your community's artworks in the three areas of theatre, dance, and visual arts, inviting you to get out to the theatres, see the dance offerings local to you, and visit the museums in your area to refine your expressive instruments of observation, reflection, and critique. This direct experience of art making in your area connects you to others and will deepen your own sense of identity as a fellow creator of art.

The Creative Process

A significant outcome of the explorations and activities in this book is to better understand the creative process. The opening night of any performance carries a lot of weight in any performer's mind and may seem to be the focus of the preparations. However, it is the process of developing the performance and reflecting afterward that provides the greatest learning. All art making is an iterative process. Therefore, you will create each presentation in this book using these steps as a guide:

1. Thumbnail sketch
2. Assimilation of feedback
3. Presentation
4. Reflection

Thumbnail Sketch

In any creative process, one must simply begin. Certainly, that is an obvious thing, yet the beginning of a project sometimes presents a challenge. The terms *thumbnail* and *sketch* offer some freedom. This means you form your thoughts in a manner you can then work from and take forward into your project. Within this step, there is also research, clarification of ideas, and creation of production schedules. While these elements can have a sense of finality about them, the first step is always to sketch them out. Think of it as creating a rough draft or an outline. The key thing is to make something—to start.

Assimilation of Feedback

Feedback is an incredibly important part of interdisciplinary art. Feedback can come in many forms, of which these are just a few examples: standing back to look at the work and reflecting on it by yourself; turning outward and floating the idea to others; brainstorming possibilities; and eventually presenting to an audience, even if the work is still in an early state. But all of that means nothing unless you choose to respond to the feedback you receive. Taking the time to reflect on the observations made by your peers and instructors can yield new connections in your mind and spur on the growth of your work. Perhaps some of the feedback you let go is unhelpful, but some comments might inspire you to dive deeper. Feedback can be painful, and in the undergraduate experience, it sometimes comes in the impersonal form of a grade. But that is only one form of feedback. In this book, we hope to help you train yourself to look for feedback or ways to grow beyond a grade. Learning something new can be difficult because it involves a level of risk. It can also sometimes seem painful, because we must let go of our old ways of seeing and doing things (Boostrom 1998). The collaborative process requires creation to be iterative, and even solo work demands reflection to achieve its potential.

Presentation

Showing your work to an audience brings anticipation and its own sense of glorious magic. Again, the study of interdisciplinary arts is a way of growing as a more creative and innovative thinker. The presentation, however, is not the end goal. Showing your work to your peers, professor, and community can carry a lot of social weight, but it is not everything. That is why each presentation you work on in this book is broken into four parts: thumbnail sketch, assimilation of feedback, presentation, and reflection. Sometimes the performance seems to be the focus due to the social pressures of performing, but it helps the artist much more to place the emphasis on the creative development process that comes before it.

Reflection

Your job as an interdisciplinary artist is not finished with the presentation. You should be able to articulate your answers to the following questions: Why did you make the work? What does the work mean to you? What did you learn from the process? What do you hope your audience might gain from the work? It is also important to reflect on the question of what comes next. What can be gained from each moment, each production, to lead you to the next step? For some in the class, perhaps the goal is to fulfill a fine arts core or general education art requirement, so they might be tempted to say there is no next step. But a true lifelong learner sees each opportunity as just that: a place to learn. Maybe the person will not learn to paint a better picture or create another dance, but skills used in the course can feed into any career.

Throughout this book there appear spotlight introductions to various artists from history. These, paired with the case studies about former students who have created exciting projects, help you see what might be possible and spur on further creative thinking. It is one thing to graduate with a degree showing that you have taken courses in specific subjects; it is another thing altogether to have integrated your skills into self-directed projects and solved problems that demonstrate your synthesis of knowledge.

Conclusion

Having taught hundreds, perhaps thousands, of students over the years, we have seen growth in every individual. Fear not if this is new to you; we have full confidence that you will find yourself better equipped to embrace the world of art and performance after taking the journey laid out in this book. Your reserves of creativity may be yet untapped, but once you take this step, you will find that your creative energies flow more freely and that the skills in this book are transferable to a host of endeavors in your life. You might start to discover that there is a little bit of artistry within every pursuit, even in areas you now consider outside the realm of art; you may find greater self-expression in the areas you identified in the brainstorm such as gardening, cooking, or woodworking, or choosing colors and furniture for your room.

The knowledge you will gain here is not just about theories and methods to apply within the fields of theatre, dance, and visual arts, though certainly you will gain that understanding in this course. You will leave this course with a better sense of your capacities for creativity, cross-disciplinary thinking, and the connections between your body, mind, and spirit. In other words, you will gain self-knowledge. Your cognitive capacities will get a workout just as fierce as the exercises of the body described in this book, but even more important is the connection to what it means to you and to your heart. Even though you might be hesitant to call yourself an artist, we believe that you, like so many of our students, will find that you have been an artist at heart all along.

ACKNOWLEDGMENTS

The authors would like to thank Mark Ostersmith and Guy Jeffs, as well as Bethany Bentley and Anna Seaman. We are grateful for our research assistants Macy Conant, Blake Fry, Isabelle Horgan, and Sydney Zinnecker. Thank you to Gonzaga Campus Services, including Diana Lartz, Sheila Schulz, and Sandy Hank, and to Tim Fry for help with photography.

Illustrations by Suzanne Ostersmith with thanks to our models Ryan Hayes, Olivia Sands, Mikaela Perry, Elisabeth Ehnert, and Zoe Driml. We also extend our thanks to Halle Goodwin for her assistance and to Charlie Pepiton for coaching Queen Mab breath scoring in the theatre chapter. Thank you to interdisciplinary arts students past and present, including those taught in Florence, especially Miguel Angala, Sarah Bradford, Clara Buck, Xander Claypool, Claire Colombini, Quynn Dong, Brooke Geffrey-Bowler, Ryan Gotshall, Hillary Longoria, Alaina Margo, Allison Osthoff, Mia Person, Claire Russell, and Katrina Wagner.

Introduction to Interdisciplinary Arts

What do we mean by the term **interdisciplinary**, and what is it for (i.e., what problem does it help us to solve)? A person who can work interdisciplinarily is one who is well-rounded, not limited to tunnel vision, and well-connected instead of isolated. Interdisciplinary people are innovative, on the cutting edge; it is a way to be more, and by implication to be better, than to work only in one discipline. However, an interdisciplinary focus is not necessarily better in value terms than a purely disciplinary focus. By Frodeman's definition, "the term more specifically refers to the intra-academic integration of different types of disciplinary knowledge" (2017, 4). This definition is not a value judgment, but a practice, a way of knowing and of seeing the world from more than one perspective.

You will experience from time to time that the approach taken in this book verges into territory that could properly be described as **transdisciplinary**. *Trans* means "across." Transdisciplinary knowledge is "knowledge that is co-produced, where academics work with nonacademic actors of one type or another" (Frodeman 2017, 4). You will learn so much more working with members of your community for a common goal that is not limited to the university or disciplinary context in which you find yourself. This work can include professional dance companies, theatre artists, visual artists, thinkers, and practitioners who join you on projects and do so across (*trans*) the artistic disciplines. As collaborators they are members of a shared art form but of separate institutional contexts.

The structure of this book is, at first, an epistemological one; that is, it is rooted in the methods and processes of theatre, dance, and visual arts. Chapters 2, 3, and 4 cover each of the three disciplines, explore the terms and concepts pertinent to those fields, and honor their uniqueness and individual contributions to the arts. Assignments, projects, and reflections appear in each chapter to focus your attention on the ways that theatre, dance, and visual arts express truths about the world, human relationships, and the way individuals relate to their social and environmental contexts.

Chapters 5, 6, and 7 are where the interdisciplinary work is done. The fruits of juxtaposition, the merits of contrasting approaches, and the benefits of thinking in dialogue will allow you to experience how "ideas come alive within a community" (Frodeman 2017, 4). This is the goal; with the appearance of more and therefore better expression, your work will demonstrate the "increased societal relevance" interdisciplinarity often brings (Frodeman 2017, 4). Creativity comes alive in the spaces between the disciplines, where new craft and true originality are forged. You are invited to delve deep into the craft of the interdisciplinary artist fluent in the languages of theatre, dance, and visual arts. Then, you are challenged to build, create, and transform yourself and your burgeoning artistic practice into something that is truly new, truly yours, and authentically expressive of something only you can say.

KEY TERMS

Alexander Technique
asanas
Bartenieff Fundamentals
body half
breath
core
core–distal
cross-lateral
distal ends
head–tail
interdisciplinary
proprioception
transdisciplinary
upper–lower
warm-up
yoga

Irmgard Bartenieff (1900-1981) was the founder of the Laban Institute for Movement Studies, now known as the Laban/Bartenieff Institute for Movement Studies. She developed the **Bartenieff Fundamentals**, widely practiced movement concepts, in the 1960s and 1970s. The central concept is a "re-education into body connection" (Hackney 2002, 19). The ideas are fundamental in the sense that they derive from the earliest physical movements made by human beings and that are developed through babyhood, childhood, adolescence, and adulthood. Returning to one's earliest movement patterns is the core of Bartenieff's teaching. Whether you are new to movement work or an accomplished dancer, you engage with the Twelve Principles of Bartenieff Fundamentals (see chapter 3) and the developmental stages, even if you are not aware of these concepts. Becoming aware of these principles allows you to begin to use the body to its full potential both in artistic expression and the way you use your body in daily life.

can make, using all the tools within your grasp. This book is about providing you with those tools and arming you with the courage to step into the crucible of interdisciplinary arts where your skills can be tested.

Moving into, through, and across disciplines in art sharpens your sight and clarifies your voice. This book will enable you to perceive with your senses what the world is offering you, to sift through the meanings there and the modes available to express your unique perspective.

The audience for the work created as you explore this book is typically in a classroom or peer setting. While performance for the public or a paying audience is certainly an aim of some performance and artistic practice, here we are focused on the process and thus have pitched the activities for a workshop environment where you can present relatively safely and receive formative feedback from your peers and instructor to help you grow.

Frodeman (2017, 7) asks the important question, "How are we to translate disciplinary knowledge into particular circumstances?" The answer is again to start at home in oneself, with the person "in the mirror," as Michael Jackson put it, and to learn to see an artist there looking back at you. We are all artists "in particular situations" (Haynes 1995, 51), in that each of us is "calling for reclamation of the sacred and the future" by going in and seeing what is inside us, bringing it out in our expression that connects us with other human beings. The final chapters of the book are where the "jazz" and "riffing" of multiple art forms in dialogue take shape around a particular topic for a particular audience (Frodeman 2017, 5). To begin, we introduce you to artists who have mastered techniques of bringing that which is inside you to the fore, that inner-outer expression that begins rightly in you, in your sacred inner being.

Interdisciplinary Movement

An interdisciplinary artist's approach might contrast with some show-based practices. There might be a final performance for a class or a particular production run, but there is no closing night on the work undertaken in this field. You can always improve what you are making, develop your process, refine your tools or your approach; you can always see it from another angle. The practitioners central to this field were and are never satisfied with one static vision of their ideas, never stood back and admired a finished product. Inherent in interdisciplinarity is a deep commitment to personal practice, rigorous investigation and research, and the continual refinement of one's ideas. There might be opening nights, but the work is never complete; it is continually evolving.

Artists prepare their minds and bodies in as many different ways as there are artists; each person must develop what works for them. This section introduces foundational artists whose innovations in human expression are at the heart of the field of interdisciplinary arts. These practitioners are introduced one by one in a practical way, so you can build a warm-up to use at the start of each class meeting or as the basis for your own developing personal practice. Within this context of an academic course in interdisciplinary arts, whether you are working in a classroom, a studio, online, or independently, this sequence of embodied practices sets you up with a warm-up that you can repeat, refine, and make your own.

Bartenieff: Six Developmental Stages

The goal, as stated by Bartenieff practitioners such as Peggy Hackney, is to embrace a "lively interplay of Inner Connectivity with Outer Expressivity to enrich life" (2002, 34). We can think of our "inner connection" as tuning in to how we feel inside and perhaps the content of our hearts. When we express ourselves to the outer world, we can choose whether to share what is inside. This is just as true during daily activities as it is in performance. When we slouch and furrow our brow, perhaps we are outwardly expressing an emotional struggle within, but we can also choose to stand up straight, soften our brow, and become aware of how our physical expression affects our inner world. Inner and outer do not exist independently, but if we are aware of a "lively interplay" (Hackney 2002, 34) between the two, we are in a better place to express ourselves in ways that help us lead fuller lives or that enrich our performances. Bartenieff's stages are as follows:

Breath

Core–distal

Head–tail

Upper–lower

Body half

Cross-lateral

Terms based on a sequence developed by Bonnie Bainbridge Cohen.

The six stages begin with the energizing, life-sustaining awareness of the essential building block of breath and conclude with the integration of the stages and a full-body awareness of how each stage contributes to basic movements such as walking (see the "simple" walk, Hackney 2002, 177). Awareness of each stage enables us to use our full physical instrument.

Our set **warm-up** (a process to engage the mind and body that can be repeated before creative work begins) starts with Irmgard Bartenieff's developmental stages. We will explore the stages sequentially, building on them day by day. Exploring the movement and then understanding the theory helps you engage with the movement in a new way as you review and add on each day. Counts are included in case it is helpful for you to do this warm-up to music. Find songs for this warm-up that are energizing, inspirational, and perhaps familiar to you, but branching out with your music choices can also unlock new perspectives and ideas as you move. A contemplative piece suits a slow warm-up to truly center yourself, while a high-tempo piece to wake you up might be better in the morning.

STAGE ONE **Breath**

Breath is the first stage because it provides a foundation for every other movement and function of the body. Even before birth, humans engage in preparatory respiration that enables the body to thrive, and after an infant is born, it cannot survive without breathing. Bringing awareness to the breath at any stage of life has a grounding and centering effect and is used in many meditational and spiritual practices (Wahl 2019). Supporting the breath enables the body to connect to its inner volume and its interaction with the outer world. Breath travels from outside to inside the body and forms a direct connection with the environment. As human beings, our emotional lives are tied to our breathing; we breathe in certain ways when we are frightened or elated, for example. To experience this, take short, shallow breaths in quick succession, and note the effect on your body and mind. Follow this with long, slow, deep breaths, and feel your body calm and recenter. Engagement with breath is a foundation for the study of movement.

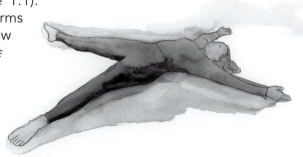

FIGURE 1.1 Lie on the floor with your body in an X shape, opening and narrowing the angles of the arms and legs to find your most comfortable position.

Begin by lying on the floor with your body in the shape of an X (see figure 1.1). Explore different angles of your arms wide above your head, then narrow the angle as you bring your arms closer together. Do the same with the legs to find the most comfortable position for you. This might feel odd at first, but you will feel your body yield into the floor from this position in time. You might have your eyes closed or in a soft focus looking at the ceiling, but the key thing to remember is this is not a performance; it is about becoming more aware of your own relationship to movement, your inner connection.

Envision yourself as a vessel with a clear plexiglass outer shell; you are an empty, clear shape. Imagine a warm, honey-colored liquid flowing into this vessel. Feel it pooling in your feet. As this warm, honey-colored liquid pools in your feet, feel it melt and soften the sides of your clear vessel. As this warm liquid fills your ankles and calves, feel them soften, and continue connecting with each breath. Move through the whole body, concluding with the head, face, and the top of the skull.

Once you are fully relaxed and present, think of each breath as an inhalation of opening and an exhalation of contracting.

Then, with the inhale, expand your body in an X shape in all directions. With the exhale, curl into a ball on your right side. Relax, breathing on your side. Remain in that ball shape for a moment, allowing yourself to yield into the floor. Can you soften your shoulders, arms, and hips? Blow the air out of your lungs, and with the next inhalation, open back up into the big X on your back. Taking your time, do the same thing on the left side, and then connect the movement together. The steps are as follows: inhale as an X, exhale to the ball on the right, inhale as an X, exhale to the ball on the left, inhale to the X. This should be an organic process; let the breath flow naturally, and allow the body to use the music of the breath to dictate the movement. Allow the body to rest for only a moment, yielding into the ground as each inhalation and exhalation follow each other naturally (see figure 1.2).

As stated before, the breath is the first stage that happens once out of the womb, and it follows us until our last breath. But it is easy to forget this is an ongoing process. If we direct our attention to our breath, it can tell us a lot. Sometimes we hold our breath if we are nervous or anxious, but if we allow our attention to focus on what we are feeling and we slow down and deepen our breathing, some of that anxiety might slip away. Certainly, our brain and body functions need air to work properly, so connecting breath to movement is an excellent tool (see figure 1.3). The symbol of the infinity sign (∞) or Möbius strip illustrates the figures that represent the six developmental stages (Hackney 2002, 34). This is the image for breath, and it forms the basis for all other movement and dance.

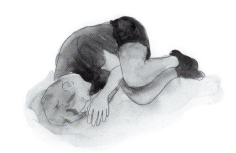

FIGURE 1.2 Curl into a ball, relaxing as you breathe on your side.

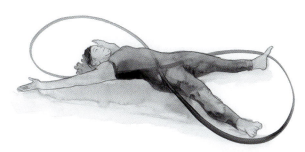

FIGURE 1.3 Breath is the link between inner connection and outer expression.

STAGE TWO **Core–Distal**

Core–distal is the relationship between the **core**, or center of the body (the muscles around or just below the belly button), and the **distal ends**, or the fingertips and tips of the toes, that are the extremities of the limbs (Hackney 2002, 68). To explore the connection between your core and the ends of your fingers and toes, work through the limbs. Lying in an X position, reflect on the movements you did with the breath, and think about the inhalation as an expansion and the exhalation as a contraction. Place one hand on your core at your navel and just below, then put your other hand behind your back on the floor, with awareness that this is your core or center. Just like it is good to think of movement connecting to breath, it is also good to think of how movement can begin with and is related to the core of the body. Can you feel the warmth generated from your hands? Now hanging on to that awareness of the location of your core, move your hands back to the big X. Can you still imagine the warmth? Envision that with each breath, the core grows brighter. Now allow that bright core to focus and move like a beam of light down your left leg, past your knee, down through your ankle and your foot, and beyond your foot to the edge of the room, then shining past the wall way out into the distance. Allow that light to keep shining, and put your focus back on your core. Allow that brightness to shine down your right leg, past the knee, out past the foot, and far into that distance. Feel the light of the core brighten and shine up past your left shoulder, elbow, and wrist to the distal ends of your fingers and beyond. Feel the light of the core shine up the right side, out your right distal fingers, and beyond. Feel the enormous X shining out from your core. Now imagine the light going straight down your spine and out your tail, as well as straight up your spine and out the top of your head, as though you are now a six-pointed starfish radiating light out in all directions (see figure 1.4).

Connect this imagery again to the breath. As you inhale, the six lights shine away, and as you exhale, you contract. Next, connect this imagery to the movement of the breath. Inhale, and then curl over into a ball on the right with the exhale. Inhale back to the X, exhale to a ball on the left side, and inhale back to the X.

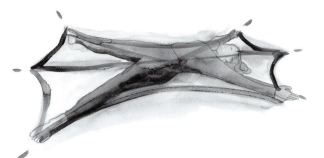

FIGURE 1.4 Imagine you are a six-pointed starfish radiating light out in all directions.

Taking this imagery of the connection of your core to your distal ends, again go to the right side in the shape of a ball. Once there, yield into the ground, and imagine a large ball touching your back. Staying on your side, open and reach with your six-pointed starfish back around that ball (see figure 1.5). Make certain your eyes follow the direction of your spine. Created with an inhalation, use the limbs closest to the floor to create a C shape opening behind you to help with stability. Now imagine curling

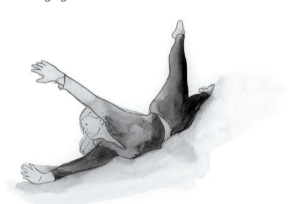

FIGURE 1.5 Imagine a large ball touching your back, and reach with your arms around it. Notice the right hand at the floor reaching behind in the shape of a C.

your six-sided starfish around your core in a ball on your right side with the exhalation, and then inhale back to the X at center. Repeat on the left side.

Once you have experienced each of these steps organically, making certain to connect the breath and maintain awareness of the imagery, you are ready to connect these movements to counts. Use eight counts for each movement. Here, the body is like an amoeba in which all parts work together, so work to allow each of the six parts of the starfish to arrive at each shape together.

Following are the movements with the eight counts:

	Breathing	**Movement**	**Counts**
	X inhale		5678
Breath	Exhale	into a little ball on the right	12345678
	Inhale	back into the big X	12345678
	Exhale	into the little ball on the left	12345678
	Inhale	back to the X at center	12345678
Core–distal	Exhale	into a little ball on the right	12345678
	Inhale	around the ball at your back	12345678 really reaching
	Exhale	back to the ball on your right	12345678
	Inhale	back into the big X	12345678
	Exhale	into the little ball on the left	12345678
	Inhale	around the ball at your back	12 really reach 345678
	Exhale	back around your core on the left	12345678
	Inhale	back to the X at center	12345678

This developmental stage of core-distal comes when an infant is suddenly aware of their fingers and toes. Have you ever seen a baby hang on to their feet or look with wonder at their fingers? Babies at this stage can see about as far as the length of their arms. Their own fingers and the faces that come close to them are their entire world. When we engage with the concept of core-distal in movement, we revisit this sense of wonder. Reaching out from the core of the body, we can experience an awareness of self that extends to the distal ends, connecting us from our center to our extremities (see figure 1.6). Thinking about the body as connecting to all of the six points of the image of the starfish is a great connection to make in your mind. Performers think about all six points of the starfish and have a full, connected sense of the body, leading to greater **proprioception**. Proprioception is that knowledge of where your feet are, your head in relation to your spine, awareness of your shoulders and fingertips. Most likely, you are aware of those parts of your body without having to look at them; you can sense your body. Proprioception is something that also goes away as people age, which can cause challenges with balance or even falling. As artists, strengthening our awareness through proprioception leads to a fuller life because we can feel more and thus express more. Moving through and experimenting with this core–distal stage helps us have a sense of how much space we can take up and then project our energy out and beyond the edge of our distal ends, which is key for both daily life and performance.

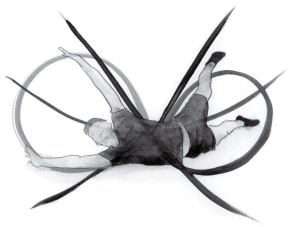

FIGURE 1.6 Awareness of the self extends to the distal ends, reaching out from the core of the body.

STAGE THREE Head–Tail

Head–tail is the connectedness of the head to the base of the spine and the fundamental connection of the spine to the rest of the body. Lying in an X position, imagine that you are lying in water that is the perfect temperature. Allow your body to float, perfectly supported by this clear blue water. Picture a single sparkling droplet falling from above, making contact with the water right at the center of your core. Imagine the ripple effect it has on the water as concentric circles radiate out from that core, out to the tips of your fingers and beyond.

So far, we have created three different ways of connecting to the body: imagery of the plexiglass vessel softening and yielding, light emanating from the core and beyond the six distal ends, and now the water droplet. Different images will resonate uniquely with each individual, so you can think of these as tools for bringing awareness to your mind and relaxing the body as you warm up. You can choose a prompt of your own to allow you to relax and tune in to the body. Release the thoughts that journey into your practice from the outside.

Once you have moved through the movement sequences for breath and core–distal, roll onto your right side and onto your belly with your hands under your shoulders. Gently press up with your hands, allowing your head to reach back to your tailbone (see figure 1.7a). Keep your shoulders down and your neck long. In

yoga, this is called cobra pose. Slowly come back down into a brief X, then repeat. Once you are at the highest point of the second cobra, push with your hands and contract your core to fold onto your feet into what is known as child's pose (see figure 1.7b). Notice how you are connecting your head toward your tail in the opposite direction.

Now imagine a blue glass marble on the floor just past your head. Push the imaginary marble forward with your nose, returning to a lying position, and then roll onto your back.

Bringing your arms and legs together (see figure 1.8) and pressing your heels into the ground, begin a rocking motion. These ankle pumps happen when you stabilize your heel and alternate pointing and flexing your toes. Your body is made up of 60 percent water, so imagine it sloshing up and down as you allow your head to release and rock. Use whatever tempo feels right for you, but find a way to make it feel free. This is a great way to release tension and realign your head–tail connection. Think about expanding the spaces between your vertebrae that get crunched by gravity throughout the day. This movement helps lengthen your spine and can help avoid slouching as the body ages. When you have concluded the process of finding that sloshing and rocking, return to the big X.

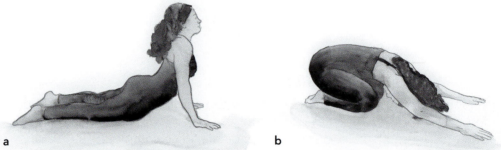

a b

FIGURE 1.7 *(a)* Gently press up with your hands, allowing your head to reach back, in cobra pose. *(b)* Push with your hands and contract your core to fold into child's pose.

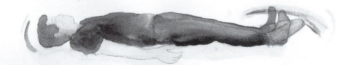

FIGURE 1.8 Rocking head–tail.

Following are the movements with the eight counts:

Breathing	Movement	Counts
Exhale	rolling over onto belly X	12345678
Inhale	while placing hands under shoulders and push up into cobra	12 push up 345678
Exhale	easing back to the ground	12345678
Inhale	while placing hands under shoulders and push up into cobra again	12 push up 345678
Exhale	contracting your stomach and fold into child's pose	12345678
Inhale	pushing the 'marble' with your nose	12345678
Exhale	rolling back into the X	12345678
	Hands by your side and feet together rock (as many counts as fits the music) and finish in the X	

(Head–tail)

Once an infant's muscles are strong enough that an adult does not need to hold their neck, they can hold up their own head. This stage is evident when you put an infant on their belly, and they are able to do a cobra by pushing their hands into the floor and raising their head to look around. It might be fun to imagine how limiting it would be to stay on your belly, just looking to the side, and the wonder it must involve at the first moment to be able to lift one's head and look around. At this stage, babies can see beyond their arms. This stage is so helpful to think about with posture awareness (see figure 1.9).

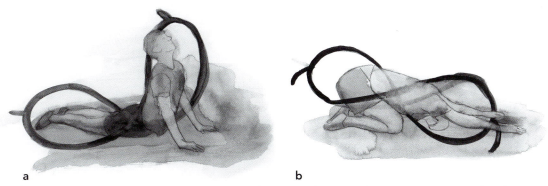

a b

FIGURE 1.9 *(a)* Head–tail connection in cobra pose. *(b)* Notice how you connect your head toward your tail in the opposite direction while in child's pose.

STAGE FOUR **Upper-Lower**

Upper–lower is the connection between the top and bottom halves of the body, divided at the core. To begin to explore this relationship, review the consecutive movements for breath, core–distal, and head–tail. Once completed, start again in the X, but this time imagine your body divided into two halves with a line directly across your core (see figure 1.10a). Visualize the top half of your body as one color and the lower half of your body as another color. Stabilize your lower half into the ground, and allow your upper half to bend to the right as though it is a tree in a strong wind (see figure 1.10b).

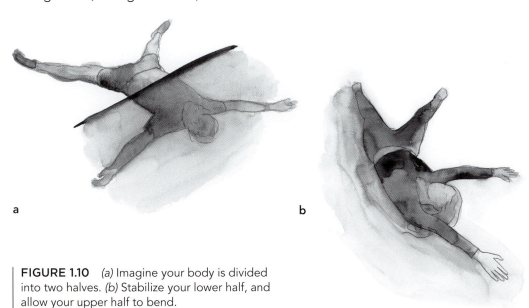

a b

FIGURE 1.10 *(a)* Imagine your body is divided into two halves. *(b)* Stabilize your lower half, and allow your upper half to bend.

Now bring your knees to the right as well, completing the movement into the ball on the right (see figure 1.11a). From this side ball that is yielding into the ground, remember the two colors, and again sink the lower half into the ground and allow your upper half to open back to its half of the X (see figure 1.11b). Once there, let the legs join, completing the X. It is important to divide the body so that half is stable and the other half is mobile. Do the same to the left side.

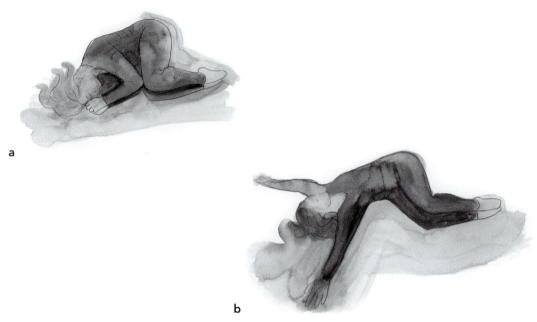

a

b

FIGURE 1.11 (a) Bring your knees to the right, completing the movement into a ball. (b) Ground your lower half, and allow the upper half to open.

Now repeat the sequence initiating with the lower half of the body. The upper half is stable, and the lower half is mobile, bringing the knees up to the right side (this can be a lovely stretch for your back), and then the arms come to complete the ball on the right. Stabilize the upper half as the lower half reaches out through the toes to make the lower half of the X, and then the upper half opens to complete it. Perform the same thing on the left side (see figure 1.12). It is very helpful to connect counts so that you do not release the stable part too soon, allowing for a full stretch.

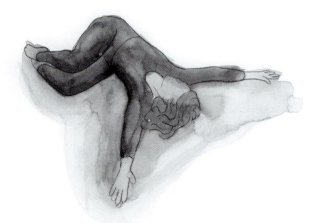

FIGURE 1.12 The upper half opens to complete the lower half.

If you are using music, depending on the tempo of the song, this might be best done in four counts each, but it is listed here in eight-count segments. Move through the breath, core–distal, head–tail, and continue with the upper–lower.

Following are the movements with the eight counts:

Movement	Counts	Movement	Counts
Upper moves to the right	12345678	and lower comes to meet and complete the ball	12345678
Upper moves back to the X	12345678	and lower completes the X	12345678
Upper left	12345678	and lower comes to meet and complete the ball	12345678
Upper returns to the X	12345678	and lower completes the X	12345678
Lower right knees pull up to side	12345678	and upper comes to meet and complete the ball	12345678
Lower moves back to the X	12345678	and upper completes the X	12345678
Lower left knees pull up to the side	12345678	and upper comes to meet and complete the ball	12345678
Lower back to the X	12345678	and upper completes the X	12345678

(Left margin label: Upper–lower)

This developmental stage begins as a first step in coordinating elements of the body to work together (see figure 1.13). This is the first step to the movement of rolling over. If a child is on their belly or back and a toy is just out of reach to the side, they can now use the upper half of their body to reach and roll themselves over. The once immobile child is now mobile and requires the caregiver to be more attentive.

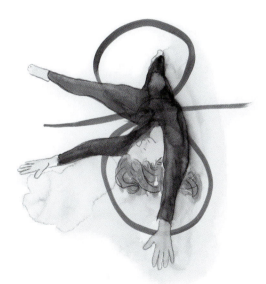

| **FIGURE 1.13** The upper and lower parts of the body coordinate to work together.

STAGE FIVE **Body Half**

Body half is connecting the left side of the body to the right side. From the big X, use whatever method works for you to relax and release into the ground. Move through the first four stages, and then rest again in the neutral X. This time, imagine a line running down your spine from your head to your tail, dividing your body in half (see figure 1.14a).

Imagine each half being its own color. Now move into a little ball on the right side, but once there, organize your mind to see that dividing line and the two colors. Holding this shape, stabilize the right half of your body while you open the left half like a book (see figure 1.14b).

Continue to open as far as you can until you can no longer hold your right side, and roll your body to the left into the ball again. Once you are in that little ball on the left side, yield into the ground, and again imagine those colors dividing the body in half. Stabilizing the left side of the body, open the right side like opening a book, with the spine of your body like the spine of a book, until it cannot open any farther without the left side releasing and then rolling onto the right side. Conclude by moving back to the X, with all parts of the body arriving together. This should feel like a gentle massage on your back. If your spine clunks against the floor or anything hurts, you can control this by softening the muscles in your back and letting your back ooze against the floor as you roll.

Now that you know breath, core–distal, head–tail, and upper–lower, you can add on body half.

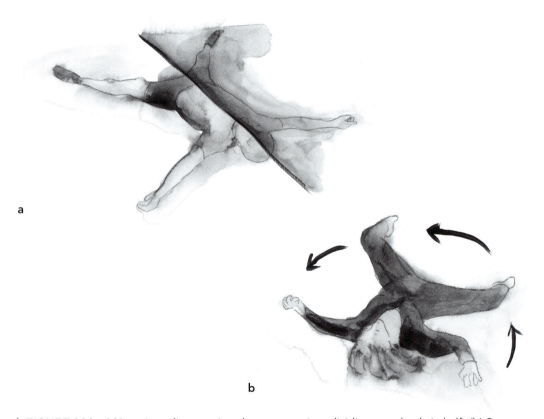

a

b

FIGURE 1.14 *(a)* Imagine a line running down your spine, dividing your body in half. *(b)* Open half of your body like a book.

Following are the movements with the eight counts:

	Movement	Counts	Movement	Counts
Body half			From the X move to a ball on your right side	12345678
	Open the left half of your body	1234	let the right side of your body join to a ball on the left	5678
	Open the right half of your body	1234	let the left side join to create a ball on the right	5678
			Back to the center X	12345678
			Move to a ball on your left side	12345678
	Open the right half of your body	1234	let the left join to make a ball	5678
	Open the left half of your body	1234	let the right join to make a ball	5678
			Back to center X	12345678

A baby who can push up from their belly and see a toy in front of them can now coordinate the right side of the body to reach toward that toy and pull toward it. The baby can now creep along the floor. If they are strong enough to hold on to something, they reach using half of their body. Later, they might even teeter with a couple of steps with the delightful body half coordination of a new walker. As people age, sometimes they move back to the awkward shuffle of a body half walk. This body half orientation can be understood within the dance field as doing *chaînés* (chain or linked turns), opening half of the body, and bringing the other half to join (see figure 1.15).

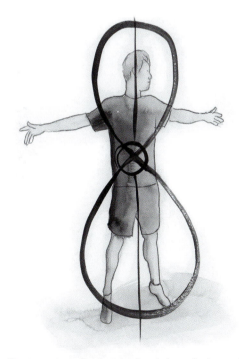

| **FIGURE 1.15** Body half orientation divides the body lengthwise as in this reach of a *chaîné*.

STAGE SIX **Cross-Lateral Connection**

Cross-lateral is the connection diagonally across the body, from the left upper side to the right lower side or the right upper side to the left lower side. To explore this connection in the final stage, as you lie in the big X position, be aware of the places your body makes contact with the floor. Imagine if your body had paint on it where it would leave an imprint on the floor. You can feel the gaps in the paint (e.g., from your heels to your calves, there is a gap from your ankle). Do a body scan, and be aware of the paint and the gaps.

If you are able, partner with someone for this next exercise. If you are working alone, you can imagine the same exercise, but it is key to imagine feeling the pull on your limbs.

Begin with your partner lifting your left leg. When your partner lifts your leg, they may be surprised by its weight. More volume and muscle mass adds to that weight, but do not engage your muscles to make it easier on them; the more you relax, release, and let them do the work, the better the spiral stretch of your torso and spine. Allow them to move your left foot and leg parallel to the ground across your right leg and then pull at a diagonal opposite your left hand (see figure 1.16a).

Let your partner pull at that diagonal, and this time the release will happen first in the pelvis as it rotates to face down, then the mid-torso, then the shoulders and arms to reorient into the big X facing the floor (see figure 1.16b). This is a give and take, so do not relax so much that you flop onto the floor. Once you have articulated through the spine and shoulders, you can control the flow of the arms to the ground.

Once you relax, breathe, and reassess how you feel, lift your left foot just a few inches off the ground (see figure 1.16c). Resist engaging your muscles to help them.

As your partner begins to move your left leg across your centerline, they will rotate the foot and leg to open up away from the ground, and as the leg, staying low to the ground, crosses the right leg, the hip will rotate, then the mid-spine, and finally the shoulders (see figure 1.16d). Continue this using the right leg.

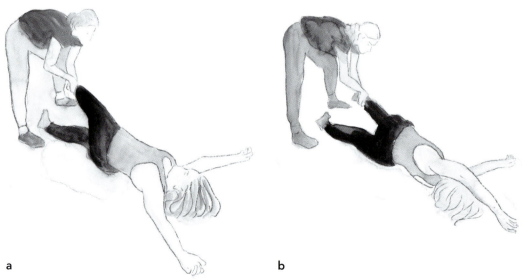

a b

FIGURE 1.16 *(a)* Allow your partner to move your left foot across your right leg and pull at a diagonal. *(b)* This is a give and take; relax but stay engaged. *(c)* The left leg lifts just a few inches off the ground. *(d)* The left leg crosses the right leg, rotating the hip, spine, and shoulders.

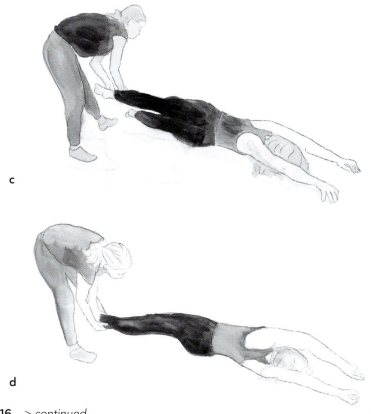

c

d

| **FIGURE 1.16** *> continued*

Now have your partner grab hold of your left hand to do the same exercise with the arms. Experiment with holding that weight so that you are passive and your partner is doing most of the work; it is important to be aware that you are not engaging additional muscles unintentionally. Now have them move your left arm across your face, rotating your shoulder so that they are pulling your hand parallel to the floor at a diagonal angle. Be slow and attentive; this should provide a luscious release to your spine. The shoulder follows suit with the ribs and the middle spine until eventually the hips join in the spiral and, with control, you roll over into a big X with your face down on the floor. It is tempting to try to push with your legs or rotate your torso as one blob, but the spiraling motion will provide the most information, stretch, and awareness. Take a moment to breathe and yield into the floor, and then begin the journey back. The partner should now take that same left hand, rotate the arm so that the palm is facing up, and rotate through the shoulder across the face, pulling at a diagonal back to the upper left side. In time, the ribs will rotate, and the mid-spine, hips, and legs gently return to the big X, facing up. Take a moment to breathe, and be aware of the openness and stretching you may feel.

Repeat this same exercise with the right hand and arm, rotating, spiraling, folding, unfolding, and then returning. Once you have done this initiating with the arms, it is important to tune in to your body and see how you feel. It is easy to go through the motions, but allowing your awareness to become razor sharp with how you are feeling and which muscles have been stretched will serve you in your body awareness and proprioception.

Now that you have fully experienced this work with a partner, you are ready to do this movement on your own. As you begin with the legs (see figure 1.17a) crossing your midline, imagine your partner pulling on your ankle so that you rotate your hips; your shoulders are the last to go in each direction. As you initiate movement on your own with your arms (see figure 1.17b), imagine once again your partner pulling your wrist so that your hips are the last to rotate into the big X.

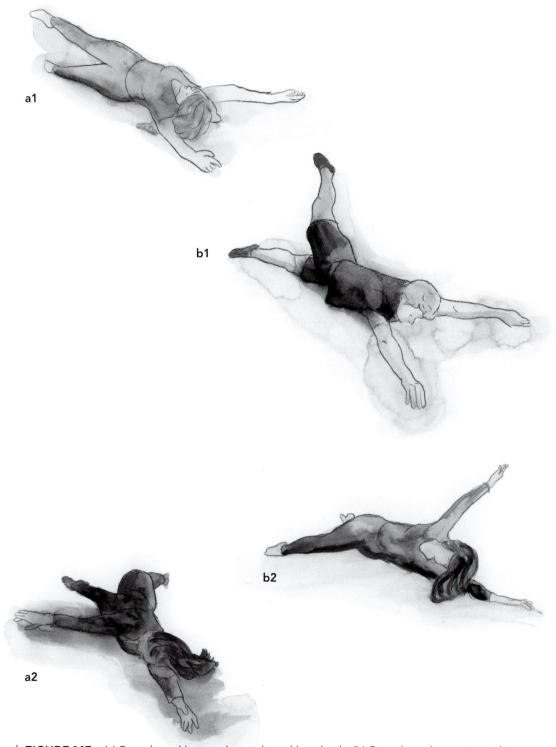

a1

b1

b2

a2

FIGURE 1.17 *(a)* Cross-lateral legs and cross-lateral legs back. *(b)* Cross-lateral arms at a right angle, and cross-lateral arms back.

You can see how this movement correlates with the symbol (see figure 1.18). You now have multiple ways to imagine this movement, with a partner, on your own, and with the visual element of the symbol.

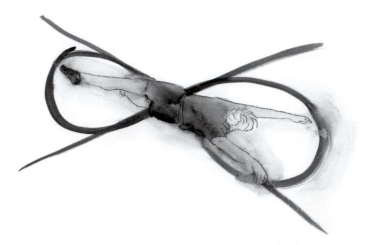

| **FIGURE 1.18** The cross-lateral connection divides and unites the body.

When done carefully, thoughtfully, and properly, exploring cross-lateral connection creates a wonderful release and stretch along the spine. Cross-lateral is the most complex of all the stages, ultimately allowing us to walk with more awareness. As discussed with body half, try walking in this way. It is awkward, and you might feel like a toddler just learning to walk.

Once we are able to use opposition (left arm swings forward as we step with our right foot) we are able to move in more complex ways. Being able to cross over the midline, or cross-lateral, we are able to walk with ease, run, and spiral.

We have already explored cross-lateral first with our legs, but our warm-up begins with the arms.

Here are the counts:

	Movement	Counts	Movement	Counts
Cross-lateral	Left arm reaches across	1234	then shoulders and hips	5678
	Open back with left arm	1234	then shoulders and hips	5678
	Right arm reaches across	1234	then shoulders and hips	5678
	Open back with right arm	1234	then shoulders and hips	5678
	Left foot reaches across the body	1234	then hips and shoulders	5678
	Open back with left foot across	1234	then hips and ribs	5678
	Right foot reaches across the body	1234	then hips and ribs	5678
	Open back with the right foot	1234	then hips and ribs	5678

Complete Warm-Up So Far With Counts

Following are the movements with the eight counts:

Breath

Breathing	Movement	Counts
X inhale		5678
Exhale	into a little ball on the right	12345678
Inhale	back into the big X	12345678
Exhale	into the little ball on the left	12345678
Inhale	back to the X at center	12345678

Core–distal

Breathing	Movement	Counts
Exhale	into a little ball on the right	12345678
Inhale	around the ball at your back	12345678 really reaching
Exhale	back to the ball on your right	12345678
Inhale	back into the big X	12345678
Exhale	into the little ball on the left	12345678
Inhale	around the ball at your back	12 really reach 345678
Exhale	back around your core on the left	12345678
Inhale	back to the X at center	12345678

Head–tail

Breathing	Movement	Counts
Exhale	rolling over onto belly X	12345678
Inhale	while placing hands under shoulders and push up into cobra	12 push up 345678
Exhale	easing back to the ground	12345678
Inhale	while placing hands under shoulders and push up into cobra again	12 push up 345678
Exhale	contracting your stomach and fold into child's pose	12345678
Inhale	pushing the 'marble' with your nose	12345678
Exhale	rolling back into the X	12345678
	Hands by your side and feet together rock (as many counts as fits the music) and finish in the X	

Upper–lower

Movement	Counts	Movement	Counts
Upper moves to the right	12345678	and lower comes to meet and complete the ball	12345678
Upper moves back to the X	12345678	and lower completes the X	12345678
Upper left	12345678	and lower comes to meet and complete the ball	12345678
Upper returns to the X	12345678	and lower completes the X	12345678
Lower right knees pull up to side	12345678	and upper comes to meet and complete the ball	12345678
Lower moves back to the X	12345678	and upper completes the X	12345678
Lower left knees pull up to the side	12345678	and upper comes to meet and complete the ball	12345678
Lower back to the X	12345678	and upper completes the X	12345678

Body half

Movement	Counts	Movement	Counts
		From the X move to a ball on your right side	12345678
Open the left half of your body	1234	let the right side of your body join to a ball on the left	5678
Open the right half of your body	1234	let the left side join to create a ball on the right	5678
		Back to the center X	12345678
		Move to a ball on your left side	12345678
Open the right half of your body	1234	let the left join to make a ball	5678
Open the left half of your body	1234	let the right join to make a ball	5678
		Back to center X	12345678

Movement	Counts	Movement	Counts
Left arm reaches across	1234	then shoulders and hips	5678
Open back with left arm	1234	then shoulders and hips	5678
Right arm reaches across	1234	then shoulders and hips	5678
Open back with right arm	1234	then shoulders and hips	5678
Left foot reaches across the body	1234	then hips and shoulders	5678
Open back with left foot across	1234	then hips and ribs	5678
Right foot reaches across the body	1234	then hips and ribs	5678
Open back with the right foot	1234	then hips and ribs	5678

Cross-lateral

Alexander Technique

The next step in the warm-up includes elements drawn from **Alexander Technique,** a method of study founded by Frederick Matthias Alexander ("FM" Alexander) (1869-1955) that offers the opportunity to investigate the modes of study that have influenced many great performers. In his study of the body, Alexander found that overall health, as well as artistic performance, can be improved by observation and improvement of the "use of the self" (Park 1998, 7). He discussed "misuse" and "good use" in the postures and functioning of the body and was attentive to the postures and sequences of the movements we use in everyday life. Observing your physical habits and "unlearning" them by consciously applying principles of "good use" to your day-to-day operations is what Alexander Technique is all about (Lee 2002, 65). To explore your own habits, it can be instructive to take a look at how you are positioned at this very moment. What posture, or carriage, do you adopt while reading? Where is the center of weight distribution in your body? How are your face, neck, spine, and legs positioned while you read? You might find that you typically adopt more or less the same position each time you sit down to study or read. If you are a student, you might spend long periods in this same position. Simply being aware of your own habits can help you notice the thoughts and feelings that are associated with holding your body this way. Are you relaxed or anxious in this position? Can you subtly alter the way you are sitting in ways that change how you feel about what you are reading?

JOURNAL REFLECTION www

Write in your journal about movement habits you observe in yourself. Observe your roommate, family members, and friends, and note their carriage and posture when going about their activities.

EXERCISE **Body Mapping**

One element of Alexander Technique is body mapping. The idea is that each person has an idea of how their body appears and moves in space, but this map in their mind might not be correct in terms of how their body really looks or functions. Teachers of the technique can offer their students corrective suggestions that enable that student to think more accurately about their body.

Here is an example of how you can adapt this technique for yourself:

Look at your hand from the back, and track the knuckles. You can find a joint by your fingertips, a joint midway on your fingers, and a joint where your fingers are connected to your hand. Focus on the third set of knuckles on the back of your hand, and feel their nubby protrusions as you move your fingers from that joint. Now turn your hand over. Without touching, notice the joint near the fingertips, marked with a crease, as well as the one midway down the finger toward the palm, marked with a crease. Now touch with your other hand where you think the next joint is. Very likely, you touched where the crease is. But if you turn your hand to the side and move those fingers, you will find that the crease is much closer to the tip of your fingers than the joint. Once you have done this body mapping exercise and begin to think of moving your fingers from the true joint, it can make them feel much longer than originally perceived. This is how body mapping works: information brings new awareness.

Moving Back to the Warm-Up

From the final X, roll onto your stomach again, and then bring your hands and knees under your shoulders and your hips. Think about the orientation of your head and neck to your spine. If you look straight ahead, the head and neck actually bend up to see, but since humans walk on two feet, our spine aligns when we are on all fours (see figure 1.19).

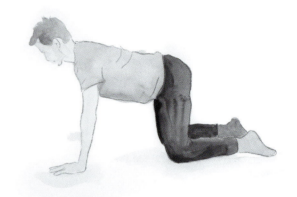

| **FIGURE 1.19** On all fours, lengthening the spine.

EXERCISE **Partner Up**

Partner up. One of you should get on your hands and knees, and look at the floor, properly aligning the spine, neck, and head. The partner gently places their hands on the sides of your head, not pulling but simply being a gentle guide, to give a sense of lengthening the spine further, with the head moving away from the tail. Observe your partner, and observe yourself in a mirror. Flex the spine into cat position, or let the belly button move as far away from the floor as possible, arching up like a cat (see figure 1.20a). Feel the head aligning with the curving spine with this movement. Now do the opposite with eyes toward the ceiling as the belly moves toward the floor in cow position (see figure 1.20b). Thinking of all the vertebrae moving to create these two shapes allows for a sense of freedom in the movement and in the articulation of the spine. Now go back to an aligned spine on all fours, seeing if it can be re-created by feeling and a new awareness.

Coming to standing, continue to work with your partner. Select one side of the body and place a piece of tape at the top of the ear, middle of the shoulder, middle of the hip, middle of the knee, and the ankle (see figure 1.21). The student with the markers should look straight ahead while their partner observes.

Stand as though you are tired; slouch in an exaggerated manner (see figure 1.22).

Now stand with a proper stance. Observe the movement of the dots of tape. When the person with tape markers stands in what they feel is alignment, their partner can guide them to see if they are hyperextending their knees or rolling their shoulders forward. Conclude with each partner by touching the back of the neck and again gently lifting (see figure 1.23). Just like on all fours, this is not about pulling or pushing, but about your touch guiding them so that they can re-create the feeling of that hand behind their neck in the future. This is another form of body mapping. Once each partner has had the opportunity to learn from observing and doing, come to a standing position, and sense the lengthening of the spine from the back.

Now add this to your warm-up.

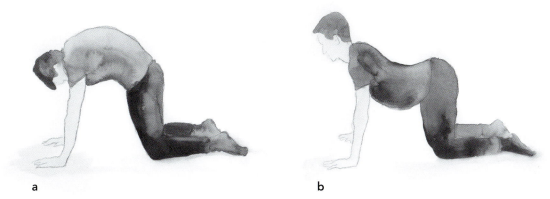

a b

FIGURE 1.20 (a) Cat position with the core pushing away from the floor. (b) Cow position with the core moving toward the floor.

FIGURE 1.21 Points along the body. FIGURE 1.22 Slouching. FIGURE 1.23 Gently guide your partner.

EXERCISE **Spinal Awareness**

Following are the movements with the eight counts:

Movement	Counts	Movement	Counts
		From the X roll over to the right and onto your belly	12345678
		Push yourself up onto all fours with straight alignment looking at the floor	12345678
Push your belly away from the ground into cat	1234	back to neutral	5678
Let your belly move toward the ground into cow	1234	back to neutral	5678
		Come to a standing position with good alignment, knees soft, lengthening from the ground	

Spinal awareness

EXERCISE **Visualization**

Form a comfortable stationary standing position. Visualize crystal-clear bowls of beautiful blue liquid positioned at various points throughout the body: one at the chin, one at the back, one at the ribs, and one at the hips. Rotate these bowls, imagining water spilling out in each direction depending on how you shift their alignment (see figure 1.24a).

Next, imagine that you have to move to pour the blue liquid out of the front of the bowl at your chin. How do you have to move your whole body in order to tip

a b c

FIGURE 1.24 *(a)* Visualize crystal-clear bowls of liquid positioned throughout the body. *(b)* Imagine that you have to move to pour the liquid out of the front of the bowl. *(c)* Envision pouring the water out the back.

the bowl? Try another way of thinking about this: If you stand as if you are wearing a heavy backpack, feeling its imaginary weight on your neck and shoulders, what would the position of these bowls be now (see figure 1.24b)?

Now do the opposite: Imagine pouring water out the back of your head bowl (see figure 1.24c). How do the other two bowls respond?

Try walking around with each of these orientations. When exaggerated, does it make you feel a certain way? Could you create a character from this posture?

This exercise, another example of body mapping, is helpful for understanding posture and alignment with a new perspective. Just like the first step of the warm-up in an X on the floor, the images will resonate differently for each person; either the water drop or the plexiglass vessel imagery might be more effective depending on the individual. Standing in alignment can be prompted by imagining the touch at the back of the neck to lengthen, or the images of the bowls spilling water. The key thing to remember is that this is not a rigid stance. Aligned posture is a living, moving experience, not something to be held. One way to think about this is like a hug. We have all experienced a stiff, rigid hug, and perhaps we have experienced a floppy hug where someone gives you all their weight; neither of these are pleasant. A life-giving hug comes from a balance between the two. Holding your own weight but yielding into the other creates a sense of balance. Imagine your posture this way, living, breathing, able to respond.

Yoga

Yoga is a somatic practice with roots in spiritual and physical training of the mind and body and is a powerful movement form for meditation, awareness, strength, and stretching. Yoga takes different forms, including hatha yoga, which is popular in Western cultures as a form of physical wellness and exercise, and pranayama, breathing exercises that purify the mind and spirit. When used in theatre and dance practice, yoga practices are often separate from their spiritual history, and as such must be treated with respect and awareness in that the **asanas**, or yoga postures, represent only one small portion of a broad and ancient spiritual practice. Asanas are poses, but just as we were talking previously about not holding postures rigidly, it is helpful to think of yoga poses as living and breathing. We recommend selecting some yoga postures that suit your body to conclude your warm-up. Here we will discuss sun salutations and four asanas including warrior I, extended lateral triangle, warrior II, and a balancing asana such as tree pose.

Try the yoga postures one after another in this order as listed, then try them in a different order. What images or associations come to your mind when you vary the order? Can you think of a movement that serves as a smooth transition from one form to the next?

EXERCISE Sun Salutations

The final step of the warm-up is to do sun salutations, moving through the following sequence.

Standing, press the palms of your hands together as in a prayer. Begin moving by pointing the tips of your fingers toward the floor and then, with a sweeping motion, point in front of you and then over your head, releasing your hands in an

open V stretch. Aware of keeping the back flat, fold forward from the hips again, and sweep the hands in a V toward your feet. Keeping them there, raise your head, looking in front of you, and then fold forward again. (Throughout this movement, you can modify as your flexibility allows.) Extend your left foot behind you, and put your hands on the ground in a runner's lunge, looking forward. Continue by putting your right foot back beside the left, and move into plank. Place your knees on the ground, push back into the child's pose, repeat the head–tail stretch from earlier, and push the marble to release into the cobra pose. This time, however, push with your hands into downward facing dog or a pike. Reach your left foot forward between your hands into a runner's lunge on the other side, reversing the action. Bring the right foot to the left in the forward fold, then reach through the hands, swinging out and standing up with the arms in a V above your head. Conclude in the prayer position.

As you do the sun salutations, begin to think of a cyclical or circular motion flowing and moving through the poses. If you have enough time in the warm-up song you selected, you can move through the sun salutation slowly one time and then a second time more quickly but still smooth. A good way to conclude this exercise is to lie on the floor and relax for a moment, then slowly come to sitting, then a final standing position.

Now move into the asanas, warrior II (see figure 1.25), extended side angle and variation (see figure 1.26), and warrior I (see figure 1.27), on the other side.

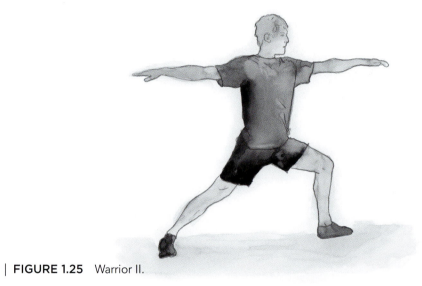

| **FIGURE 1.25** Warrior II.

a b

| **FIGURE 1.26** *(a)* Extended side angle pose. *(b)* Extended side angle pose variation.

| FIGURE 1.27 Warrior I.

For each of the asanas, take eight counts to get into position smoothly and eight counts to continue to flow and grow through the movements as they are not static. Following are the movements with the eight counts:

	Movement	Counts
Yoga posture	Move into warrior II position	12345678
	Continue to stretch, breathe, and grow	12345678
	Move into extended side angle pose variation	12345678
	Continue to stretch, breathe, and grow	12345678
	Extend to side angle pose	12345678
	Continue to stretch, breathe, and grow	12345678
	Move into warrior I	12345678
	Continue to stretch, breathe, and grow	12345678

Conclusion

This chapter introduced you to the concept of interdisciplinary thinking and provided a structure for a warm-up routine. Now it is time for you to take the warm-up and make it your own. Put on some music of your choosing, and begin moving through Bartenieff's six stages, exploring each stage and how it feels in your body. Continue the warm-up by using the Alexander Technique and add on body mapping, allowing you to bring more awareness to your body and creating a stronger mind–body connection. This outline is not set in stone; use it as a guide to find what you like and works best for you as you move through your body in new ways.

APPLICATION ACTIVITY

To complete your work in this chapter, practice the warm-up with each of the portions assembled together. Modify to suit your body and your mind each time you warm up and prepare.

Complete Warm-Up With Counts

The following are the movements with the eight counts:

	Breathing	Movement	Counts
Breath	X inhale		5678
	Exhale	into a little ball on the right	12345678
	Inhale	back into the big X	12345678
	Exhale	into the little ball on the left	12345678
	Inhale	back to the X at center	12345678
Core-distal	Exhale	into a little ball on the right	12345678
	Inhale	around the ball at your back	12345678 really reaching
	Exhale	back to the ball on your right	12345678
	Inhale	back into the big X	12345678
	Exhale	into the little ball on the left	12345678
	Inhale	around the ball at your back	12 really reach 345678
	Exhale	back around your core on the left	12345678
	Inhale	back to the X at center	12345678

	Breathing	Movement	Counts
Head–tail	Exhale	rolling over onto belly X	12345678
	Inhale	while placing hands under shoulders and push up into cobra	12 push up 345678
	Exhale	easing back to the ground	12345678
	Inhale	while placing hands under shoulders and push up into cobra again	12 push up 345678
	Exhale	contracting your stomach and fold into child's pose	12345678
	Inhale	pushing the 'marble' with your nose	12345678
	Exhale	rolling back into the X	12345678
		Hands by your side and feet together rock (as many counts as fits the music) and finish in the X	

	Movement	Counts	Movement	Counts
Upper–lower	Upper moves to the right	12345678	and lower comes to meet and complete the ball	12345678
	Upper moves back to the X	12345678	and lower completes the X	12345678
	Upper left	12345678	and lower comes to meet and complete the ball	12345678
	Upper returns to the X	12345678	and lower completes the X	12345678
	Lower right knees pull up to side	12345678	and upper comes to meet and complete the ball	12345678
	Lower moves back to the X	12345678	and upper completes the X	12345678
	Lower left knees pull up to the side	12345678	and upper comes to meet and complete the ball	12345678
	Lower back to the X	12345678	and upper completes the X	12345678

	Movement	Counts	Movement	Counts
Body half			From the X move to a ball on your right side	12345678
	Open the left half of your body	1234	let the right side of your body join to a ball on the left	5678
	Open the right half of your body	1234	let the left side join to create a ball on the right	5678
			Back to the center X	12345678
			Move to a ball on your left side	12345678
	Open the right half of your body	1234	let the left join to make a ball	5678
	Open the left half of your body	1234	let the right join to make a ball	5678
			Back to center X	12345678

Cross-lateral

Movement	Counts	Movement	Counts
Left arm reaches across	1234	then shoulders and hips	5678
Open back with left arm	1234	then shoulders and hips	5678
Right arm reaches across	1234	then shoulders and hips	5678
Open back with right arm	1234	then shoulders and hips	5678
Left foot reaches across the body	1234	then hips and shoulders	5678
Open back with left foot across	1234	then hips and ribs	5678
Right foot reaches across the body	1234	then hips and ribs	5678
Open back with the right foot	1234	then hips and ribs	5678

Spinal awareness

Movement	Counts	Movement	Counts
		From the X roll over to the right and onto your belly	12345678
		Push yourself up onto all fours with straight alignment looking at the floor	12345678
Push your belly away from the ground into cat	1234	back to neutral	5678
Let your belly move toward the ground into cow	1234	back to neutral	5678
		Come to a standing position with good alignment, knees soft, lengthening from the ground	

Yoga posture

Movement	Counts
Move into warrior II position	12345678
Continue to stretch, breathe, and grow	12345678
Move into extended side angle pose variation	12345678
Continue to stretch, breathe, and grow	12345678
Extend to side angle pose	12345678
Continue to stretch, breathe, and grow	12345678
Move into warrior I	12345678
Continue to stretch, breathe, and grow	12345678

DISCUSSION QUESTIONS

1. What helps you relax your mind, body, and spirit in other aspects of your life other than rehearsal or performance, such as giving a presentation or speaking in front of a group?

2. Which aspects of this warm-up are the most helpful for you, and which are a struggle?

3. What is proprioception, and how do you see it changing for yourself as you become more aware of how your senses perceive your environment? Are you becoming more aware of your body after completing this warm-up?

4. What kinds of music would you like to try with the warm-up? Name at least three songs or types of music you think would be worth a try.

CHAPTER 2

Theatre

Meaning can be communicated in many ways within theatre arts. The disciplines included vary with each production's style and needs but might involve acting, directing, technical theatre, design, dramaturgy, voice, movement, dance, choreography, and other arts. This chapter focuses on the craft of **acting**, exploring the main elements of acting in the Western tradition through concepts developed by the foundational practitioner Konstantin Stanislavski.

Getting Started: Connecting to the Text

Aristotle was perhaps one of the first theorists of the arts, and in his *Poetics* he divided the elements of performance into six areas:

- **Plot:** The events and actions
- **Characters:** The people or figures who appear or are important in the story
- **Theme:** What the play is about, or its main concepts or messages
- **Diction:** Dialogue spoken by the actor and chosen by the playwright, but also the style, whether it is verse or prose, and use of rhythm and type of speech
- **Music:** Includes any type of sounds used
- **Spectacle:** Design elements such as scenery, costumes and makeup, machinery, or stage effects

When you first read a play it can be helpful to take notes on those six broad elements to guide your observations.

When you begin to rehearse a role, it is sometimes daunting to approach the text as a whole. For this reason, many practitioners advocate breaking up the script into manageable **bits** or units. (Both terms are used, but practitioners normally prefer one or the other.) Stanislavski's practice of doing this has been foundational in the field. In his book *An Actor Prepares*, he provided an amusing analogy between carving a large turkey into manageable pieces instead of trying to eat the whole thing all at once. So it is with beginning to work on a script. It is helpful for students to be able to look at any piece of written text and to **score** it (break it down into chunks), like a symphony is typically made up of four movements, each of which can be broken down into phrases, measures, and individual notes. Stanislavski taught his actors to break up the script so that when seen as a whole, the bits come together to form the score of one performer's own role. Those individual roles combine to produce the score of the performance as a whole (Merlin 73).

Within each bit or unit, the actor studies their part to identify the **objective** of the speaker within each section. Objectives are characters' desires, what they want in each scene and over the course of the play as a whole. One of the actor's first jobs when approaching the role is to ask the question, What is it that this character wants? That work has a psychological aspect to it, as the actor incorporates emotions and drives to express what the character needs. The character's desires are revealed to other performers and the audience via the **actions** that the character carries out in pursuit of their objective (Merlin 75). These are the foundations for the practice of acting, and they can be built upon and adapted to the other artistic practices to create art in

KEY TERMS

acting
actions
aside
bits
blocking
cast
characters
costume designer
costumes
diaphragm
diction
direct address
director
dramaturg
dress rehearsal
ensemble
given circumstances
kinesphere
method of physical actions
monologue
objective
playwright
plot
production manager
projection
props
rehearsal
scenic designer
score
stage business
stage electrician
stage manager
technical director
theme
voice

Like so many of history's great thinkers, Kostantin Stanislavski's (1863-1938) ideas were dynamic and responsive to his ever-evolving practice. One of his books, foundational in the Western acting tradition, is *An Actor Prepares* (1989a), in which he lays out many of the tools and concepts he developed with the Moscow Art Company, which he founded in 1897 with Vladimir Nemirovich-Danchenko. His first book was intended to be read alongside the second, *Building a Character*, though *An Actor Prepares*, with its system of action, imagination, concentration of attention, relaxation, units and objectives, and emotion memory, remains fundamental to mainstream actor training in the West. The third book in the trilogy, *Creating a Role*, is a collection of his other writings. Stanislavski lived and worked in Russia at a time when the craft of acting was not systematic. But the development of evolutionary science brought about by Charles Darwin's *Origin of Species* (1859) created a wave of methodological thinking that pervaded areas of investigation, including theatre and the arts. His career intersected with the political climate created by the Soviet regime, which favored direct action over individual emotion, leading him to develop two of his most influential concepts, the **method of physical actions** and active analysis (Merlin 2007). These concepts took Stanislavski's ideas beyond the psychological investigations made famous by his first book, into the more directly physical work that characterizes his later career.

interdisciplinary fields. In dance, for example, the intent is a driving force behind the movement. (We will study this further in chapter 3 when we delve into Bartenieff Fundamentals.)

The next step in the process is to think about how the objective is expressed in words and actions. Here, we look for a verb that ends the sentence: "I want to . . ." Once the verb is identified for each objective, scene partners or solo performers discuss and play different actions that aid them in the pursuit of those objectives and of finding the true meaning of a section of text. This can help in the process of naming a bit or unit.

Critical to an actor's understanding of the text is an appreciation of the **given circumstances** inherent in the situation. A good place to start when establishing the given circumstances of a role is with these questions: Who? What? Where? When? Why? Studying the context of the situation can be done in many ways, and here Stanislavski's work has again been foundational for the field (see his *Creating a Role*). The actor does initial research into the life and times of the character by looking at the personal, psychological, physical, social, historical, and geographical context of the character and situation. This work flows into a study of the situation in which the production is taking shape; that is, the actor also must be aware of the circumstances created by the presence of other influencing factors such as the director, designers, and conditions of the performance space.

Preparing a Scene

After performing analysis, the actor transitions to the practice of embodiment, communicating with scene partners on stage and, most importantly, with an audience. An example from Gonzaga University's 2013 production of *The Force of Habit* (Castro 2019) illustrates how the text was broken up into bits for **rehearsal** (working with the actors and director before the audience sees it) and knitted together for the performance. The context of this moment is that Hipólita's father, Pedro, has raised her in a war zone and dressed her as a male, training her in the ways of war. Pedro has returned home and intends for her to learn the ways of a woman. She tries on the dresses, shoes, and hairpieces in the fashion of her day and finds them reprehensible (see figure 2.1).

Even worse, Hipólita's father takes her precious sword, which has been at her side as her protector all her life and gives it to her brother instead. She resists at first, then addresses a monologue directly to the sword at the end of this excerpt (Castro 2019, 151-153):

FIGURE 2.1 In *The Force of Habit*, Félix helps his sister put on the shoes, which are high to keep off the muck in the street.

Bit 1

HIPÓLITA. I confess, I am not skilled at
 walking this way.
(She trips in the high-heeled shoes, takes them off, and throws them.)
COSTANZA. Listen, wait.
HIPÓLITA. Walking on such flimsy things
 how will I keep my head safe?
 How can a woman,
 perching on these cork sandals,
 spend her entire life
 on the verge of falling, and not fall?

- *Objective:* To walk in the shoes without falling
- *Physical action:* Walk valiantly, though it is difficult

Bit 2

 I refuse to wear these shoes,
 this dress and this headpiece;
 frivolous adornments that
 are sure to come to a bad end.
PEDRO. What's wrong, Hipólita? What is it?
 You look pretty.
HIPÓLITA. To you, sir,
 I appeal this punishment;
 this dress is drowning me.

As for this false hairpiece
squeezing on to my head,
I can feel the finest strand
serving as a noose around my neck.

- *Objective:* To get out of the shoes, dress, and hairpiece
- *Physical action:* Take off and throw the shoes, and pull at the dress and hairpiece

Bit 3

COSTANZA. Daughter, stop this right now.
Jesus! How strange!

PEDRO. Monsters of nature
are our children, my lady.

GALVÁN. Have the brother give her his beard,
and the sister lend him her bravery
in exchange, and then, sir,
you will have the business all fixed up.

COSTANZA. The blood has all rushed
to his face. Is he angry?

PEDRO. Having been raised so badly
has caused him to live in shame.

(He takes the sword from the hands of the servant.)

Note that we are working from Hipólita's perspective, and although she does not speak in this bit, she is active in hearing her parents' disapproval and the mocking of the servant, Galván.

- *Objective:* To resist her parents' attempts to change her
- *Physical action:* Put distance between self and clothes while acknowledging parents' disapproval

Bit 4

HIPÓLITA. I must return my sword to my side
and be freed from this,
which does not suit me at all.

PEDRO. Patience, as you are a woman,
and I want to put this sword
at your brother's side.

- *Objective:* Restore myself to order by trading the sword back for my normal (soldier) clothes
- *Physical action:* Go for the sword

Bit 5

HIPÓLITA. What injustice!
Please allow my soul
to say goodbye to it properly.

(She draws the sword.)

> Oh, sword! You deserve my adoration
> for your many merits,
> the insignia of your cross guard
> and the steel of your blade.
> I do not hope to wear you again,
> because that would be to act cruelly,
> with scant honour and little loyalty,
> if having hung a distaff, against my will,
> at the place of your sheath,
> I returned you to my side.

- *Objective:* Say goodbye to the sword with the dignity both it and I deserve
- *Physical action:* Receive the sword and say goodbye to it

The Force of Habit by Guillén de Castro, translated by Kathleen Jeffs (Liverpool University Press, 2019. pp. 151-153).

How does an actor approach this passage, from the perspective of Hipólita, employing the terms discussed so far? In rehearsal, each of these tools allows for a deepening examination of the text and offers clues for the actor to begin to build a performance. First, look at the context and given circumstances of the piece, answering these questions: Who? What? When? Where? Why?

Who
Hipólita (young noble woman who has been raised as a boy by her father in the wars), Costanza (her mother), Pedro (her father), Félix (her brother), and a servant

What
Hipólita learns to wear female clothing, and her father takes away her sword and gives it to her brother.

When
The play was written between 1610 and 1615 and is set just before that, during a temporary truce that began in 1609 (the Pax Hispanica. or Twelve Years' Truce, between Spain and the Netherlands, who had been fighting in the seemingly endless conflict known later to historians as the Eighty Years' War).

Where
The play takes place in Zaragoza, Spain.

Why
Pedro feels he must take Hipólita's sword from her for two reasons: (1) to give it to her brother in an attempt to make him a man and (2) to take it away from Hipólita so that she can start the process of leaving her past behind and becoming a lady. Hipólita shows courage and dignity in the face of this challenge; her sword has been her protection and a source of pride in her skills, and she is being asked to give all of that up.

Then divide the portion of text into bits, offering a bit change with every entrance or exit of a character or a change in the character's objective. We look at what Hipólita wants in each moment of this passage. Dividing the passage into bits, there are natural breaks between Hipólita's attempts to walk in the precarious shoes, begging her father to free her from the obligation to wear the outfit, and Pedro's action of taking

her sword, which the servant has been holding for her as she totters in the shoes, and giving it to her brother. The bit breaks could be divided like this:

Bit 1—Questioning: How can I survive in this outfit? I will make a valiant effort to try.

Bit 2—Deciding: I refuse to try anymore; it is hopeless.

Bit 3—Forced to listen: My parents react to my decision.

Bit 4—Take action: Restore myself to order and double my efforts to reclaim the sword.

Bit 5—Capitulation on my terms: Give in to defeat, and say goodbye to the sword.

An actor would then seek to refine the verbs used to express Hipólita's objective within each bit, expressing each as an active verb. Stanislavski wrote on the subject of articulating verb choices precisely for the purposes of aiding the actor in making active, physical choices, separating states of being from actions of doing (McGaw, Stilson, and Clark 2007). It is more useful for an actor to *do* the physical actions such as walking in uncomfortable shoes than it is to work with the vague idea of *being* frustrated. "Acting frustrated" does not produce the same results as "putting distance between myself and those clothes."

Stanislavski's method of physical actions takes this work further, prompting the interplay between external action and inner feeling. This is precisely the flow of Hipólita's experience in the earlier excerpt as she responds to the uncomfortable stimuli of the forced transition into the modes of dress and behavior expected of women of her time, when she had been raised as a young man fighting under the Spanish flag in Flanders. Her choice to use a **monologue** (extended speech by a character) to address her sword allows her family (and the audience) to see her interior feelings of grief after she has expressed her frustration in more overtly physical actions such as throwing the shoes and pulling at the dress and hairpiece. This transition from external to internal is in this particular piece of text, but actors can experience this transition in any performance process that follows Stanislavski's methods. These concepts are interdisciplinary in nature, and we will visit them again in chapter 3 when we look at Bartenieff's notion of inner-outer.

Interdisciplinary Example: Interpreting Text for Performance

A production with an intentionally interdisciplinary approach also employs these techniques of breaking up a text before reassembling the parts to create the whole. Figure 2.2 depicts a **dress rehearsal** (one of the final steps before opening the production, in which all the elements of costume, makeup, lighting, and sound are practiced together) of the interdisciplinary production *A New Season*. Actors are interacting with sculpture (trees) and scenic elements (projection ribbon) while performing the work of poets local to the area in which the work was conceived. These actors worked with the poems as scripts for performance, breaking them down into constituent, playable bits that could be rehearsed and analyzed in isolation, then assembled to create the whole. In this example, each bit was spoken by a different actor, which is one possible adaptation of this technique for an interdisciplinary performance.

| **FIGURE 2.2** Rehearsal of *A New Season* at the Woldson Performing Arts Center Dedication, 2019.

"Tell Me About the Trees" by Terry Bain

Not about the trees but
the trees.
Tell me about the trunks and the pitch and
the leaves. The bark. And the shape.
Where the birds live.
About the cones and the whirlygigs
and pollen. Say deciduous and coniferous.
Unexpectedly pronounce the "h"
in "herbaceous." Just for me.
Tell me about roots and soil.
Wildlife. Squirrels.
Explain what a cache is,
and what I can expect to find there
if I dig it out with my hands.
Tell me again.
About shade. About autumn.
About rain and moss and
clearcuts.
Fire.
Chainsaw, cordwood, and pickup.
Robin, sparrow, starling.
Flicker, crow, cat.
Termites and ants.
Tell me
about ants.

Reprinted from *Poems Selected by Tod Marshall: State Poet Laureate*
(Spokane, WA: Sage Hill Press, 2017), 10-11. By permission of Terry Bain.

In the production, the poem was spoken by multiple actors as they moved into place with the trees to build a feeling of that moment. Each time a new thought arose, a different actor spoke, their movements with the trees capturing the emotion and lyricism of the text.

Here is an example of a way to break up Terry Bain's poem for one actor. As you read through this example, consider the following questions: Where would you divide the thoughts? How would this affect your breathing? How are you inspired to move? To put these skills into practice, read it aloud, changing places where you mark the divisions and noticing how this affects the meaning and your delivery of the poem.

Bit 1

Not about the trees but
the trees.

- *Objective:* To get the person to whom the speaker is talking to stop doing what they are doing and listen
- *Physical action:* Stomp and put arms out to get their attention

Bit 2

Tell me about the trunks and the pitch and
the leaves. The bark. And the shape.
Where the birds live.
About the cones and the whirlygigs
and pollen. Say deciduous and coniferous.
Unexpectedly pronounce the "h"
in "herbaceous." Just for me.

- *Objective:* To remember all the elements of trees that are so wonderful
- *Physical action:* Reach from low to high, trying to see each thing mentioned

Bit 3

Tell me about roots and soil.
Wildlife. Squirrels.
Explain what a cache is,
and what I can expect to find there
if I dig it out with my hands.

- *Objective:* To get the listener excited by all the wonderful details of animals and memories
- *Physical action:* Reach toward the floor, scooping up the soil and letting it fall

Bit 4

Tell me again.
About shade. About autumn.
About rain and moss and
clearcuts.
Fire.

- *Objective:* To plead with the listener and surprise self when remembering dark elements that affect the trees
- *Physical action:* Reach for a big shape like shade or autumn, and let arms fall toward the floor, dejected by the memory of clearcuts and fire.

Bit 5

Chainsaw, cordwood, and pickup.
Robin, sparrow, starling.
Flicker, crow, cat.
Termites and ants.
Tell me
about ants.

- *Objective:* To remember ways humans affected the trees, and the various creatures, no matter how small
- *Physical action:* Continue to melt toward the floor, and conclude at the lowest level

Using different given circumstances, an actor could take inspiration from the text to create a backstory (information about the character's life history before the time of the story) for the speaker. Here, creative details can be imagined to give a very different interpretation, or reading, of the poem. How would this information change the actor's delivery and performance?

Who

Impatient schoolteacher

What

Exhausted and insisting that the students recount all the things they have been studying about trees in the Pacific Northwest

When

End of the school day in the 1950s

Where

In the classroom in a small town outside of Spokane, Washington

Why

The teacher is tired from a full day of teaching and just wants to be certain the students remember all the details from their lessons. As the teacher prompts the students, they get more exasperated by the lack of participation from the students. They use different words with different sections of the class, speeding up, desperate for someone to remember something, until they try to come up with the simplest element of ants.

Actors can express meaning in texts in very different ways depending on how they answer what it is they want, as well as the who, what, when, where, and why. What is another way you could interpret this poem? In art and interpreting texts, there can be more than one answer, and sometimes the first answer is not necessarily the strongest. Allow yourself to explore multiple approaches.

EXERCISE **Painted Kinesphere Bubble**

From a standing position, imagine you have paint on your hands, and you want to smooth that paint on your **kinesphere** (the area right around your body, or "personal space bubble") (see figure 2.3). Be certain to get paint on all parts of this bubble, from high to low, behind you and in all directions. Observe how much you are able to use your arms and torso to explore just this single space. Look at Bain's poem again. How might you use your body to express an excerpt from the poem within this space you have just created?

| **FIGURE 2.3** Kinesphere.

EXERCISE **Physical Shapes**

Look through the poem again and select three action words that you feel are important for the meaning of the text. Create a large physical shape to represent each one of the words. Ideally, this takes up a lot of space; trying to fill your kinesphere. Rehearse the three shapes as though they are independent of each other. Next, rehearse the three shapes in sequence, connecting them together through movement (see figures 2.4, 2.5, and 2.6). Experiment with saying the text with this abstract movement. How does it engage your body in a new way?

| **FIGURE 2.4** Big shape.

| **FIGURE 2.5** Big shape 2.

| **FIGURE 2.6** Big shape 3.

Body: The Actor's Instrument

The text is a foundational starting point for many processes, but from there on, the body and physicalizing the text takes over. Some tools that are commonly used to articulate and bring forth these ideas physically are breath, voice, projection, face, eyes, and focus. The activities in this section will grow your awareness of the personal power of your body to communicate and make connections using these tools.

Breath

Begin by connecting to the breath. The breath is the foundation of both the spoken word and the moving body, as we explored in chapter 1 at the start of the warm-up. Many performing arts methodologies pay specific attention to the breath for a reason (Thomas 2002; Hackney 2002). It is important to learn to center and relax the mind and body in order to think and perform effectively. Focusing the mind on the breath centers the actor and provides a base in moments of anxiety or stress. Many studies have proven that breathing techniques can mitigate stage fright (McGaw, Stilson, and Clark 2007). When you are nervous, it is very common to hold your breath or to tighten or shallow your breathing. If you have ever sat close to the stage for a performing arts production, you know that sharing space with the performer involves seeing them breathe, hearing them breathe. This is also why live performing arts are so effective in drawing out natural visceral responses in audience members. If an actor on stage is holding their breath, you might find yourself doing the same. Performers who are highly trained and prepared create the life of their character in the breath and bring the audience into their world. You can learn to skillfully paint captivating pictures with words that ride effortlessly on the breath and to move with your breath, supported in the core of your body.

It is important to continue to practice regular breathing exercises as part of a performer's training. To gain a sense of how your body functions while breathing, a couple of physiological points are important to learn. The first is the use and function of the lungs and **diaphragm**. Within your chest cavity are your lungs, which take in air when you breathe. It can be helpful to think of breathing *down* rather than *in*, because your lungs are connected to the second-largest muscle in the body, the dia-

phragm, which moves up and down in association with your breath. The diaphragm is at the bottom of the chest cavity and the top of the abdominal cavity, so think of it as forming an upside-down bowl shape within the center of the body or as a dividing wall between the upper and lower halves of the trunk. If you place your hands on your hips, slide them up to your waist, and try a few short quick exhalations, like blowing out a candle with your lips pursed, you can feel the muscles at the bottom of your rib cage respond dramatically to your short, sharp exhalations. If you vary the sounds as repeated s sounds, you can feel how voicing sound on the breath changes the experience.

Try this: Take a deep breath in slowly through your nose. At the top of the breath, hold it while counting for a few seconds, then exhale through the mouth, pushing the air out through the lips in a sustained flow. Repeat this a few times, then take a moment to notice how you feel. Controlling your breathing eases tension in the body.

EXERCISE **Circular Breathing**

Stand with your feet firmly planted on the floor, shoulder-width apart. Unlock your knees so that you are standing firmly but lightly, as if you are ready to move and not stiff. Place your hands at your side, rolling your shoulders a few times to relax your neck and arms. Rest your gaze in the middle distance, seeing through the space in front of you, so that your eyes are looking parallel to the floor but not fixed on any one thing in particular; just look ahead softly and with purpose. Begin your inhale slowly, taking care to breathe down, imagining that the air travels down through your body to the base of your spine. As you are ready to exhale, imagine that the air comes up in a tube along your spine, up to the top of your head. Think of your air as traveling in an oval shape from the top of your head and down your spine again, like the shape of a long rubber band, up one side as you inhale to the top and down the other side as you exhale down to your tailbone (see figure 2.7). This continuous flow of breath gives you a touchstone to return to when you need to find your center, regain your balance, and focus your mind and body to work together.

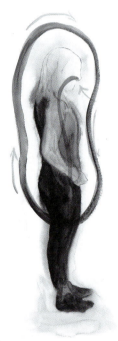

FIGURE 2.7 Think of your breath like a long rubber band.

EXERCISE **Abdomen Breathing**

1. Find a comfortable place to lie down on the floor, giving yourself enough room to stretch out. Make a snow angel to ensure you have enough space to breathe and move freely. Rest your hands on your abdomen. As you breathe in, feel the rise and fall of your hands as they move with your body. Ensure that you are breathing down so that your chest and shoulders are moving minimally. Feel the area at your waist, at the bottom of your rib cage, expand. After gaining a sense of where the movement is in your breath, try the exercise while lying on your front, and compare the sensation.

2. Try it another way: Lying on the floor on your stomach, place your hands behind you on your back, and locate the areas of expansion. Breathe deeply and breathe down.

3. To finish, stand and breathe again, this time noticing how the muscles in your body respond to breathing while standing. How do you experience breathing while standing now? How is it different from breathing while lying on your back? On your front?

Voice

It is no surprise that actor training includes developing the **voice**. We typically learn to speak at a young age, and our upbringing and the situations in which we learned to speak and mimicked the speech of those around us have a tremendous influence on our voice and the composition of our sound (Berry 1992). A fully trained actor has learned to overcome their own personal vocal qualities, becoming a chameleon of voice depending on the role, story, and intention. The voice can be an important tool in so many fields and applications. Think about how you use your voice in presentations, in interviews, and in meeting others, and how its use can have a powerful impact. To be intentional in how you are perceived vocally is of value. Think about how you use your voice in different ways as you go about your day.

The goal is to integrate the breath and the thought you are expressing into one so that you can speak with one thought and one breath (Berry 1992). When working with a piece of text, it is common for actors to mark the thoughts and the breaths so that they do not run out of breath, especially in long speeches. This is part of scoring an actor's text.

Using a piece from Charles Pepiton's adaptation of Shakespeare's *Romeo and Juliet* (2019), you can practice marking where and when to breathe. Here, Romeo's friend Mercutio tells a fanciful tale of Queen Mab, the fairies' midwife, who rides on a tiny chariot to bring dreams to men and women. He describes her nightly trip to deliver dreams to various people.

MERCUTIO.

And in this state she gallops night by night

Through lovers' brains, and then they dream of love;

O'er courtiers' knees, who dream on curtsies straight;

O'er lawyers' fingers, who straight dream on fees;

O'er ladies' lips, who straight on kisses dream,

Which oft the angry Mab with blisters plagues

Because their breaths with sweetmeats tainted are.

Reprinted from Romeo & Juliet Redux by William Shakespeare, adapted by Charles M Pepiton, 2019, p. 27-28. Permission by Charles M Pepiton.

The actor playing Mercutio must score this bit of text carefully to breathe in the places that will best help them to convey the meaning of the speech. Try reading just the first two lines out loud, noticing where you naturally breathe. The text is written in iambic pentameter, meaning there are five two-syllable units of stressed and unstressed syllables. But this does not indicate where to breathe; the actor must work this out. It helps to score the breath tightly, thought by thought, from the first moment, taking more lines and thoughts on a single breath as Mercutio's story becomes frenzied. The trick is to strike a balance between keeping the thoughts and diction clear

and the emotional sense that the story begins to blow through Mercutio as if it (or Queen Mab) takes him over. Notice that as you read, you do not stop at the end of the first line. The actor does not need to stop to take a breath after "night by night," but instead can carry on, adding "through lovers' brains" quite easily. Then the actor could take a pause before "and then they dream of love." They could deliver those two lines in one breath, noticing the comma after "brains" but not stopping to breathe there, finishing with "dream of love" as the end of that breath. The next three lines are easily delivered as separate items of a list (that you can imagine pair well with a dynamic actor's physical choices for each one), with three separate breaths, one per line. Then the actor faces another choice: what to do between "kisses dream" and the start of the new line "Which oft the angry Mab." Should the actor run that third item in the list together with this new line, which turns away from the list format and embellishes the thought? Try speaking the last three lines of that passage, making a different choice each time. Which choice most clearly expresses Mab's disdain for ladies' habits of eating sweet treats that give them bad breath? Label your breaths in the text with a slash in creating your personal score of a text.

Projection

Projection is the art of ensuring that your voice fills your performance space and that you can be heard even in the back rows of the auditorium (see figure 2.8). Projection is not merely about being loud; it is as important in a stage whisper or in a fight scene to support your voice so that your message will carry to the audience. Projection is a physical endeavor that comes from a proper understanding of how to support your voice using the musculature of your body, the path of the breath, and the use of your diaphragm. Remember that the diaphragm is a dome-shaped muscle that connects your upper body where you feel your breath in your lungs, to your torso, lower core, and abdominal muscles. When learning to use your diaphragm in breathing and projecting your voice, it is not about consciously contracting your abdominal muscles as you would do in sports, but about breathing deeply into the spaces to support your

FIGURE 2.8 Performance of *A New Season* at the Woldson Performing Arts Center Dedication, 2019.

voice. The goal is not to put pressure on the delicate folds of your vocal chords, which are not muscle, but tissue. Projection comes from deep below, and different pitches are created by the speed of the air as it travels past the vocal chords. In projection for the spoken word, breathing and vocal support are paramount.

EXERCISE **Projection with a Partner**

Stand tall with your feet on the floor and your shoulders back. Face your partner, and start at a distance of about 10 feet (3 m) apart, though you can vary the distances depending on how much space you have. Take a deep breath in and down, filling your lungs and engaging your lower core muscles to support the breath. As you exhale, use a vowel sound such as "aaahhhh" to carry the sound on the breath. Ensure that your throat is not tense, and that air is moving freely through the throat. On the next breath, use an "eeee" sound, then go through the vowels one by one, lifting the air up through your body so that you imagine it bouncing off the back wall. Once you have finished the vowels, select a piece of text that you have memorized or an excerpt from a piece that you are working on. An example from *The Force of Habit* scene would be to try the phrases "Monsters of nature" or "This dress is drowning me." Take a deep breath in, and as you exhale, say the words to your partner, carefully judging the distance necessary for them to hear. Confirm that they heard you, and then it is their turn. After they have spoken their words to you, double the distance between you. (If your room is too small, try working in a safe place outside for this exercise.) Try it again. Gradually increase the distance between you and your partner; do not strain past where you can be heard, but practice this exercise again until you feel more comfortable increasing the distance with a free and supported voice.

If you feel yourself forcing or straining, stop. This work takes practice, and you might not be able to reach the back wall on the first day. Your voice should pass freely from your body, and if you are straining, the voice needs to come from deeper in your core, not from harder work in the throat. If you are struggling, slow down and blow raspberries to feel the engagement of your core, placing a hand there to feel the movement of the muscles. Take a deep breath, and ride your voice on the breath, keeping the throat open.

Face

The face is a very important communicative instrument for the actor. When actors warm up their bodies and voices to prepare for performance, they will also often warm up the constituent parts of the face in isolation. For instance, before you begin to speak a text, it can be helpful again to buzz your lips while "humming" the text in front of you. This not only loosens the muscles of your face but can help you connect the right amount of air you are using to make sound. Other exercises for the face include overemphasizing the facial expressions possible with each organ, working from the chin up to the forehead.

Try this: Engage and then relax each area, starting with the chin and jaw. Relax your jaw, and then engage it in a circular chewing motion. Move up to the lips and produce an extra-large grin before turning it upside down into an exaggerated frown. Engage your nose. How much can you move it from side to side, for instance? Up and down? Shut your eyes tightly, then open them as widely as you can. With the

forehead, practice a deeply furrowed brow, followed by the serene and untroubled countenance of one in meditation. Finally, wiggle your ears. How much can you control your movement? If you engage the full face in as much range of motion as you can, fine-tuning the use of your face for the purposes of acting becomes second nature. With time, you become able to express a greater range of emotion as you deepen your connection to your face's capabilities.

Eyes and Focus

Eyes are also a major part of expression and lead to explorations of how to use focus. Where an actor looks on stage is significant for the audience. Think of visual art pieces in which the painted subject's eyes are looking at something in particular, and the eye of the viewer is directed there. In some performance work, actors avoid looking at their audience in order to keep the fictional world of the play separate. In other pieces, actors sometimes look (and speak) directly at the audience; when they speak to the audience, it is known as **direct address**. When an actor makes eye contact with an audience member, the audience might change from seeing them as a character to being more aware of them as an actor, because some of the fiction of the situation on stage might be broken in the moment of direct address. Think of the effect it has when characters in television and film look directly at the camera, for instance; it is a common tool used to momentarily break the fictional situation. This often has a comic effect, such as in the television program *The Office*. The character appears to comment on the action taking place, raising their eyebrows in disbelief at what is happening, as though asking the audience, "Can you believe this?"

In the situation of a monologue for the stage, it is best for the actor to imagine speaking to someone specific, and it is important for the actor to place that person in a definite place that holds the audience's attention. If the monologue contains moments of direct address to the audience, as sometimes happens in Shakespeare and other works, you can make it clear when you are turning away and then speak to the audience, drawing the observers into the conversation. A moment like this is called an **aside**, which is text that is directed away from the normal flow of the conversation to a specific hearer or to the audience. If the text does not make clear to whom the aside is directed, the actor must make a decision.

EXERCISE Direct Address and Asides With a Partner

First, assign one of the characters to each person, and say the words to each other from where you are. Try it again, and this time say every line directly to the audience. It should become clear which lines are designed to be said to your partner and which are meant for the audience (see figures 2.9 and 2.10).

HIPÓLITA. *(Aloud)* I am not satisfied by your words;
 stand and take up your sword . . .

LUIS. *(Aside)* Now there is more shame
 than outrage in her reply, I think.

HIPÓLITA. . . . and defend yourself now,
 my rage grows higher still.

LUIS. Now the rays from your eyes
 are that of sunlight, not fiery anger.
 (Aside) But, what light-hearted thought
 delighted my entire soul,

FIGURE 2.9 Hipólita confronts Luis.
Photo by Kurt Walls, University of Puget Sound (2015).

FIGURE 2.10 Luis and Hipólita engage in a fight.
Photo by Kurt Walls, University of Puget Sound (2015).

 when this glory, that is mine,
 has played right into my hand?
HIPÓLITA. Defend yourself now, come on!
 LUIS. You oblige me to fight,
 as you have challenged me,
 and it thus falls to me to choose the place
 and the weapons; but, let's
 use those that we carry with us.

The Force of Habit by Guillén de Castro, translated by Kathleen Jeffs (Liverpool University Press, 2019. pp. 291-299).

Vary your choices each time you read it through, which will result in a different meaning depending on the choice you make. The final time, discuss with your partner how you will deliver the asides and how you will speak the lines addressed to your partner.

Stage Awareness

You might have heard expressions such as "stage left" and "the fourth wall" and wondered where to begin. A little bit of familiarity with stage lingo can go a long way toward building your confidence to enter a rehearsal process. Figure 2.11 is a simple chart.

What do you immediately notice about this arrangement? Does it seem backwards? That is because in the theatre staging locations are given from the actor's point of view. "House left" and "house right" are the areas of the auditorium or audience space that are on the left and right from the audience's point of view. But for the purposes of beginning to take the stage, it is good to start from the commonly used actor's positions as listed in figure 2.11.

A couple of terms are useful for referring to actors' movements: **blocking** and **stage business**. Blocking is the movement of actors around the stage. It is traditionally referred to that way because in general, actors do not want to be blocking each other (i.e., they do not want to stand in front of each other and block the audience's view of another actor). So, you will hear of directors holding "blocking rehearsals" and actors "learning their blocking." This means that the director will work with the actors to decide the positions they will take on the stage in relation to one another, and the actors will note these decisions down as they go along. It is often the duty of the **stage manager** to write down all of the blocking that is decided in rehearsal as a reminder for future rehearsals. Stage business is the activity that the actor engages in while playing a character. For example, in Oscar Wilde's play *The Importance of Being Earnest*, the two principal female characters, Gwendolen and Cecily, have tea, cake, and bread and butter spread before them in a memorable scene. The actresses' stage business is to interact with these items, such as pouring tea, offering plates of treats, stirring sugar into the tea, and so on. Those actions are referred to as stage business and not blocking because the actors' blocking might remain the same (they might remain seated, for instance), yet they are very "busy" with the business of the tea.

Props and Costumes

All of the things laid out before actors are referred to as **props** (which is short for "properties"), and these are chosen by the design team to bring the world of the play to life. If they are part of the house or scenery, rather than pertaining to an actor as part of his or her look, they are props. The clothes the actors wear are referred to as **costumes**, and this includes personal accessories such as handkerchiefs, spectacles, and pocket watches, which are only included as props if they are not part of the personal items and look of the actor as created by the costume designer (see figure 2.12).

Collaborative Team

Many people work together to create a production for the theatre. The **ensemble** (group of performers) can include actors, dancers, singers, musicians, and other types of artists with special skills depending on the requirements of the production; some

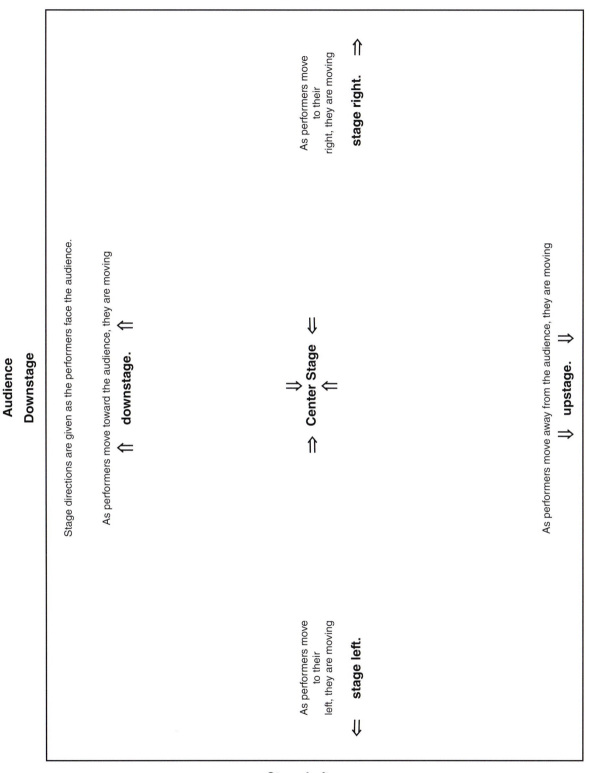

| FIGURE 2.11 Stage directions diagram.

Reprinted by permission from J. Fay, *Dance Units for Middle School* (Champaign, IL: Human Kinetics, 2010), 5.

FIGURE 2.12 Performance of *A New Season* at the Woldson Performing Arts Center Grand Opening, 2019.

productions involve the work of aerialists, opera singers, or others with unique training. The group of actors in a theatre production is typically referred to as the **cast**. Imagining and implementing the scenery and costumes for the performance are many other collaborators, including **scenic** and **costume designers**, responsible for the artistic and creative process of developing the visual and physical world of the play. They are joined in the implementation of their designs by a host of technicians, **stage electricians**, carpenters, **production managers**, and **technical directors**. These collaborators each have a special role in contributing to the one main goal they all share: telling the story. The **director** is typically at the helm, serving as the decision-maker and lead conceptual artist for each production's distinct take on the play or story. The director interprets the work of the **playwright**, author, or creative artist who has written, developed, or curated the script.

Some works of theatre do not have scripts, and some forms of theatre, such as documentaries, might have scripts that are compilations of material culled from other sources, like interviews and spoken word, or material taken from real life. But there is usually someone in charge of keeping track of what will be said and done on the stage, and often this person is referred to as a playwright.

The director, playwright (if living and participating in the process), and design team might work with a **dramaturg**, or theatre research assistant, who is there to support the playwriting process with new work and to provide contextual, historical, and linguistic information about the text for the creative team. Each team member might have one or several assistants. It is important to remember that theatre is an inherently interdisciplinary endeavor because it requires the work of many artists and technicians with different skills. Each one is as important as the next; as the voices mingle, the art is created not only in the rehearsal rooms, but just as importantly in design meetings, prop and costume shops, technical rehearsals, and in the imagination of many collaborators working together to bring the audience the complete production.

APPLICATION ACTIVITY

Your Personalized Warm-Up

It is important to continue to develop and refine your own warm-up sequence that you can repeat each time you prepare to rehearse or perform. Using the concepts from this chapter, personalize the warm-up from chapter 1, relaxing your mind and body and readying them to work.

Relax and Breathe

Start by lying down on the floor. Starting at your feet and working up the body, engage and hold each area of the body (feet, legs, hips, abdominal area, chest, shoulders, and head) for a few seconds on an inhalation, then exhale and relax. By the time you get

to the head, engage and relax each part of your face. Use your breathing to create a natural rhythm of inhalation, engaging your muscles, then relaxing on the exhale.

Vocal Warm-Up

Come to a standing position, with feet flat on the floor. Inhale, supporting the air with a midtorso breath. Place your hands on your waist just under your ribs to feel the engagement of your diaphragm. As you exhale, blow raspberries as you sing or say vowel sounds, one vowel on each breath. When you feel ready, sing or say the vowels, engaging your voice and supporting the breath. Then find a space where you can move about the room, and walk from point to point. Change your speed, direction, and level each time you set off. Your body should feel warm, as if you are preparing to play a sport. Acting is athletic.

Focus

Face a partner, look into a mirror, or focus your eyes on a point on a wall in front of you. Count to 10 slowly, paying attention to your gaze. With the next 10 count, change your physical position on each number smoothly but with a clear new choice for each number. Allow yourself to be spontaneous; do not judge or edit your gestures and physical positions. With the final 10 count, change your point of focus with each number. Work on creating smooth transitions between each new point of focus.

Text

Select a very short piece of text. You can use anything that you have memorized (e.g., the Pledge of Allegiance or song lyrics) or can quickly commit to memory. Say the piece of text quietly, first only to yourself. If you are working with a partner, take turns. Gradually increase the distance that you "throw" this piece of text, each time getting bigger and bigger, until you can reach the back wall of an auditorium.

Perform

Using the tools in this chapter, prepare a short piece of dramatic text, such as a monologue or excerpt from a play or a poem, for performance. Create the score, map out the physical actions and blocking, and rehearse the piece until you feel ready to create a sketch of your movements.

EXTENSION ACTIVITY

Collaborate

Think through other elements that would enhance the performance of this excerpt. Which disciplines within the theatre arts would most enhance the meaning of this moment? Take a moment to imagine how you would start a conversation with a scenic, costume, or lighting designer. Which elements of your work would be most important to communicate?

DISCUSSION QUESTIONS

1. What is Stanislavski's method of physical action, and how is it used in theatre?
2. Give examples for different ways of breaking up a poem or a script.
3. Define *kinesphere*, and describe how an awareness of the body in space is helpful for performers.
4. What are some of the key tools actors use to physicalize a text? Describe how you can develop your expressivity using the breath, voice, and face.
5. Give examples of Aristotle's six elements of drama in relation to works you have seen or read.

CHAPTER 3

Dance and Movement

To some, dancers appear to do the impossible. They move freely and expressively in front of others. Even the idea of being a dancer can sound exclusive and elusive. But every person has the ability to dance. Liz Lerman, one of the leading choreographers and thinkers in the field of movement, comments that she is interested in "performers who look like people dancing, not dancers dancing" (2014, xiv). Dance belongs to everyone in all cultures. The human body is a physical instrument that is capable of minute expressions of deep emotion as well as stunning feats of athleticism. The ability to corporally express something that comes from the mind or emotions of an individual brings about new perspectives.

We know movement is good for us, and while many different forms of movement and dance can be applied to the study of interdisciplinary arts, many artists find that the fundamentals of Bartenieff and Laban's efforts are excellent starting places. You will learn in this chapter to employ some of the vocabulary of Bartenieff's Fundamentals and Laban's efforts to create your own movement language. The limitations of the body are not limitations on creativity. No matter what your abilities or experience with movement, no one is an expert on your physical instrument except for you. Think back to the movement in the warm-up in chapter 1, which used yoga and Bartenieff's six developmental stages to engage the body and mind. The goal of this work is for all students to come to feel they are experts of their own physical expression. You can, and should, adapt anything here to suit your own situation and physicality.

Dance and **movement** both involve understanding and training the body. Dance styles are systems of organized movement. The words *dance* and *movement* are sometimes used to differentiate the field of dance with its subgroups of genres (e.g., ballet, tap, jazz, modern, folk, social) within the wider category of movement, which includes not only dance but also a range of somatic (*soma* = body) and therapeutic practices designed to maximize the human physical experience.

Laban: Still Forms

It is now time to adapt our movement from chapter 1 to the work of Rudolf Laban. Just like in yoga, when the body is held in certain deliberate postures, Laban's still forms are just that, still shapes the body forms. Laban, looking at the ways the human body moves in all its many and varied situations of life, found that movement tends toward several forms that can be expressed as the pin, wall, ball, tetrahedron, and spiral (see figure 3.1). We can analyze frozen, abstract shapes based on these forms. We

KEY TERMS

body shape
choreographer
compositional form
contrast
dance
developmental
 progression
dynamics
effort
ensemble
exertion-recuperation
function-expression
impulse
inner-outer
intent
isolation
Laban/Bartenieff
 Movement Analysis
Labanotation
level
mise en scène
movement
notation
pathways
personal uniqueness
rhythm
space
stability-mobility
time
total-body connectivity

ARTIST SPOTLIGHT: RUDOLF LABAN

Rudolf Laban (1879-1958) is known to the field of performing arts for his international work in the field of human movement during the 20th century. He was born in Bratislava, Slovakia, built a community of artistic study in Switzerland, developed his ideas in Germany, fled to Paris during Nazi rule, and established a school of dance in England. His primary influence is in the field of dance, but his work has been applied in a vast range of related disciplines, including acting, movement efficiency in the workplace, and physical therapy. He wrote many books, including *The Mastery of Movement* (1960) with Lisa Ullman, which is a foundational text in movement studies. The Theatre Workshop Company, founded by Joan Littlewood and Ewan MacColl, applied Laban's ideas through the intercession of Jean Newlove. The idea that physical action is how artists express objectives, needs, or desires in performance is central to the works of Konstantin Stanislavski and Laban (Laban 1960; Adrian 2002). Laban's ideas can be used for developing expression not only in movement for acting and dance, but also in interdisciplinary media, such as painting and visual arts.

Other companies and practitioners have built on and adapted Laban's ideas. Principal to these is Irmgard Bartenieff, introduced in chapter 1, one of his students who brought Laban's work to the United States (Wahl 2019). Bartenieff adapted this work in her book *Body Movement: Coping With the Environment* (with Dori Lewis). This work is now known as **Laban/Bartenieff Movement Analysis** (see Wahl 2019) and is widely influential in the fields of dance, therapy, and personal expression.

can also begin and end performance in these shapes, engaging the performer to hold the beginning and ending of a sequence of movement. This helps the audience prepare for performance at the start and know that it has fully concluded at the end.

Each shape has the following key points:

- A *pin* is straight, can include the arms, and can also be lying on the floor.
- A *wall* takes up space, is narrow, can engage the arms and legs or just the arms, and is also on the floor.
- A *ball* is voluminous and curving, and can be made in the front space and the back space.
- A *tetrahedron* has three points of contact with the floor and is angular.
- A *spiral* can be linear or voluminous.

FIGURE 3.1 *(a)* Pin, *(b)* wall, *(c)* ball, *(d)* tetrahedron, and *(e)* spiral. These symbols help make sense of the shapes the body can make. The hashes through the symbols indicate these are still shapes.

EXERCISE **Still Forms**

Walk through the space. Stop and form your body into the shape of a pin, then change. How can you be a different type of pin? Change again into another pin. Forming yourself into more than one type of pin engages your body more as you realize there is more than one way to make each of the still forms.

Continuing this exercise, begin to move again.

Move through space as though you are moving through a thick substance such as glue or peanut butter. This allows you to engage your body with stronger movement. Then freeze. Holding a position, ask yourself which of the still forms you are most like.

After experiencing each still form, turn to some inner reflection. Using a whiteboard or a notebook, write out the symbols and how you related to each one. Writing and reflecting after movement helps solidify the concept.

Asanas, or poses, can be done together. Then think about which of Laban's still forms connect (see figure 3.2a-e).

a

b

c

d

> continued

FIGURE 3.2 (a) Pin = tree pose, (b) wall = warrior II, (c) ball = ball stretch, (d) tetrahedron = extended lateral triangle, (e) spiral = revolved lunge.

e

| **FIGURE 3.2** > *continued*

The still forms, and the transitions between them, form the basis of many movement sequences in dance. Familiarity with how your unique body responds to each of the still forms will help you develop your own expressivity by giving you an initial vocabulary. From here, you can begin to create other patterns.

Centering the Body: 12 Principles of Bartenieff Fundamentals

Irmgard Bartenieff developed 12 principles in her study of the fundamentals, which guide and structure our work in movement and dance. As articulated by Peggy Hackney (2002), these concepts are the following:

1. Total-body connectivity
2. Breath support
3. Grounding
4. Developmental progression
5. Intent
6. Complexity
7. Inner-outer
8. Function-expression
9. Stability-mobility
10. Exertion-recuperation
11. Phrasing
12. Personal uniqueness

As we move through the concepts in movement and dance, we will touch on each one of these fundamentals. At the end of the chapter, you will be asked to apply them to your experience and put them in your own words, a process encouraged by Bartenieff specialists such as Hackney (2002, 40). This is necessary to make the work truly your own and to heighten your personal expressivity. Each term will mean something slightly different to every individual, and your **personal uniqueness** will enrich the process. Each one of us brings to movement our own physical perspectives and cul-

tural awareness. In dance, for example, it can be tempting to try to copy others, but it can be discouraging when the movement does not look the same; however, personal uniqueness in movement expression is to be accepted and celebrated.

Preparing for the Work

A session in dance or movement led by an instructor often begins with a warm-up, just as in chapter 1. Just like it sounds, this process is designed to properly warm the participants' bodies to prepare them for the work. Warm-ups are not just for the body, but also serve to focus the mind. A warm-up might include steps for bringing the mind's attention to the here and now. For example, some instructors will ask the group to imagine they are leaving all their worldly cares, pressures, and thoughts at the entrance to the space. This can aid concentration and prevent injury because the movers must be present to one another and their bodily experience.

Preparation of the body leads to greater **function-expression**, one of Bartenieff's (2002) fundamental principles, which holds that a strong, functioning, articulate body is more capable of expressing itself. The conditioning, body awareness, and fitness benefits that come from movement practice will have positive effects for all areas of your life, not only your skills as an artist or performer.

It is important for each artist to develop his or her own warm-up practice. As you progress through your studies in the arts, feel free to emphasize or spend more time on the areas that resonate most strongly with you, and you should drop or modify the exercises to suit your own developing personal practice. The warm-up given in the first chapter of this book is an ideal way to get started. Before beginning each session of dance, movement, or physical creation, get into the habit of preparing your mind and body before you begin.

This warm-up begins with the stages of human development as articulated in Bartenieff's (2002) **developmental progression**, which describes basic movement patterns that are developed at a young age in humans and continue into adulthood. The developmental progression that leads to the most complex pattern are breath, core–distal, head–tail, upper–lower, body–half, and cross-lateral (see chapter 1).

Beginning with breath support, the first step in movement, move your body through the exercises designed to explore each developmental stage as outlined in chapter 1. These exercises enable you to build toward Bartenieff's (2002) principle of **total-body connectivity**, that all parts are connected and react to each other. Once you feel you are integrated and warmed up in mind and body and that your physical instrument is prepared, you are ready to do your best work.

The Creative Impulse

You are ready to create. But where do the movements come from? Many **choreographers** and creative artists work from an **impulse**, or a drive from within, that sparks their initial ideas (see figure 3.3). Sometimes these ideas seem to come out of the blue and can strike without warning. Music can be a great inspiration for movement but is not the only source. Other times the impulse can be generated using combinations of ideas, such as starting to move the body based on an object, idea, emotion, or phrase. This relates to Bartenieff's (2002) principle of **inner-outer** expression; that is, our inner impulses manifest themselves in our outer movements, postures, and ways with which we use our physical instrument. Expression is bringing that which is inside to the fore where it can be perceived by others.

FIGURE 3.3 Dancers use impulse of music, meaning, and joy to express outwardly in a performance of *A New Season* at the Woldson Performing Arts Center Dedication, 2019.

Try these two exercises to generate the impulse to move:

EXERCISE **Movement Words**

Select six words from the list below, and create a movement for each one. Then string them together into a movement sequence and move with what you have created, with a clear beginning, middle, and end. Perhaps create a shape and hold it to communicate the beginning and end.

Wiggle, breathe, jump, run, squat, sigh, hiccup, wave, sneeze, reach, collapse, swim, slither, exclaim, fall, laugh, write, bounce, lick, sneak, explode, ooze, cower, ruffle, search, sniff, wag, open, close, rise, fall, advance, retreat.

EXERCISE **Object** www

Choose an object in your life that has special meaning to you, and place it in front of you. If you have a partner, talk about it as if you are introducing it to a friend. If you are on your own, write about it in the journal. Now translate that meaning into movement. This is your item, so remember that there is no correct way to do this. Dance it as if you are not allowed to use words to express this object's role in your life. If you are working with a partner, you can turn away from them as you move, gently close your eyes, or look above them. Reflect in your journal or with your partner about what you observe from the movement expression of the item.

JOURNAL REFLECTION www

1. In working through this exercise, what were the various ways you found inspiration for movement and creating the sequence?

2. What is resonating with you in class so far (e.g., warm-up, theory, painting)? How can you apply elements of this class to other classes? To life? How can you engage in creative endeavors to take care of yourself during this time?

3. Who was Irmgard Bartenieff, and what do you find interesting about her work?

VISUAL REFLECTION

Create a visual exploration of Bartenieff's six developmental stages. Have fun with this. Use color pencils, crayons, paint, pens, collage . . . whatever medium speaks to you.

Intent: Moving With Purpose

Paired with the idea of moving from impulse is the notion of **intent**, one of the Bartenieff Fundamentals, and it is much like the concept of *objective* used in theatre. Movement is inherently linked to intent. Movement reveals intent, but the intent comes first. Inner intent influences our outer movements; desires motivate and drive the movement of the body. Intents can be physical or emotional, and the dancer or mover is not always conscious of them. The intent behind a dance can come from the choreographer, linked to the impulse behind their process to create the dance. The creator behind every piece of movement has an intent, but the best dancers make their own meaning, make it personal to the artist doing the movement. Watching someone move, observing their relationship to space and time, offers clues as to their need and how they choose to express both the need and their attempts to fulfill it.

Compositional form is a key part of choreography. In any method of composing movement, it is important to keep in mind the piece as a whole, as a sum of all its constituent parts, just as is done in the theatre or in visual arts, even while appreciating individual choices. Each moment, each choice, forms part of the whole. Because dance can be both narrative and abstract, the compositional form can be a driving impulse for the work. A choreographer might create the beginning and then end in the same way. (This is known as *ABA form*, in which movement A is repeated at the beginning and end, with a new movement, B, in the middle. An *ABC form* can end in a different way than it began, perhaps indicating a journey of some sort.) All movement happens in a sequence of events as moments are connected into phrases. Phrasing is a critical part of composing and executing movement that enables the body to properly engage muscles in sequence, building movements that have a beginning, middle, and end. Just like words can work together into phrases or sentences, movement can be connected and created into movement sentences. Over the course of a piece, meaning is created when phrases are linked together and attention is kept on how the phrase lives in the dancer's body, within that moment of the work and within the whole of the piece.

It is helpful to think about scoring, or **notation** of the progressions of sounds, musical notes, and movements, as it is used in music (see chapter 2 for how it is used in theatre). Early examples of musical scoring or notation include the former monk Aurelian of Réome whose writing, *Musica Disciplina*, was one of the first (ca. 843). Even composers such as Beethoven were already straining against the rigid systems of notes, bars, and the musical staffs we have come to know as standard (Hall n.d.). Exciting new systems of notation have emerged with new technology, inviting nonlinear notation and symbols that can be given in three dimensions. The balance between clear notation (setting down exactly what has been created by the composer) and

the freedom for the performer to interpret the work with the appropriate amount of liberty has caused a great debate among musicians for centuries.

Within the field of dance and movement, practitioner Rudolf Laban developed what has become known as **Labanotation,** or kinetography, and Bartenieff built on this work to create Laban/Bartenieff Movement Analysis. These aspects of movement have been studied by theorists and practitioners, systematized, and set down in methods and schools. Movement notation is a science that has enabled dances to survive the test of time without the use of film (Newlove 1993, 11). This process captures otherwise ephemeral data of how to move, play, and speak, as well as the progression of decisions throughout a scene or piece of music. In either discipline, setting the sequence down on paper or into a computer allows for a consistent record of the art to be kept. Scoring as an interdisciplinary artist involves building a bridge between music and dance notation. Modern advances in technology allow performers and technicians to create and run complex performances involving multiple voices such as music, dance, and other collaborators (see figure 3.4).

FIGURE 3.4 A conductor uses the score to keep tempo of the orchestra during a performance of *A New Season* at the Woldson Performing Arts Center Dedication, 2019.

EXERCISE **Score a Song for Dance**

Select a song that you know and perhaps love. Think about the ways you might creatively score that song. You could draw pictures or create a symbol for the regular beats (in popular Western music, most often in eight or six). You could write the time signature for what you deem important moments, and you could write movements next to a sheet of the lyrics. When organizing your thoughts about movement and sound in this way, it can clarify how you might want to construct a dance. It also helps in the rehearsal process to find specific sections of a song rather than always just starting at the beginning of a recording.

Time

Bartenieff's (2002) principle of complexity, the truth that there is always more than one thing happening in any movement, contains within it a myriad of opportunities for bringing elements of expression together. For instance, choreographers and dance makers create **contrast** within movement to provide visual and emotional interest. Juxtaposing seemingly disparate elements in order to create pieces that stimulate interest is a common way to evoke a desired response in the viewer. One way to do this is by varying the element of **time** with the level of energy in a relationship known as **dynamics**. High-energy movements that are short in duration might be described as sharp (Ambrosio 2016). Some ways of describing dynamic qualities include sustained, percussive, swinging, suspended, collapsed, or vibratory (Sofras 2020). Using different qualities in the same piece can inspire various emotional responses, depending on the movement. Swinging, for example, is something that is done by children on the playground, and the regular motion of the limbs can be reassuring. Sustained movement is done over a period of time—longer, for instance, than a percussive movement, which might be short and conveys a more excited or higher energy state than a sustained movement. Vibratory motion can remind the body of impending danger such as increasing rainfall during a heavy storm. Collapsing motions often have the feeling of giving up, of capitulation, while suspended movement can be held, or balanced, in the body (see figure 3.5).

Rhythm, the number of beats within a certain division, such as a measure, is important in dance and relates to the use of time. Music is one way of marking the passage of time and can be used to structure time in movement work, although music is not always used (Ambrosio 2016, 32). In dance as in music, time signatures and the metrical rhythms of music control time within a dance. Some works do not use

FIGURE 3.5 Leaps create an illusion of suspension in a performance of *A New Season* at the Woldson Performing Arts Center Dedication, 2019.

a set time signature. Rhythm is also linked to tempo (fast, slow, and everything in between). Each person's body has its own unique rhythm and tempo, which changes in different contexts or situations. Some people's natural rhythm is slower, others faster, and you can observe this in their speech and physicality. Stanislavski put the two concepts together, referred to as tempo-rhythm, and encouraged actors to observe the people around them to create fuller characters. Often new artists think that slow means sad or dark, but the complexity, contrast, and punctuation that can come from a quick moment can add much to a piece that is otherwise perceived as melancholy.

Repetition in movement, also linked to time, can mean repeating an action right after it is completed or as a movement motif throughout a work. Either way, repeating a movement or phrase can help the audience find meaning by highlighting that it is important within the piece.

Shape

Bartenieff's (2002) principle of function-expression comes into play again as choreographers and dancers make decisions about how to shape and design the body in the context of a piece of movement. How you shape your body is a type of communication, and different body shapes convey meanings, feelings, and concepts to the viewer (see figure 3.6). In theatre, we use gesture and body position to tell the story and reveal the relationships of the characters in a scene. In dance, **body shape** is used to convey the intent behind the dance and express the emotions and ideas behind the movement.

The shapes made by the body in space can be described with vocabulary such as straight versus curved, angled, and twisted (Sofras 2020). Body shape is linked to the directions in which the body can move: forward, backward, side to side. The three dimensions of space (vertical, horizontal, and sagittal) are described in terms of directions the body or parts of the body can go. Vertical means up and down; horizontal means open and closed; sagittal means forward and backward.

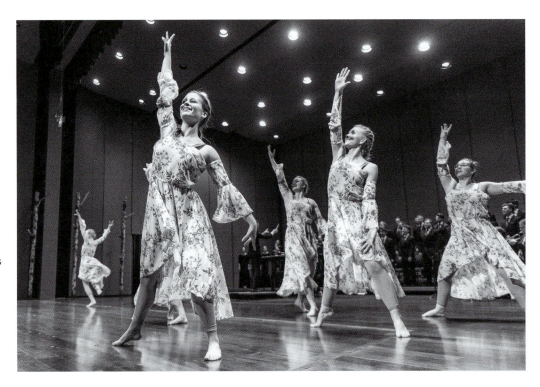

FIGURE 3.6 Students reach in a straight line upwards, conveying hope and joy in a performance of *A New Season* at the Woldson Performing Arts Center Dedication, 2019.

EXERCISE **Body Shape**

Choose a word that expresses an emotion. With your body, create a shape that expresses the word as precisely as you can. Notice how this assists you in getting out of your head and how your body can create meaning that you might not have thought about consciously. Move before thinking, act on the word, and see what you can create. For example, how can you create a body shape that communicates sadness? Attempt three more shapes that might communicate sadness. Try your own versions of shapes inspired by other words, such as *resist*, *surprise*, *nurture*, or *give* (see figure 3.7). You might find that thinking of the entire body as a tool to communicate can be abstract; sadness does not need to just be expressed with turned-down lips, but can be a full slump of the shoulders, turned-in knees, or a tiny ball on the floor.

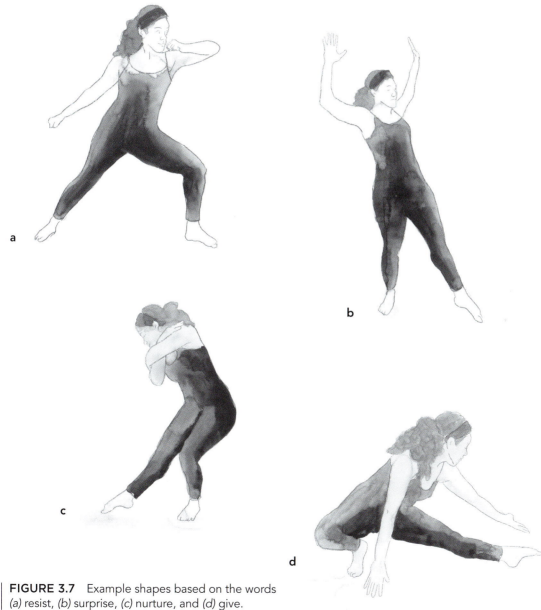

FIGURE 3.7 Example shapes based on the words *(a)* resist, *(b)* surprise, *(c)* nurture, and *(d)* give.

Isolations

Using one area or part of the body at a time is called an **isolation** of that part, either with stillness or with movement. The other parts of the body respond and stabilize, or balance, during isolations. In the warm-up, when exploring the developmental stages, you are isolating parts of the human physical experience and taking them apart in order to understand how the body moves as a whole. Bartenieff (2002) worked with many people to assist them in developing **stability-mobility**. During any one movement, the elements of stabilization (equilibrium and balance) and mobilization (activity and motion) occur. For new dancers, it can be a challenge to learn to use new muscles to keep the rest of the body still while the one part is engaged. Isolation is a significant part of dance technique. The choreographer Bob Fosse was known for his work with isolating parts of the body or highlighting a seemingly small movement like a simple flick of the hand (see figure 3.8) to use it as a dramatic statement.

FIGURE 3.8 An example of Fosse-style choreography using a flick of the hand.

Isolations are essential to many dance forms, and for the beginner they are important for understanding the feeling and physiology of each body part and muscle group (see figure 3.9). Isolations enable the body to develop coordination because with time and practice, dancers improve the ability to move areas in isolation and in relationship to one another. This skill assists with precision and carrying out complex sequences of movements of the separate parts of the body.

FIGURE 3.9 Isolation to the (a) left and (b) right.

a

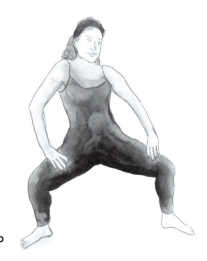

b

EXERCISE **Body Part Isolation**

To begin, focus on your ankles and wrists. While seated, move just the left ankle in a circular motion, so that your foot traces a clockwise O in front of you. Now trace that O leading with your big toe, as if you are drawing the shape with imaginary paint on the big toe only. Reverse the direction, and paint the O counterclockwise. Repeat with the right ankle. When changing to the wrists, vary the level at which

you hold out your hand; feel how the sensation differs when you make an O shape with your individual fingers, for instance. Try this while seated: Trace an O in space with each of your fingers individually, but do it in such a small way as to be almost imperceptible if someone were watching. How small can the movements be? Can you isolate just the tip of your little finger to make the tiniest O, so small no one would know you were doing it? Increase the size of the O each time you change fingers so that by the end you are including your arms and shoulder muscles in the movement. This is the power of isolation: Each part of your body can move and create shape in its own unique ways and by combining them, create infinite possibilities for meaning.

Space

Bartenieff's (2002) principle of grounding, moving in relationship to the earth and with gravity, expresses that the mover moves through three-dimensional **space**. We interact with space by making contact with the floor and changing the position of the body within the air. If you were to paint the bottoms of a dancer's feet before they dance, the tracks along the floor would note where they had been. Choreographers plan these routes, called **pathways**, as part of the choreographic process. *Pathways* is a common term used in dance to describe the way the artist makes their way across the floor and through space. Choreographers carefully map and plan the pathways given to dances with more than one participant so that they do not run into one another. Just as blocking is a part of acting, pathways are the movement patterns in dance (see figure 3.10). Pathways that are a loop, or end where they began, are called *closed*, and those that end with the dancer in a different part of the space are called *open* (Sofras 2020). Recognizable floor patterns include circles, zigzags, or figure eights (Ambrosio 2016). Sometimes the floor patterns relate to the theme or idea of the piece, such as when a shape from nature like a tornado might call for a spiraling pattern of movement (Ambrosio 2016).

However, as noted, dance happens in three-dimensional space, so we are not limited to what happens on the floor; the pathways traversed include the movement of the whole body, not just the feet (see figure 3.11). This area also involves the direction that the dancers are facing. Imagine a dance

FIGURE 3.10 One dancer grounding so the other can use his back as a place to roll over through space in a performance of *A New Season* at the Woldson Performing Arts Center Dedication, 2019.

FIGURE 3.11 Dancers use all three dimensions of space in the position of the feet and the body in a performance of *A New Season* at the Woldson Performing Arts Center Dedication, 2019.

in which the actors all faced the audience directly the entire time. Varying the pathways across the floor and the directions the dancers face is important in creating visually interesting movement.

When you watch dancers or actors moving, you will notice that they often do not stay on one **level** only but will vary their movements to include low, medium, and high. Different feelings and images come from these movements. A connection to the earth is emphasized in low movements. Medium-level movements include standing upright and moving on a plane that is more or less a conventional standing position; much of the traditional postures of classical ballet include the dancer with their torso on the medium plane. A high plane is used for lifts, jumps, and moves that allow the extremities such as arms and legs to be lofted far above the head. The effect of high-level movements is often to bring the viewer out of everyday space and into the clouds or other images, concrete or abstract (Ambrosio 2016).

EXERCISE **Exploring Levels**

To explore the concept of level (see figure 3.12), lie flat on the floor and focus on your breathing. Slowly, begin to explore how you can move while lying on your back, and then move to a crawling or slithering position. How close to the ground can you move, and what feelings and images come to your mind? You can also

FIGURE 3.12 *(a)* Low-, *(b)* middle-, and *(c)* high-level movements used in a performance of *A New Season* at the Woldson Performing Arts Center Grand Opening, 2019.

| **FIGURE 3.12** > *continued.*

move on a low level from a standing position; movements such as lunges and pliés bring the legs and body closer to the ground.

EXERCISE Pathways

To bring this concept to life, take a sheet of blank paper, and draw a continuous line that changes direction as it moves across the page. Then move as if you were traversing this line in the space around you. Pathways are the line the dancers make with their feet across the space. Now take that same line; how can you use it to inspire pathways in space off the ground and in one location? Perhaps begin with your hand, continue with your nose, and conclude with your foot.

EXERCISE Direction and Level

Write your name in three-dimensional space, creating pathways on the ground and using multiple directions and levels to create a dance.

Laban's Effort Factors

Effort is one of the key concepts found within Laban's foundational ideas on body, efforts, shape, and space (BESS) (Adrian 2002). Laban's work is interpreted in as many ways as there are practitioners, so each actor and coach uses these terms in the way that most suits their particular practice. Efforts are impulses to move that are expressed as attitudes and behaviors within the following factors:

Time: Urgent or sustained

Weight: Heavy or light

Space: Direct or indirect

Flow: Bound or free

We will focus on time, weight, and space.

EXERCISE Sensory Exploration

Begin to explore Laban's efforts by moving through the room in different shapes and with varied actions. Visualize that you are on vacation in a marketplace. This can be a market or bazaar you have been to before, or want to go to, or even one from your imagination. As you walk around, imagine all kinds of items for sale around you, perhaps on tables or on blankets. Perhaps items are hanging above you. There are lots of smells and sights and sounds. What are you walking on? Perhaps a carpet, tile, grass, or dirt. Take it all in.

EXERCISE Time

Now imagine that you have all the time in the world. You walk with ease, and you can take your time seeing what you want to see, fully experiencing the market. Perhaps slow down your gait. Think of a sense of suspension and luxuriate in the time you have to experience this wonderful market.

By contrast, now imagine you are in a tour group making a stop to see the same market. Though you are just as delighted to see it, you have only been given a short amount of time to look around. So, look more quickly, pick up your step, try to take it all in. How does this feel in your body? In your knees? In your stomach? Move to catch a better glimpse; you want to see everything, but you have a lot less time. Now pick up the pace even more because you know your time is just about up. Oh, now you hear the bus horn!

Return to your neutral walk through the market, take a few deep breaths, and relax your body as you walk.

EXERCISE Weight

1. Imagine that the temperature is perfect and you are wearing just the right amount and weight of clothing to feel free and light. Walk with a sense of lightness. How does that change the way your feet strike the ground? Imagine light between your shoulders and your ears, a sense of effortlessness.
2. Now shift your awareness. Picture the same market, same glorious vacation, but this time it is a very cold day. As a result, you are wearing a heavy jacket or backpack. How does that change the way you move through space?
3. Add that you have received a call from home with news that gives you a sense of heaviness. Exaggerate this further, and take note of how this feels in your body.
4. Return to your neutral walk, and expand your perception again to take it all in. Do not lose sight of the fact that this is a terrific market that you have been looking forward to exploring. Breathe and let go of any heaviness or tension; look around you and just see.

EXERCISE Space

Remember there are many, many things to experience. Perhaps there are items on tables on either side of you or items are hanging from above that you can look up and see. Imagine items are even on blankets at your feet. There is so much to

look at. Engage your other senses. Can you smell all the delightful smells? How about the sounds, people talking, children, music, and so on? The key thing is you are trying to take it all in in a multidirectional way. Indirectly take it all in—you can focus in multiple ways—and you want it all.

Now, by contrast, notice an item on a table to your right. Look directly at it, pick it up, and look it over. You realize it is the perfect item for that friend for whom you wanted to purchase a gift. Now turn it over again and see the price. You realize it is far too expensive, so you put it down on the table and go back to taking it all in.

For one more example of this, as you are looking up and down and all around, multidirectional in your focus, all of a sudden you hear a piece of pottery breaking on the ground behind you. You stop and turn to see the pottery pieces. You are focusing on the pottery, only seeing it, and then you see in the direction you are looking that it was a child who broke the pottery and an adult is there taking care of it. Go back to your indirect observations of the market.

At this time, return to your notes, and begin to create a table. Time can be quick or sustained, weight can be heavy or light, and space can be direct or indirect. Lay out the table like so:

Effort	Time (quick or slow)	Weight (heavy or light)	Space (direct or indirect)

Space can be described in various ways—multi-focused, single-focused, direct, indirect, multidirectional, single-directional—but direct and indirect are the most applicable to all three art forms of theatre, dance, and visual arts that you will explore in this book. For the purposes of your table, use this as a key: Time = Q or S (quick or slow), Weight = H or L (heavy or light), Space = D or I (direct or indirect).

The effort factors of time, weight, and space combine and can be expressed in eight actions, called the eight efforts, which are punch, slash, flick, dab (or tap), press, wring, float, and glide. They can be understood as bringing the factors together in the following combinations (see also Newlove, 1993, 78-85, for another articulation of Laban's efforts):

Punch: Quick, heavy, direct

Slash: Quick, heavy, indirect

Flick: Quick, light, indirect

Dab or tap: Quick, light, direct

Press: Slow, heavy, direct

Wring: Slow, heavy, indirect

Float: Slow, light, indirect

Glide: Slow, light, direct

The best way to internalize the efforts is to physicalize them for yourself.

EXERCISE The Efforts

Walk around the space again. Now find a place to stand. Ideally, you cannot really see anyone directly, so you can face a wall or window or even close your eyes.

Adopt a neutral stance, with your feet parallel, your knees soft, your hips and ribs stacked up, and your shoulders back and down. Lengthen your neck. This position is like a sorbet, a cleansing of the physical palate.

With each effort, vary the body parts you use to explore.

1. Try a punch and slash (see figure 3.13). How can you punch with your legs? Slash with your hips? Try unusual combinations to reveal unique movements. Keep going until you feel you have come to a natural stopping point.

2. After punch and slash take a break and stand in a neutral stance. Typically, those two efforts require a lot of energy, and it is good to take a moment to be aware of how your body feels. Do you feel warmer? Has your breathing changed?

3. Continue to move and explore:

 Flick and dab (see figure 3.14)

 Wring and press (see figure 3.15)

 Float and glide (see figure 3.16)

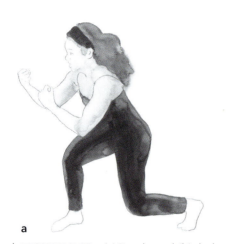
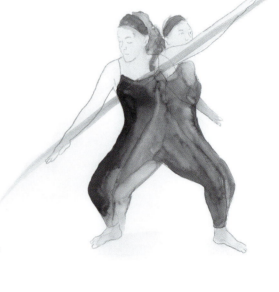

a b

| **FIGURE 3.13** *(a)* Punch, and *(b)* slash.

a b

| **FIGURE 3.14** *(a)* Flick, and *(b)* dab.

FIGURE 3.15 *(a)* Wring 1, *(b)* wring 2, and *(c)* press.

FIGURE 3.16 *(a)* Float 1, *(b)* float 2, and *(c)* glide.

4. After trying these, go back to your notes or whiteboard to fill in the efforts in a table such as the one below.

Effort	Time (Q or S)	Weight (H or L)	Space (D or I)	Notes
Punch				
Slash				
Flick				
Dab				
Press				
Wring				
Float				
Glide				

5. Write notes next to each of the efforts such as colors, people, or images that came to mind. None is right or wrong; these are just ways of moving. Select the one that you were most comfortable doing, and put a (+) by it. Select another one that was less comfortable for you, and put a (–) by it.

6. Go through the rest of the table, noticing what kind of time, weight, and space each movement has.

7. Punch, slash, and flick probably feel pretty clear, but note that the word *dab* currently is a specific thing in pop culture. Think of other ways to dab. That word is used in painting and cleaning, for example. How else can you dab with your body? With your fingers, toes, head?

8. Press and wring (as in wringing out a washcloth) are also likely quite clear by now, and then float. Explore float before glide because it is clearly indirect, and that might help you understand the difference between the two.

9. Once you have finished exploring the efforts, fill out the rest of the table like the example row completed below.

Effort	Time (Q or S)	Weight (H or L)	Space (D or I)
Punch	Q	H	D

Exertion-recuperation is the natural cycle of the body, and when either is ignored, the body can become out of balance. After completing your table, take a moment to reconnect to your breathing. Stand with your feet firmly planted on the floor, your shoulders back and down, your neck long. Feel your breathing restore your body to its resting tempo-rhythm. Notice how exploring each effort has left an imprint on your understanding as well as on your physical body; your understanding of your body might have changed through the exercises you just completed. Recuperation involves rest, but it also can be enriched by reflecting on what was learned during the exertion. Do you see yourself in a new way?

Another way to look at this is if you spend most of your day being direct, heavy and quick (punch), doing the opposite (float) can be a recuperative act. Contrast is important in that if an entire dance is a glide, we can be lulled to sleep, but throw in a slash, and suddenly you have the audience's attention.

Mise en scène

Movement takes place in time and space. Creating the illusion of locations other than where the movement is taking place can involve multiple art forms. The making of a look for a performance is called **mise en scène**. It can be simple or complex. The movement work is primary, but elements such as lighting, levels, and visual aspects of the production such as costumes can add a lot to the meaning of a piece for the audience. These art forms are inherently interdisciplinary because each element relies on the others. For *A New Season*, the costumes added to the sense of flow and gave extra emphasis to the levels used in the movement by the dancers (see figure 3.17).

In addition to lighting and scenery, costumes are another aspect of mise en scène for dance and movement performances. Sometimes when we think about dance costumes, we think about a group in matching leotards. This is often done to create a unified look among the **ensemble**. However, many artists work with the concept of unity in other ways, such as creating a series of individual costumes that share a color palette or silhouette (see figure 3.18). Costume designers take their inspiration from many sources, including the choreography, the music, and the context of the piece. For Gonzaga University's production of *A New Season*, costume designer Leslie Stamoolis (2019) comments,

FIGURE 3.17 Costumes emphasize levels in a performance of *A New Season* at the Woldson Performing Arts Center Dedication, 2019.

"My process for designing this show began with the inspiration that our director articulated: "*A New Season* is meant to be a celebration of artistry, place, and potential. It is a sweeping work for musicians, actors, dancers, and designers too, but it is deeply rooted here in Spokane." I started looking to our region for inspiration: the Palouse, the Spokane River, and Riverside State Park. My palettes are based on the beautiful seasonal colors we experience here in eastern Washington. Beyond that, though, I wanted this show both to meet audience's expectations for a beautiful-looking dance piece, as well as to subvert their expectations for what traditional dance design looks like. We begin with lovely, uniform chiffon dresses and skirts in the spring movement, but we also see more pedestrian, varied looks in summer and autumn."

by Leslie Stamoolis

FIGURE 3.18 Costumes share a color palette in a performance of *A New Season* at the Woldson Performing Arts Center Dedication, 2019.

Collaborative Team

Collaboration is a rich and exciting opportunity in dance, and one can think of it as a creative or choreographic continuum. Some settings have a choreographer and dancers who put their ideas into practice. Other times choreographers carefully observe their dancers and create movement to serve both the concept and the dance. Sometimes the choreographic process is very democratic, and everyone works together to create the dance. Within an interdisciplinary arts context, you might find that the democratic model is most conducive to creating work.

APPLICATION ACTIVITY

Journal Reflection

1. Look down the list of Laban's efforts. What do you see as your primary effort in your movement in daily life? Why? Think about someone else in your life, and analyze them using the efforts.
2. Do some additional research on Rudolf Laban. Who was he, and what did he do? What do you find interesting about his work?

Visual Reflection

Refresh your memory about the concepts of time, weight, and space, and explore them by sketching, drawing, or making a collage. Have some fun with this.

Experiencing Bartenieff's Fundamentals (www)

Deepening your relationship to each of these concepts, write in your journal about examples from your own life, whether dancing, movement, or anything else, you feel resonates with each of the 12 principles of Bartenieff Fundamentals.

EXTENSION ACTIVITY

Create and Perform

Using the tools in this chapter, prepare a short piece of movement or dance for performance. Begin with an impulse; explore different body shapes, pathways, and efforts; and rehearse the piece until you feel ready to create a sketch of your movements and receive feedback.

Relating Theatre and Dance Concepts (www)

Building on what you have learned, fill out the table on HK*Propel* relating theatre concepts to dance concepts.

DISCUSSION QUESTIONS

1. Who was Rudolf Laban, and what were his main contributions to the field of dance and movement?
2. Find objects from your own life that relate to each of Laban's still forms.
3. What Laban still forms would you use to describe each of the yoga asanas as you continue to personalize your warm-up?
4. Discuss three of the 12 principles of Bartenieff Fundamentals in relation to your own life. Where do you use or experience these concepts in your day-to-day life?
5. Give examples of how time, weight, and space are used by designers for dance.
6. What is the role of a costume designer for dance? Use the Internet to provide an example of a unique costume design for dance.

Visual Arts

The journey into interdisciplinary arts continues with visual art concepts. See figure 4.1 for how concepts from theatre, visual arts, and dance interrelate and complement one another.

Keep these connections in mind as you explore visual arts in this chapter.

Almost everyone is able to make marks on a page. If you allow yourself the freedom to create, you can delight in the feeling of a crayon or oil pastel leaving traces on a piece of paper or the soothing experience of paint coming off a brush and smoothing onto the canvas. These sensations, when you allow yourself to have them, can be wonderful experiences of creating visual artwork.

Watching the freedom of a child making art is delightful, and you might even remember those sensations from your own early experiences. The problem comes when you start to judge yourself, and this can cause a sense of immobility. The notion of being an artist can carry such weight. The truth is, everyone is an artist. Some are professional, others are emerging, and still others are just enjoying the freedom of creating art. You might be quick to say, "Yes, but what is 'good' art?" That is for art scholars to debate, but frankly, that question has no place in the arena of creating art with freedom, which is what this chapter is about. Creating art serves an important purpose in the *making*. In the *doing*. In the journey.

So rather than limiting your thinking with inner statements like, "I am not good at drawing," we invite you to put those notions aside and give in to childlike abandon. You will learn so much more if you approach visual arts with an attitude of inner freedom. Give yourself permission to create, to be an artist, just for this moment.

KEY TERMS

aerial/atmospheric perspective
chiaroscuro
color palette
complementary colors
dry brush painting
form
found art
frame
glaze
hues
impasto
intuitive painting
line
linear perspective
monochromatic
palette
perspective
sfumato
stipple
tempera paint
texture
value

Theatre concepts	Visual art concepts	Dance concepts
Given circumstances	Inspiration	Impulse
Bits or units, score	Form	Compositional form, phrasing, scoring
Objective	Color	Intent
Action (conflict, contrast, dynamics, antagonist, protagonist),	Value and contrast	Complexity, contrast, dynamics
Beat, timing, pace	Rhythm	Rhythm, time, repetition
Method of physical actions	Shape	Body shape, body part isolations
Blocking	Line	Pathways, level
Breath, voice, projection (inner truth, vocal inflection, character physicality)	Texture	Effort, energy
Eyes and focus, stage awareness, blocking, composition	Space	Space, level, weight, direction

FIGURE 4.1 All three art forms interconnect.

ARTIST SPOTLIGHT: LEONARDO DA VINCI

Leonardo da Vinci (1452-1519) was the ultimate interdisciplinary artist. He was an inventor, an engineer, an astronomer, a physicist, an anatomist, and a botanist, among other things. His designs for buildings and sculptures astounded his patrons and proved his abilities in three-dimensional forms. Best known for his innovations in painting, he produced such masterpieces as the *Mona Lisa* and *The Last Supper*. As a visual artist, he changed both the materials and the techniques of his day, mixing new oil paints and using them with meticulously calculated geometrical lines of perspective. He refined the technique of **chiaroscuro**, or contrasting light and dark. Leonardo da Vinci depicted landscapes in new ways and had many imitators in the way he blended light with shadow in **sfumato**. His abilities in painting were astounding, but it is his range, his interdisciplinary prowess, that has continued to inspire artists and scientists throughout the ages (Sporre 1996; Gelb 1998).

Do you keep a personal journal or sketchbook? What would happen if you carried it with you everywhere and made notes and drawings throughout the day? So many happy accidents of art can happen in the counterposing of ideas from different subjects. Get your hands on a notebook or sketchbook. It does not have to be fancy, and even a lined composition book will do. As you work through this chapter, take a moment to explore the ideas and concepts visually in your notebook. For students of interdisciplinary arts, the work of Leonardo da Vinci is a bottomless wellspring of inspiration. Leonardo kept copious, detailed notebooks that included his drawings, writings, and ideas. It is not just his finished products but his methods as well that are inspiring. You do not have to be a Leonardo to keep a notebook full of ideas! Leonardo never systematically organized his notes; he just made them as the thoughts came to him, often exploring very different subjects on one page. The field of interdisciplinary arts is built on these kinds of juxtapositions of ideas and on the notion of being inspired by the world around you. Your visual arts journey can start in this way, in your own notebook, today.

Visual Arts

The field of visual arts has multiple modes, including painting, drawing, sculpting, and much more. The materials used to make art are only limited by the imagination, but some media include oil paint, watercolor, charcoal, clay, and stone. Artists can spend lots of money or very little money on materials for these various methods. Some create **found art** using things they acquire in the environment rather than media designed specifically for making art. Great freedom can be found in using inexpensive, readily available materials. A common attitude for beginners is to be overly cautious about the materials, and cost can make one want to eke out every drop of paint. This can lead to a tightness visible in the art itself. One way to avoid stinginess with the materials is to begin with big jugs of inexpensive, easy-to-find **tempera paint** (see figure 4.2).

Pumping a big dollop of paint onto your plate can be a satisfying performative act. We recommend covering a paper plate with cling wrap and using this as a **palette**. This way, at the end of your painting session, you can just throw the cling wrap away, reusing the plate or palette and saving water for the cleaning of the brushes.

When you begin, the first thing to do is relax your body. Tightness is not helpful in the creating of art in any form. Tight breathing can prevent actors from using their voices and projecting well. Restricted airflow keeps dancers from fully using their bodies as they intend. It can also limit the freedom of a visual artist. Remembering to use your body, noticing your breath, and experiencing freedom are helpful to the painting process. Begin with a physical warm-up like the one in chapter 1

(yes, painting is physical!). Following your warm-up, the following three techniques will assist you. First, use very large sheets of paper. The large size of your canvas will be freeing and will encourage you to move your body as you explore its dimensions. Second, when you first begin, require yourself to paint for a set amount of time; if you are not working in a classroom setting, set a timer for 60 to 90 minutes, and paint for the entire time. Finally, see how much of the paper you can cover. This prevents you from starting tiny and getting lost in the tightness.

FIGURE 4.2 Do not add water to your tempera; just enjoy pumping and spreading it.

Large insulation boards, readily available at home improvement stores, give a feeling that the paper is even larger than it is (see figure 4.3a). Pinning your large piece of paper to an insulation board will enable you to have a painting surface for your canvas that you can repeatedly use, serving as a great big easel (see figure 4.3b). The size encourages freedom for the artist to make big dance-like strokes.

This kind of setup might not always be possible for the artist or student. You can still work with these ideas even if your only supplies are a pencil or pen and a journal or sheet of printer paper. Experiment with standing, sitting in various locations, and lying on the floor as you work. Continue to be aware of your breath, body, and a sense of joy and freedom as you work.

FIGURE 4.3 (a) Use a large sheet of paper pinned to an insulation board as a canvas. (b) Insulation boards serve as easels you can use repeatedly.

a

b

Inspiration

Experienced artists know that inspiration can come from anywhere. It can come from something you see in front of you as you go about your life, or it can come from a feeling, a memory, or an abstract concept. There is a true freedom in inspiration. What lights your fire, what is a juicy idea for you, what makes you feel excited and an urge to create? This energy can drive you as an artist, but sometimes your inner judgment comes out when you put paint to paper or step into the rehearsal room. This powerful form of self-criticism can get in the way. You begin to work, you look at what you did, and you think, "Dang, that wasn't what I imagined," or "That line is too thick," or "That doesn't look like a dog." What happened to that childlike wonder that was the delicious inspiration? It was shoved aside for some adult construct of what is good, right, or correct.

Take a deep breath, and let it out slowly. Try to push that harsh judgment aside and continue to allow yourself to live in a world of wonder and curiosity. Let that inspiration guide each moment and engage your senses in the act of painting, not the result. At the very heart of this work is a commitment to the process. Let yourself dwell in abstraction as you learn to express yourself in visual arts. The meaning, intent, inspiration, and, finally, the *act* of creating are all more important than the actual art. The process itself is the primary factor. You are learning to dwell in uncertainty. Artists are at home in uncertainty. Do not worry about whether something is going to be deemed "good" or not; just allow yourself to dwell in the meaning of the experience. The result is yours alone.

A technique to try as you begin is to work in silence. Humans are social beings, and some people process verbally when they are nervous or uncomfortable. By forcing silence when you enter the studio, everyone there enjoys the luxury to focus only on the work. It is fine to notice others' work as you walk from your workstation to the paint cart, for instance, but do not allow yourself to comment on their work. Commenting creates a social dynamic that is not helpful. It is common to be tempted to say something self-deprecating, such as, "I hate how this is turning out; I am just not good at painting." This often makes someone else feel like they need to negate the comment, and by speaking it you might be owning that harsh language. Instead, let those feelings flow in and out of your consciousness. Refocus on your breath and how your body feels, and enjoy the sensation of laying the paint on the paper (see figure 4.4). You might also be tempted to compliment someone else's work, but this is not helpful either because then the person next to them might wonder why you did not compliment them, and it becomes about judgment again instead of focusing on the experience.

Artists experience periods of flow, and other times they might feel stuck. Your responsibility is to enjoy the moments of flow and give yourself grace when you get stuck. One tool to help you continue is to step back, look at your work, avoid harsh judgment, and instead look for places that bring you joy or are juicy. Dwell in those places, and see if that can inspire you to move more deeply in that direction. Again, be aware of your breath and body. Do a little stretch or wiggle, smile with your face and your body, take a deep breath, and be present to yourself. Find some joy in mixing colors, putting paint on the brush and going for more. Remember, you have plenty of supplies and inspiration, just go! Harsh criticism and judgment will not help you in this process.

FIGURE 4.4 Do not limit yourself; let your early ideas run free on the canvas.

EXERCISE **Come Back to It Later** (www)

Leave your work for a while, then return to it with fresh eyes. What do you remember about the experience of creating? What jumps out to you now with a lesson or nugget of inspiration for future projects? What else can the work mean? It can be helpful to ask yourself these things. Make a note in your journal about how the process is going and any ideas you would like to save for a future project.

EXERCISE **Revisit Your Work With a Partner**

Once you have each painted something, partner with someone with whom you feel safe. Allow yourself to speak for a set amount of time (perhaps three minutes), and let them share about their experience of looking at the work. The benefit of learning to continue to look at the work and talk about what the meaning might be and what moments are interesting is that you start to see which sections are exciting. It is a common trap to look at art and feel like you have to get it and to stop sharing when you feel like you got it (or did not). To combat this, each of you should aim to continue speaking for the entire three minutes. That allows flow to continue and prevents making final judgments. Your partner can also share what they heard from you about the work and what they observed in the way you talked about it.

EXERCISE **Intuitive Painting** (www)

The field of **intuitive painting** has grown in recent years, and practitioners offer courses and workshops. The main premise is to focus on the process rather than the product to liberate you as an artist from unhelpful, negative thoughts about the perceived quality of the work and then to see what you can learn about yourself and the work by openly reflecting. Explore HK*Propel* for more about intuitive painting.

Michele Cassou talks about three dragons that come out when we go on a creative quest like the process of painting. They are the dragons of product, control, and meaning (Cassou 2010). Dealing with each of these can be freeing as we let go of what we are making, how we are making it, and how it might be interpreted. The ideas within the field of intuitive painting can be useful for unlocking personal creativity and learning to shut down the voice of the inner critic. Artists trained in psychotherapy, such as Chris Zydel, use intuitive painting as a path to healing and self-knowledge. Interdisciplinary teachers such as Cassou draw out the voice of the individual in pursuing their own creativity. Artists such as Flora Bowley employ techniques of intuitive painting in order to create art and bring peace and creativity to their lives. The theme of finding your unique voice is common in intuitive painting, such as in the work and the classes given by Dominique Hurley (Hurley n.d.).

Flora Bowley, author of *Brave Intuitive Painting*, suggests a couple ways of starting, including using your nondominant hand or closing your eyes. Using music and moving your body to the music while painting can be a good way to move your attention from your head center into your physical center. Bowley asks, "Can you paint with your whole body?" and moves to the music as she starts a painting, sharing that it can be daunting to confront the blank canvas but that moving your body and your paintbrush to the music can be freeing (2016).

Form

Once you have given yourself the freedom of free form and just experimenting with putting paint on paper, you can begin to turn your attention to the various visual arts concepts. **Form** in visual arts has to do with the structure of the elements of an image or object and the way they are configured (Sporre 1996, 632). It is an important part of composing constituent parts, colors, items, or materials to create an artwork, and in this sense, form can be said to be its shape. You can take some of your past paintings and look at them in new ways to play with form. Perhaps a section of a painting really draws you in. Using an actual frame to look at portions of it at a time can be helpful for thinking about the various forms that draw your eye.

EXERCISE **The Frame**

Draw a box or cut the middle out of a piece of paper in a square or rectangular shape to make a paper **frame**. The lens you look through in life can yield different images and ways of looking at things. Training your eye to do something like this in creating visual artwork can be very helpful. Looking for sections of a painting that you like can help discern ways to continue to develop a work. Even if an entire painting does not bring you joy, perhaps there is a little section where the colors and textures combine in a way you love. Take your frame and move it over the larger work until you find that section you find interesting. You might find that using a cutout of a frame can help direct your eye to just that section. Now you have the option to work with just that section or take a photo of it and use it as inspiration for another painting.

EXERCISE **Part of the Whole**

Take a small section from the favorite chunk you found in your painting, cut it out, and glue it into your sketchbook. Write about why you find it interesting. You can even imagine it is an important message from someone. Let your mind have fun, and write about what the message is.

EXERCISE **Mix It Up**

Take one of your paintings and cut it into strips or squares. Mix the pieces up and then try putting them together in a new way, unlike re-creating a puzzle. Think of each piece as its own contribution, and see how the pieces "talk" to each other.

Color

You were probably introduced to basic color theory at a young age when you learned that the primary colors are red, blue, and yellow. If you are working in tempera as we recommend, start only with those three paint **hues** (colors). Red and blue mix to create purple, blue and yellow mix to create green, and red and yellow mix to create orange (see more on HK*Propel*). www Experimenting with portions of each of these paints can create all kinds of variance in hue (see figure 4.5). Also keep in mind that a painting can also be **monochromatic**, with variations of one hue used throughout.

FIGURE 4.5 Experiment with using isolated portions of your painting.

You might wish to add two other paints to expand your palette: black and white. Just a touch of black can gray down a color combination, and white can create a pastel or more opaque look. This enables you to explore another aspect of color, **value**, which is how light or dark a color is (which is really how white or gray a color appears). It can be tempting to use other colors, but we encourage you to see what kinds of colors you can create from this limited number. As artists, a boundary provided by limiting the number of options can expand your creativity to find new combinations and ways of working with what you have. The color combinations used by artists are known as the work's **color palette**, the combination of hues and values to develop the visual look of the piece, the emotions it is intended to evoke, and the ideas it stimulates. The palette is also the physical hard surface, like a plate, on which the artist mixes the paint.

Begin by putting a squirt of each primary color of paint in a circle on your plate or palette. Then, one by one, enjoy putting each color onto the paper. Mix your colors on the palette or right on the paper to create the in-between colors. Whenever you are working with a new medium, it is good to play around with this mixing, because different types can mix in very different ways.

Mixing can even be done with pens and crayons in a journal when you are brainstorming for painting ideas.

Another element of color that can be exciting to work with is the idea of opposites. Opposite colors are called **complementary colors.** Traditionally, complementary colors are red and green, yellow and purple, and blue and orange. What happens when you see a field of green and then notice a bright red ball in the middle? The contrast might cause a sense of energy, even vibration, in the image. This is true of a bouquet of purple flowers tied with a yellow bow, or an orange kite against a rich blue sky.

EXERCISE Complementary Colors

Go online and find images where complementary colors are at play. Save the images that draw you in, that excite your eye. Show them to a friend, and talk about them. Use them as inspiration for your own work: Create a drawing with markers or a painting that uses a color scheme inspired by the images you found.

Value and Contrast

As the saying goes, "Variety is the spice of life." In visual artwork, contrast is the spice. When looking at a piece of visual art, it is natural for the eye to go first to the place of greatest contrast. Put another way, the eye goes to the spot where the darkest and lightest place meet. Look at a variety of paintings, either online or in-person at a gallery. Let your eye roam, and then notice where the darkest dark meets the lightest light. Was that the first thing you noticed?

It is easy when beginning to create visual arts to keep the tone of an image the same. It can feel extreme to emphasize the dark and light areas, but making the light parts lighter and the dark parts darker can allow a two-dimensional image to look more three-dimensional and create more interest.

Chiaroscuro is a historical painting term used to describe the dynamic interplay between light and shade, pioneered by Leonardo da Vinci (see Artist Spotlight at the beginning of this chapter). It was used by many artists, including the painter Caravaggio (1569-1609), during the Baroque period to illuminate the subjects portrayed and create contrast with the dark parts of the composition. The viewer's eye is drawn to the light, but curiosity and interest are evoked by contrasting high-value areas with shadowy areas. In Caravaggio's work, the dark corners are nearly black, while the areas of highlighting shine with radiant energy and light.

EXERCISE Chiaroscuro

For this exercise, use a pencil, and begin by sketching something that is near you. Avoid trying to make it look accurate; just be loose in your sketch (see figure 4.6a).

Now look at your drawing, and darken where things are dark (see figure 4.6b). Then use your eraser to lighten the areas that are lighter.

You can see from the demonstration that it is loose and extreme and almost gives more feeling from an ordinary image. Play with this, increasing the contrast in your sketch as you go.

a

b

FIGURE 4.6 *(a)* Chiaroscuro. *(b)* Adding shading darkens the darks, and using an eraser makes the lighter parts lighter.

Rhythm

Where do you experience rhythm in your life? Perhaps you think of music, a toe-tapping to the beat, a heartbeat. But rhythm also can be found visually in something like a painting of rows of trees in an orchard, lines on a highway, or multiple bees swarming a hive. Those examples are of realistic items, but it is also possible to experience rhythm in an abstraction (see figure 4.7).

As you look at figure 4.7, can you feel it in your body? What if you were to use your shoulder to express this rhythm? Your knee?

Use the concept of rhythm as you create visual artwork. If you find a moment particularly satisfying, do it multiple times. What does that communicate? In dance this is called a *movement motif* that can be repeated to create a language of a dance.

| **FIGURE 4.7** Rhythm.

EXERCISE **Rhythm in Interdisciplinary Art**

Rhythm shows up in theatrical language as well. Take these lines from act 5, scene 5 of *Macbeth* (2007) that repeat to create a visual representation of this rhythm.

Tomorrow, and tomorrow, and tomorrow,

Creeps in this petty pace from day to day

To the last syllable of recorded time

Next, choose a favorite song, and paint an abstraction of the song focusing on its sense of rhythm. Could you then use that painting as a score for a dance? Move in relation to how the visual cues inspire you to move.

Inspiration comes from everywhere. What fun creativity and creating is!

EXERCISE **Rhythm Inspired by Another Subject** www

Take something from another class you are taking (or subject you are studying that interests you), and sketch the rhythm that demonstrates this. Write a paragraph in your journal explaining the concept and how you visually abstracted it.

Shape

There are as many shapes in the world as can be imagined. Just as we explored body shapes in dance, we can also do this in the things around us (see figure 4.8).

In visual arts six forms make up the basis of shape: cone, cylinder, pyramid, ball (sphere), prism, and cube.

FIGURE 4.8 Translating real-world shapes such as *(a)* cone, *(b)* cylinder, *(c)* pyramid, *(d)* sphere, *(e)* prism, and *(f)* cube.

Drawing these shapes can be an exercise in creating volume in a two-dimensional work of art. Each form relates to a two-dimensional shape (Capitolo and Schwab 2005):

Cone: a triangle and a circle

Cylinder: a rectangle and a circle

Pyramid: a triangle and a square

Ball (sphere): a circle

Prism: a triangle and a rectangle

Cube: squares

Notice that the use of contrast from the lightest to the darkest sections gives a sense of volume to the shapes.

Letting your eye see the world as shapes can also help you think about the constituent visual elements.

EXERCISE **Shapes in a Photograph**

In your sketchbook, tape or glue a photo of a part of your world and translate it into drawn shapes like the exercise in figure 4.8.

Line

We all know what a **line** is (a continuous strip of color, ink, or marking that can be straight or curved, or take any number of shapes), but there are many different styles of line: thick, thin, short, long, curved, straight, and so on. Again, variety and contrast are the spice of life and art. It is easy to get comfortable making one kind of line, but if you draw an image and all of the lines or marks are the same, the viewer's eye will not linger very long.

Think back to the Laban efforts explored in chapter 3, and see what kind of variety you experience if you translate those ideas to the art of painting. How can you punch, flick, or dab paint onto a canvas? How can you press, glide, or slash your pen across the paper? How do these efforts in mark-making communicate something different? How do these lines create different feelings within you as an artist? What feelings and ideas would you like to evoke within the viewer?

EXERCISE **Draw the Efforts**

In your sketchbook, make nine boxes. In the middle box, draw a tree or glue in an image of a tree. Then label each of the surrounding boxes with each of the efforts (punch, slash, flick, dab/tap, press, wring, float, glide). Now draw that same tree using only one effort to create it within the box. Allow yourself to have fun with this. When you are done, reflect on how it felt to do each one, and a write a few words that express those feelings. Finally, create one big box and draw the same tree using all eight efforts to create contrast and dynamics within the drawing.

Texture

Your images naturally will have more **texture** once you begin to add various efforts to create the lines in a drawing. These create visual texture in interesting ways. But you can also think about the materials used to create texture. For example, you could use paint or clay, or you could make a collage. It can help to think of literal material, as in a costume, as you imagine what might happen if you explored fabric with different weights or textures (e.g., silky, gauzy fabric; fabric with heft; or stiff fabric).

Paint can go onto a canvas in various textures:

Glaze: This can be a watery, transparent, or light use of paint to create a thin film on a surface. Glazes are great for creating atmosphere, the sky, or soft variations in skin tone. Glazes can be blended to create sheer looks and can be layered to create depth.

Stipple: This is like a dab or tap of the paint on the canvas. You can also use a sponge or just the tip of the brush to make this effect. Think of Georges Seurat.

Dry brush: Try this by just putting a little paint on the brush and dragging it across the paper, creating a broken line rather than a pure line of paint.

Impasto: This is a thick layering of paint onto a canvas. Sometimes artists even use palette knives to scoop up dollops of paint onto the "knife" and smear it in thick plops on the canvas.

The kind of paint we have been recommending for you to use (tempera) is not always the best to achieve all of these types of textures, but it is good to experiment to see what is possible and how to add texture to your explorations.

Space

It is important to think about space in multiple ways. First, consider it a location, as in theatre and dance, where the artistry takes place. What is the nature of the space where you create your art? Can you take a corner of a room and make it your space for making art? Even if you are in a very small space, can you tape out a square on the floor? Use special lighting such as LED candles or angle a desk light for a studio effect in your room.

What about making space in your imagination? Our lives are full of the push and pull of many responsibilities. Can you carve out space by taking a moment of deep breathing and tuning into the body to be present to the art you are about to create?

How can you think about space on canvas or paper? Artists can fill the space or be selective in what they choose to paint. One way to think of it is the rule of thirds (see figure 4.9), which means dividing the canvas into three equal sections vertically and horizontally, then

FIGURE 4.9 Division showing rule of thirds.
© Suzanne Ostersmith

placing the key element of interest at the intersecting lines. This can create an interesting tension, but as with all rules, sometimes they are made to be broken.

A significant moment in art history came with the notion of **perspective**, the way artists give a sense of distance, of forms being near to and far away from each other. Within an artwork, and specifically within a painting, two-dimensional painted forms appeared three-dimensional on the page. With distance, artists can employ the concepts of line and foreshortening (making lines shorter than they really are in order to create the illusion that they are receding). Forms appear smaller the farther away from the viewer they are, so painting objects smaller in the composition is one way of making them look farther away. **Linear perspective** is the technique of bringing converging lines together in the distance (background) of a painting. Another way to create the effect of distance is to use light and color to create **aerial perspective** (also called **atmospheric perspective**), the use of haziness or making distant objects indistinct. The human eye perceives distant objects as lighter in hue than they appear up close, and distant things such as mountains often appear to be blue. Thus, painting on a two-dimensional surface, artists sometimes use hues of blue and lighter shades to indicate distant mountains.

A final thing to think about is how you might create something that encourages your audience to spend more time with their eyes on the canvas (see figure 4.10). Remember our experiments with how your eye moves on a piece of art. It is also interesting to note that if a line drives straight up to a corner, the eye will follow and

FIGURE 4.10 Image of how the eye roams while viewing a painting.
© Suzanne Ostersmith

leave the painting. But if the line curves, this can create another interesting dynamic by encouraging the eye to round the bend and look some more (see the video on HK*Propel*).

APPLICATION ACTIVITY

Developing Your Personal Practice

Beginning with a personalized warm-up, such as that in chapter 1, to energize your mind and body, prepare your workspace and materials to create a piece of visual art. What are the conditions of your workspace, materials, and your own mind and body that you can meet in order to put yourself in as close to an ideal state as possible to create? Once you are ready, start to brainstorm, imagine, and sketch ideas for a painting or visual arts piece. Discuss your ideas with someone you trust.

Explore Ideas for a Small Exhibition

Think about a subject that is of interest to you; it could even be something you are studying in another class. Take a large piece of paper, and divide it into six squares with simple lines. Perform your physical warm-up to energize your mind and body while thinking about the subject matter. With any material you choose, write one word in the corner of each of the six boxes that connects to the subject matter you have chosen. Then begin filling in each box, following the inspiration of the word. Once you have filled all six boxes take some time to look at them and reflect. Discuss the six boxes with someone you trust, and make notes in your journal after your conversation.

Book of Inspiration

Experiment with the various techniques and methods highlighted in this chapter on large pieces of paper. Create your own shape for a frame. Build on your work with the tree shape, or choose a simpler shape like a triangle and use it to trace over your various paintings that are the most interesting to you or best highlight the various methods. Bind these images together with staples or punch holes, and sew them together with yarn or strong thread. Once you open the cover sheet, the left side of your book should be blank for you to reflect, notate, and sketch, responding to the painting on the right.

 You could also now trade your odd-shaped book with another artist, and write the same way or create a story inspired by the images they created.

EXTENSION ACTIVITY

Create and Present

Create a piece of visual art that includes all the elements discussed in this chapter. Share it with another person, take notes on their feedback in your journal, and reflect on how you might improve the piece. You could scan this image and notate the various elements to show how you incorporated them.

Create and Show

Now choose one of the boxes to develop into a full work on its own. It can contain elements from the other five boxes, but this is a more finished piece of work that you could show to a curator to use as an example of the work you might imagine putting together in a small exhibit. Think about what you would title the work and the show.

Artist's Statement

Write an artist's statement about you, your approach, why you chose the subject matter, and what you continue to learn from exploring the subject through art. An artist's statement can be brief. A few lines to a paragraph that sums up why only you can make your art. Begin by stating what is at your center as an artist; does your art usually come from ideas or concepts you find in the environment around you, from nature, music, or movement? Perhaps your work emerges from your emotions, or is tied to a personal or social issue that stirs your passions. Write about who you are as an artist, and what your art teaches you as you create it. Optionally, include your intended audience; who do you hope sees this work, and is there something in particular you would like them to know, feel, or take from it? Perhaps you hope others see themselves in the work or connect to thoughts or feelings that you express?

Postcard From the Past

This is a postcard assignment from an interdisciplinary arts class in London (see figure 4.11). This end-of-the-semester assignment required students to take all the concepts from the various art forms and create a visual artistic record. Months after the course had finished, the instructor sent the postcards to the students. Receiving them allowed for a new perspective on the work as time had passed. This is something you can do: draw or paint on an index card, give it to a friend, and ask them to mail it to you in a couple months. You might be pleasantly surprised to see your early work again.

FIGURE 4.11 Postcards from an interdisciplinary arts class in London.

© Suzanne Ostersmith

FIGURE 4.11
> *continued*

DISCUSSION QUESTIONS

1. List and describe five different elements of visual arts.

2. Discuss how artists use concepts such as contrast, color, shape, and texture to convey different meanings and emotions.

3. Where do you see the application of visual arts in your day-to-day life, and what role does it play?

Dance and Theatre

Now that you have learned the basic concepts from theatre, dance, and visual arts, it is time to dive into how to integrate them. This chapter explores some of the possibilities for creating your own unique work when merging ideas from two fields: theatre and dance.

Dance and theatre are inherently interdisciplinary because the skills from theatre and from dance are mutually complementary and inextricable; the body is the primary instrument used in theatre, and narrative and meaning pervade dance, even when they are not the primary focus. Some contemporary companies use the term **dance theatre** to categorize works that employ movement techniques from formal dance in order to tell a story or engage with a social issue. Dancers are also trained within theatre studies, including movement for performers and the study of dance for musical theatre (known as **musical theatre dance**). These fields are important for the rich variety of ways the body is used in performing arts expression.

These programs exist all over the world. The American Musical and Dramatic Academy (AMDA), located in New York, teaches students how to use the concepts within classical and modern forms of theatre and dance to create dance theatre performances. The Rainbow Dance Theatre founded in Honolulu, Hawaii, combines theatrical special effects and dance-inspired movement to captivate its audiences through storytelling and the concepts of dance theatre. Ananya Dance Theatre from St. Paul, Minnesota, is a perfect example of dance theatre, because it uses concepts and practices of theatre and dance to tell stories of social justice issues and experiences. The Dance Theatre of Harlem's *Change* uses dance choreography and theatrical effects, such as lighting and sound effects, to tell a story in New York City (see websites on HK*Propel*). www

In this chapter, you will employ terminology and concepts from the interlacing disciplines of theatre and dance to create a solo performance.

KEY TERMS

dance theatre
feedback
informance
musical theatre dance
presentation
reflection
talkback
trunk show

Integrating Dance and Theatre: Poem Performance Using Laban's Efforts

You will develop a solo performance of a poem integrating dance and theatre and using Laban's efforts, building on your work from chapter 3. Objectives for the performance include clarity of movement, polish of performance, and the ability to discuss choices for expressing the intention of the movement. By the time of the presentation, you will be able to communicate your artistic process and choices and to score a poem clearly to show artistic choices and beats.

Overview of the Process

When you approach any kind of complex project, and especially an interdisciplinary arts project, it is helpful to break the tasks down into components or steps. In the theatre chapter we broke a text down into bits, and here again we will work with smaller chunks of material at a time and then put it all back together. Just like scoring in theatre and in dance, here you will have a poem that is labeled and marked up with vocal and physical indications of the building blocks of your performance. Integrating dance and theatre concepts enables you to experience them and develop your own set of practices and skills.

ARTIST SPOTLIGHT: PINA BAUSCH

Pina Bausch (1940-2009) is known as one of the most significant and influential choreographers of our time. She started her dance training at age 14 under Kurt Jooss at the Folkwang School in Essen, Germany. After she completed her time at Folkwang, she received a scholarship to attend Juilliard School in New York, where she trained under choreographers such as José Limón, Louis Horst, La Meri, and many more. Bausch spent time dancing for various companies during her time in America but returned to Germany in 1962 to dance at Folkwang Ballet. In 1973 Arno Wüstenhöfer, director of Wuppertal's theatres, hired Bausch as a choreographer. She renamed her ensemble "Tanztheater Wuppertal Pina Bausch," and over time, it won prestigious awards and honors across the globe. Pina Bausch is most known for her unique style, which blended ordinary, everyday aspects of life with poetic elements. Tanztheater is a great example of dance theatre because its goal was to engage with the audience to focus on humanity and the human experience as a whole, undefined by borders and as free from prejudice as possible. Her choreography revolved around natural body language and poetic imagery to create an honest, emotionally driven, dreamy performance style that revolutionized a new style of movement in the choreographic world. (See www.pinabausch.org and www.pina-bausch.de.)

By the end of this chapter, you will have participated in four components of the creative process:

- *Arts-based research:* Images, writings, presenting ideas
- *Assimilation of feedback, development, and rehearsal:* Filtering feedback from peers and your instructor, developing and rehearsing your performance
- *Presentation:* Performing for your peers
- *Reflection:* Thinking about what you learned, how you learned it, and how you will apply it

Overview of the Concepts Used in the Project

Dance

- Whole-body movement expressiveness
- Creative use of space, levels, and dynamics
- Committed physicality, or clear choice of one primary effort and two secondary efforts
- Begin and end in a Laban still form

Theatre

- Creatively and carefully crafted use of text
- Clear, expressive, and articulated vocals connected to the performance (no disembodied voice)
- Poem scored with notes or colors and beats by hand to show thoughtfulness and preparation
- Include the efforts selected as well as objectives
- An extended moment of nonverbal (silent) movement

You will explore each of these concepts in the following opportunities to deepen your work and your own emerging process. Looking at each step in the process briefly in turn before beginning the project will help you familiarize yourself with the progression of activities and skills. Let's take them one by one.

Arts-Based Research

By engaging in an interdisciplinary arts project, you have the opportunity to participate in the field of arts-based research as your initial mode of inquiry. Begun in the early 1990s at Stanford University, arts-based research is a field that is inherently interdisciplinary (Barone and Eisner 2012). Using artistic and aesthetic practices and processes to conduct social research was not new then, but it was formalized in a way that is useful to you as an interdisciplinary artist as you intentionally refine your expression to reveal how you see the world, society, and

your own experience. Arts-based research uses methods and techniques from art to think through problems or to ask questions. The ultimate aim is to deepen your understanding of the world and to connect with other human beings by sharing experiences and perceptions.

Assimilation of Feedback

Once you have done your initial research and developed the ideas stemming from the poem, you will develop a presentation of these ideas so that you can receive some **feedback**. This is not a fully polished performance but a physical manifestation of the research and your ideas. You can present your work at many steps of the process, but if you are new to performing, doing this early and often is very helpful. The next step is an assimilation of feedback. Feedback information can come from the audience of the informal presentation you have just made, and it also might come later as you share your rehearsal process with your peers and instructor. Your instructor might coach you and might encourage you to bring your ideas to someone outside of the process who can be objective. Sharing your ideas with others can help refine your own thoughts. Think about what kind of feedback might be most helpful. Sometimes just articulating that need before a run-through can be helpful, such as, "Would you please let me know if my punches are clearly heavy or if they look too much like dabs?" Also, when you are giving feedback, making compliment sandwiches is never a bad idea. That is, help the artist see what you thought was really strong about their work, discuss where elements were unclear, then end with positive feedback. Asking questions, particularly neutral questions (Lerman 2014), also can be very helpful. For example, "What does this poem mean to you?" or offering your own observations with a question, "I notice that you are standing the whole time. Is there a section where you could explore other levels to express the poem as the prompts encourage?"

When receiving feedback, it is important to be able to listen carefully before you make decisions about what will help your work. It is likely that you already do this naturally during any project, trying things out and deciding what to keep and how to move on. Think about what you can learn from the feedback given to you by your instructor, peers, and even friends and roommates—even (especially) if you do not agree with what they said. It is not about giving up your artistic freedom or yielding to others' opinions. This is your work, and you make the final decisions, yet much can be gained from listening, taking note of others' perceptions and opinions, and filtering those ideas to see if they serve your vision. Sometimes deciding not to use something can spur on another idea, so be open to the process and use it to strengthen the work.

At this point, you will create and refine your piece. More is said about that later, as you work through adding movement to the spoken words of your poem. You will integrate concepts from the fields of theatre and dance, such as scoring and incorporating Laban's efforts, to create and rehearse your poem as a solo piece of spoken word with movement. You will work both independently and with others so that you can explore multiple ways of saying the words and expressing them with your body.

Presentation

The next step is **presentation**. This presentation is different than the other presentations to solicit feedback. This is a presentation of your final work. Another term might suit this moment better: **informance**, or educational performance. You might choose to give context for your poem by including a verbal introduction or by opening up a discussion with your viewers after they have seen your presentation. During that conversation, you have the opportunity to share more about the context of the poem

and your intent with the piece. Some students and instructors might prefer not to engage in contextual discussions but to let the work stand on its own. This is a valid option because it forces the artist to ensure all information necessary to appreciate the piece is contained within the work itself.

Reflection

The final step, **reflection**, is very important. Ask yourself, what did I learn? How did I learn it? How will I apply it? It might be tempting to see the presentation as the end-all, but it is only one quarter of the process. Each step in the process of researching, assimilating feedback, presenting, and reflecting holds equal importance in the learning experience.

Reiteration

The reiterative process is present in many things, including the research and development phases that involve testing and redesign phases, or multiple drafts of a paper, or the layered creative process in making a performance like this. While the four steps of arts-based research, assimilation of feedback, presentation, and reflection are a way of thinking about these assignments, it might be helpful to go back and forth between each step. For example, reflection should occur throughout, and you should do arts-based research at every step as you try new things. But ultimately, you present the work. As stated before, in this work it is not just about the presentation; it is just as important to reflect on that presentation and the steps that led to it. This is why we recommend that you perform twice and include a detailed score so that you can demonstrate the reiterative process that led to the final work. As new artists it can be tempting to just complete the assignment, but the desire with this process is to explore many options through research and feedback before settling on the work.

The Process in Detail

In this interdisciplinary project, you will develop a solo presentation of a poem integrating concepts from the fields of dance and theatre, using Laban's efforts.

Step 1 in Detail: Arts-Based Research

The first action step is to find a poem that expresses an aspect of your own experience or a curiosity that you have about the world. We use poetry in this project because it is neutral; it does not belong exclusively to either theatre or dance but is a shared language that both fields can employ for heightened expression or lyricism to share human emotion and thought.

Begin with deciding on a poem that engages your mind and body. Choose one of the five sample poems that appear later in the text, or if you have one that is similar in length that you would like to use, you can check it with your instructor.

Exploring the Text

It is important to develop a solid sense of what the poem sounds like in your own voice and what it is starting to mean to you. Ask yourself which words resonate with emotional meaning. Which images in the poem ignite your imagination? Here are three exercises designed to bring your own interpretation to the fore and help you deepen your relationship to the poem.

EXERCISE Read the Poem Aloud to Yourself

Once you have selected a poem, read it over many times, both silently and aloud, so that you can hear your voice. It is important to read it aloud and imagine you are speaking it to a good friend to help them understand the poem and its meaning to you. It is important to emphasize that there is no set way that you are supposed to interpret or understand the poem. This is now your poem to interpret as you see fit, so do not feel that somehow you must "get it" for the professor or provide a literary analysis during this step. The most important thing is that you "get it" for yourself, that the meaning of it is clear in your own mind. Your own emotional and creative response to the poem is the most important interpretation.

EXERCISE Underline Juicy Words

Working with the text in hard copy, underline the words that you feel are the most interesting and juicy to you. Read the poem again, really lingering on or emphasizing the underlined words. What new ideas or information do you gain from this experience?

EXERCISE Read Your Poem to a Partner

Taking turns, read your poem aloud to your partner. After each reading, share the important words you have underlined and discuss what those moments mean to you. Beginning this process with a partner can be immensely helpful. Two minds offer twice as much creative potential, and your partner's responses might be illuminating and clarifying for you. Yet it is important to remember that in the end this is a solo performance, so your partner is only there to process and work on things; you will need to make the decisions and ultimately present the piece on your own.

Visual Research

Collect visual images and create an electronic pinboard or collage. With the wealth of images available on the Internet, you can find rich inspiration there. Do not forget, however, the power of thumbing through a book and coming across art that you might not have been directly searching for. Find a book on art, and you are bound to make discoveries. Collect or color print the images in hard copy to have them beside you or to glue into your sketchbook. This is called making an inspiration board or vision board (see figure 5.1).

Secondary Research

You can also do traditional research with texts. What secondary literature is available about your poet or the poem? Has it been analyzed by a critic whose interpretation inspires you? Print and cut out their words to create a physical collage or juxtapose the words with your sketches or images electronically. Be sure to include where the information is from so you can credit the source or return to it later.

Sample Poems

"The Shore"

I discovered the body, finally.
Salt water dissolved feathery wax,
fish had picked at pale skin, eyes

long gone, flying
with sharp-beaked gulls, I guess.
Those who say it's a myth of foolish boys

know nothing of fathers: his shoulder blades
curved like sea shells
when he hunched over a bowl of cereal

slurping the milk. Would a seal-skin boat
have served us? Would we have starved
at sea? Those who deride ambition

know nothing of sky. Ships,
plowmen in the fields,
only offer rumor and innuendo, a lack

of facts. The sun witnesses everything,
and although some claim indifference,
I know better. A father sobs

drops of light,
and the sun knows this language,
vocabulary that ignites the earth.

Reprinted by permission from T. Marshall, *The Tangled Line*
(Marfa, TX: Canarium Books, 2009), 10.

"Describe Breton to the Enlightenment"

It's not a manifesto, really.
Never a declaration of drawers. Nothing to
 break, only the delicate saucer
 on the kitchen counter
that's filled with yesterday's milk,
the best of all
possible cream.

Reactionary's the middle name of guillotine;
revolution woven into the executioner's rope.

The many wide-eyed girls of Oklahoma
squint when they read it.

And in Texas, prairie dogs
vouch for order, dig tunnels to elude the moon
lording over the night air.

On the Kansas plains
rattlesnakes slither along, strike slow vermin,
and slumber with half-
digested rats
quivering against poison.
Cacti
bare pricklies to the moon,
and hunched buzzards wait,
pink heads like nauseated light bulbs.

Dead meat always arrives.

Art in a powdered wig
 means time for murder.

Reprinted by permission from T. Marshall, *The Tangled Line* (Marfa, TX:
Canarium Books, 2009), 14.

"Describe Divorce to Martinis"

Would Jerry Lewis declare the gray sky blue?
Not the heavy telethon host, but the slapstick spasm

for whom you felt pity to give in and laugh.
Even the ugliest scars grow smooth,

become bearable hours in an empty house, the answer
to where does your son sometimes sleep?

Ask the comedians where laughter ends up living
after the split,
the meaning of a pocketful of toothpicks and olives;

ask them to repeatedly perform their slapstick routines
until the universe is shaken and stirred

into a tolerable concoction that seems suave
and smooth but burns the gut like swallowed bleach.

Better yet, ask Jerry to rise from some farcical flop on the floor
and pour another drink for Dean, staggering Dean, charming Dino

slurring each syllable as if no sound should ever be
alone. In fact, make it two. I'll have whatever the guy in the tux is drinking.

Reprinted by permission from T. Marshall, *The Tangled Line* (Marfa, TX: Canarium
Books, 2009), 9.

"Describe Daisy Cutters to Orpheus"

The monarch in the front yard
floats like a shred of tiger,
rising and dropping to the score
of piano keys popcorn-played,

something by Chopin a young girl
practices diligently
in the sunbeams of a bay window—
other children riding bikes

through the shouty afternoon—to strengthen
her fingers and to learn the lesson
that endurance can lead to grace. The dying
Bengal tiger at the Kabul Zoo

roused people to send checks
in envelopes with return addresses
so postal clerks wouldn't suspect anthrax.
The girl's classmate grows fingernails

long as religious tracts, sometimes scratches her arms
in rosy rows that turn to scab-black stripes.
Last summer, two hundred and fifty million butterflies
froze into notes floating in the wind.

Are your fingers sore from practice?
Is one nail ragged from chewing, another long and pointy
like a pale cave fish never to see the world?
Lure it to the surface. Look through its eyes:

a monarch's unruly music
roars across the tops of daisies, the flaccid fish
flopping
in the dust, wishing darkness back, wishing

 caves, its skeleton a reliquary of a new religion
 that's already begun.

Reprinted by permission from T. Marshall, *The Tangled Line* (Marfa, TX: Canarium Books, 2009), 20-21.

"Still More Work"

The beetles bust their asses for days,
stripping flesh from the dead cow,
this overtime shift they didn't request
but had to take. No one's in charge
but the sun. Every now and then a crow
carries a brother beetle from the bones
high enough to glimpse mountains and the city
where we scavenge the hide for hours,
skeleton of days. Forget us.
This is about cows with broken legs,
the long rot, coyotes, hawks, and beetles,
with mandibles like opposable thumbs,
a complete kit for taking bodies
apart. Black lords of sage and hunger and dust,
O how they labor in the heat, they know
neither meek nor might, they feed,
they lie on ribs, they creep across skull and hips and spine,
and when nothing's left, dutiful members
of the brutal union that trades hours for food,
they crawl to death's next shift.

Reprinted by permission from T. Marshall, *The Tangled Line* (Marfa, TX: Canarium Books, 2009), 41.

Sense of pride and wonder and texture

Color and texture and a combination of flicks and glide

Anticipating the future and color and light feel

Single focus and very directional on the journey

| **FIGURE 5.1** Sample vision board.
© Suzanne Ostersmith

EXERCISE **Free Write** www

Write freely in your journal, in your sketchbook, or around the margins of your copy of the poem. Delve into any associations you have in your mind and imagination on the concept you are exploring. Do memories from your life return to you at certain points in this poem? As you read to yourself, write down how it feels, what images the poem creates in your mind, what sensations it brings to your body.

Share Your Findings

Share these images, words, or readings with a peer or your instructor. When communicating about your research on the poem, consider the emotional, intellectual, and physical echoes you are experiencing. Share your ideas both as research and then as a constructed piece such as an image board or critical review; that is a piece of art even

though it is a stepping-stone. The process of preparing to share the material can be its own fruitful form of research, because you learn from articulating your own thoughts about the poem and its resonances. Forming the words to share your research with others is an artistic moment of creation in itself.

Assimilation of Feedback, Development, and Rehearsal

Once you have selected your poem, mined your imagination and research sources, shared your initial ideas, and received feedback, it is time to filter that information and retain what is useful for you to create your performance. Set in front of you your notes, image board, and copy of the poem. Slowly read the notes and look at the images. Become aware of what draws your attention and what repels you. Absorb this information. Take a deep breath, as if breathing in all of the useful words and images, and then on your exhale, let the less useful material, suggestions, and images all ride away from you. With your next inhale, take a moment to clear your mind, and on the exhale, let it all go, positive and negative; let it all sail away from you. Put it all away; shut down the computer. Connect with your breathing and be still for a few more inhalations and exhalations, clearing the decks of your mind.

Though it might seem strange to do all of that work and then set it aside, it is essential to allow your unconscious, creative side to have a bit of freedom to roam as you enter the next phase of the process. Those ideas, images, and suggestions will be with you, but direct your attention in a fresh way as you begin this next phase of the project, which is to create the movement for your piece. Retain only your copy of the poem in front of you, and set the rest aside for the moment.

Creating Movement

When you are ready to return to the creative process, take out your poem again. Make a list of all the underlined words in your poem, and put that list on the floor in front of you. Thinking about them one by one, let your body move however it wants to as you think about and feel one word at a time. How can you move your body to express what the underlined words mean to you?

EXAMPLE Using Dance Concepts

Perhaps you have chosen the word *dissolve* in your poem. Here, employ some of the vocabulary from the dance and movement chapter to explore creating movement. For example, using the concept of isolation from chapter 3, can you move just your hand and arm to show something dissolving? With the information gained from the isolation, can you use your whole body to demonstrate dissolving? Using levels, how can you explore high, medium, and low with the word *dissolve*? Vary the tempo. Can you dissolve quickly or slowly?

As you can see from this example, you can use your body in many ways to express just one single word or moment in the poem. Continue through the poem in this way, developing movement for the key underlined words and images. If you get stuck, turn back to chapter 3 and choose other concepts to explore with your poem. Be playful and joyful in the work. You might even want to team up with a roommate or friend and see what you can come up with together.

Using Laban's Efforts

After you have explored your poem and experimented with movement qualities based on the underlined words, the next step is to choose one of Laban's efforts to be your primary way of expressing the poem and to choose two secondary efforts to provide variety and specificity. As a reminder, the efforts are punch, slash, flick, dab (or tap), press, wring, float, and glide. You might find, for example, that for the most part you are slashing through the poem. Then during one section, it seems appropriate to flick, and at the very end you punch, before finishing with the final slash. What is the progression of efforts in your poem? Make notes in your journal. www

Once you have chosen your primary and two secondary efforts, read your poem aloud all the way through three times: first as the primary effort, then read as one secondary effort, and then as the other secondary effort. Make notes about each reading. What do you learn? How do the efforts change the inflections in your voice? The meanings of the various stanzas?

The final step in creating the movement for your piece is to link the movements together. Are there natural transition movements that take you from one to the next? To assist with creating the links between the elements, look at the beginning and ending positions of your body. Where are you at the start and at the end of your movement for each word? Build your transitions by creating a movement that starts in the ending position of one word and ends in the beginning position of the next word. Doing it this way adds new nonliteral movement to your piece and helps you avoid the tendency to "act out" the whole poem.

A Note About Limitations and Creativity

The train runs better on its tracks.

Students often say that it is difficult to choose just one primary effort. You might find that more than one effort emerges throughout the poem, and that is normal. Limitations breed creativity, and here it is best to be firm with yourself. For this exercise, choose just one primary and two secondary efforts, even if you feel that more efforts are at play. The reason for this limit is that artists have to make choices when creating performance. In this activity, you will learn more by limiting your choices and seeing how many ways you can express the primary effort (e.g., slash in the modes of heavy, indirect, and quick).

Scoring

Now is your chance to dive into scoring. Remember from the theatre and dance chapters that an artist's piece, whether a script, choreography, or music, can be scored, or divided into constituent parts and labeled to separate the bits and elements within the work. To score your poem, first type it into an otherwise blank document, then print it out. Think of it as a canvas of sorts. Note on your script when you use the various efforts, perhaps using a different color to show each of your three efforts. Make notes about the kind of movements you are doing to show each separate moment, and show the transitions. Be creative! If a drawing or sketch helps you understand or remember a section, put that on there. Ideally, when you complete your score, it is colorful and filled with marks and notes. (See figure 5.2, noting that the example shows clearly marked efforts, with still forms at the start and end. The next step would be to include objectives and actions).

A FATHER MUMBLES
From The Tangled Line
By Tod Marshall

You are not lost. I know where you eat and sleep.
Here's news: this summer I grew a garden,

but only half the seeds became blooms, vegetables to keep.
The other stem rose but never blossomed—a sad choir,

in the backyard, swaying and singing the garbled music
of dying things. You ate cereal at our kitchen table

with the sloppy energy of snowmelt rushing down
a mountain slope, your shoulder blades angling beneath

a white T-shirt. When I turn soil with my hands,
I remember what does not blossom here

May blossom elsewhere, and be just as beautiful.
And if I said that was solace, the lie would not be untrue.

Handwritten annotations include: Slash; arms crossed/self; open arms & rewrap; optimistic slash; pessimistic; Wring; from plant to cereal; twist up first; point/accuse slash; Silent to shake memory; open to fist; optimism float; first to open; open poem; back to SLASH; Back to Slash; optimism = light 2nd half; heavy 1st half; look at with appreciation; + rewrap light.

SLASH – heavy indirect quick
Wring – heavy indirect sustained
FLOAT – light indirect sustained

| FIGURE 5.2 Example of a score.

Poem is reprinted by permission from T. Marshall, *The Tangled Line* (Marfa, TX: Canarium Books, 2009), 10.

Rehearsal Strategies

As you rehearse your piece, both alone and with your peers, you can employ many different activities to get the most out of your rehearsal time. Most students find that just reading the poem aloud a number of times and getting the body moving is a good way to start, but fairly soon everyone benefits from additional strategies. Memorizing is often an early step in the process, so we will begin by looking at some ways that performers learn their material.

Memorization Techniques

One of the most popular ways to learn a text is to make an audio recording of yourself saying the poem and then to listen to it repeatedly throughout the day. When you make the recording, speak slowly and clearly so that you can try different inflections and styles when you are practicing. You do not want to be locked in to saying it the way you said it in your recording. It is best to record it in a neutral tone of voice and to let the emotion and rhythm come out in different ways as you rehearse.

Another technique is to write the poem out several times by hand. Writing the words can have the effect of imprinting on your brain. Vary the size of the letters, use cursive and printing, and use all caps. As you write the poem using different kinds of writing you will change your understanding of its structure and meaning, getting to know the work in a more intimate textual, emotional, and imaginative way. Again, underline the juiciest words and see how you write them out and how they flow onto the page.

Think through the progression of your underlined words; linking the thoughts in a successive list, one thought building on and responding to the last, can help greatly with memorization. If you close your eyes and imagine a house full of rooms, with one room for each underlined word, you can fill each room with memorable images that help you get from one to the next. Once you have a visual sequence of the main thoughts of the poem, you can imagine this sequence, and it will help you remember the next lines to say.

You can ask a friend to prompt you (see instructor guide). Start to say the words of the poem, and if you get stuck, ask your friend to give you the next few words. Ask them to note down where you tend to forget, because these points are often areas where your understanding or interpretation might need deepening. If you strengthen your personal connection to the text, it will be easier to remember. Discuss with your prompter how the ideas and images flow from one to the next.

One of the best memorization aids is your movement. If you have created movements that are meaningful to you for each underlined word, and if you have connected them with transitions that link the ideas and images together, the flow of the movement will help you remember the words. Many actors in the theatre have trouble learning their text until they have their blocking and stage movements, because it is so much easier to remember what to say when the words are physically embodied.

JOURNAL REFLECTION

How are you using your time to memorize your poem and get ready to present it for feedback? Which memorization techniques work best for you? How can you connect your memory to your body to help you remember the text? What questions do you have for your instructor?

EXERCISE **Rehearse as a Group**

If you are working in a classroom setting, it can help to rehearse together (see figure 5.3). With everyone facing the same direction, start to speak your own poem at the same time as the rest of the group. When you finish, just hold; everyone will finish at a slightly different time. Do not look around; just hold your place. When everyone is done, the leader says, "One, two, three," and all together everyone says, "Ha!" or performs a single sharp clap. This clears the air. Knowing to wait until hearing "One, two, three" to say "Ha!" or to clap at the end of the exercise helps everyone know to hold positions until all have finished. This also helps your instructor assess your progress and see how everyone is doing with memorization.

| **FIGURE 5.3** Rehearsing as a group.

You might find that you are not engaging your voice to its full expressive capacity the first few times you do this. It is normal to speak quietly when beginning to give voice to your poem in the presence of others. Repeating the exercise can help root your voice in your emotional connection to the poem, because you may feel more comfortable after the first time is over. The second time, do it again, but employ your voice with the efforts you have chosen. Be strong and clear with the choices. This is more effective than just being louder, and it helps build expressiveness to layer in the efforts.

EXERCISE **Voice and Body**

After you feel comfortable speaking your poem out loud, do it again, beginning to use your body to express those efforts along with your voice. This is a good way to begin connecting your voice and body. You might find it to be a challenge, but if you trust the movement score that you put together, you will find that your voice and body can work together to bring out the meaning of the text. Play with using the efforts in your voice, then your body, then in both. Find where the expression of the efforts best suits what the poem means to you, and note this in your score.

Partner Up

Once you have connected the voice, movement, and expression of the poem, rehearse in front of a partner who can serve as a one-person audience. You can warm up together or do a mirroring exercise where you match each other's movement to establish a connection before you rehearse your pieces for one another (see figure 5.4). No doubt you will still have some sticky places you are not quite sure about; just explore your piece, and when you finish, you can problem solve together. If a certain section seems to trip you up or you have not quite pinned down the efforts or the movement, working with a partner to explore options and gain immediate feedback can help.

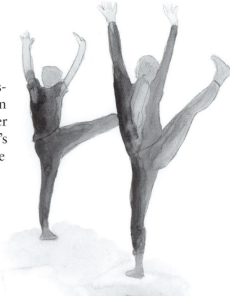

FIGURE 5.4 Warm up and rehearse with a partner.

Coaching Session With Your Instructor

It can be beneficial to sign up for a one-on-one coaching session with your instructor (see HK*Propel*). 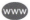 When you meet with them, arrive with your piece fully memorized. It helps to remember to start and end your piece in a still form. This work has two moments of silence: the beginning and the end. Do not rush; take a moment of stillness before and after you show your piece. This enables you and your audience to focus and contain the work within its bounds.

Use Feedback Judiciously

Now review all the feedback to prepare to present: feedback from your research and creative process that allowed you to edit as you developed the work, feedback from your peers and others with whom you shared it, and feedback from your instructor. As the artist, you get to choose what feedback is most helpful to assimilate to prepare your presentation.

Project Presentation Goals

Arts-Based Research

- Independently creates an artwork that is original, nuanced, and well crafted
- Demonstrates clear research process

Assimilation of Feedback
The performance demonstrates a level of mastery in the artistic discipline that is nuanced, compelling, and well prepared.

Presentation
Thoughts are fully developed and articulate original insights, applying the knowledge developed in the class. The performance is polished and engaging.

Reflection
The student contributes knowledge, offers critical reflection, and articulates thoughts with clarity and nuance.

JOURNAL REFLECTION www

Good job with the performances and incorporating feedback! Take a moment to celebrate, then pause for reflection.

1. Reflect on one of the performances you saw. What stood out? What did you learn from watching?

2. Reflect on your performance. What did you learn about performing? How did you learn it? How will you apply it to the next project or in life?

3. Reflect on the visual aspects of your scored poem. How did you choose to add information? What was effective in how you laid it out? What have you learned about scoring text for performance, and what will you do differently next time?

EXERCISE **Formal Reflection** ⓦⓦⓦ

Write a one- to two-page position paper, building on your journal reflection and polishing it into a more finished paper.

Prompt: Share your intentions and goals for the work. In this brief paper, articulate how your presentation grew from the initial idea to the completion, what your goals for it were at the outset, and whether the final product achieved those goals.

CASE STUDY

Weaving Our Sisters' Voices

Weaving Our Sisters' Voices (see figure 5.5) is a theatre and dance production conceived by Suzanne Ostersmith and Dr. Linda Schearing after the 2002 Gonzaga University production of *The Medieval Mysteries*. The production toured as a traveling **trunk show** (a production that is scaled down in order to travel with a small amount of scenery, costumes, and props) in 2006 and then went on to have many other iterations. The production takes stories about women from the Bible that may be lesser known to today's audiences and through poetry helps frame them in a contemporary way.

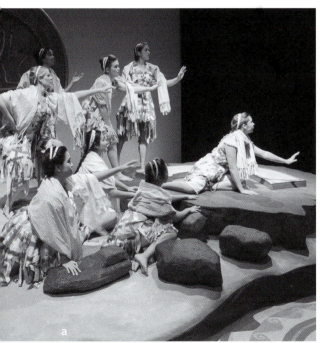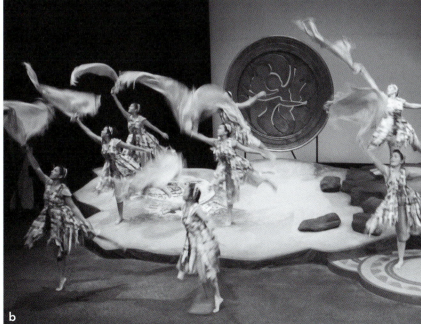

FIGURE 5.5 The 2015 cast of *Weaving Our Sisters' Voices.*

Women have power

The power to be heroes

The power to make a difference

All of us matter

Including you . . .

WSV Scene 7—I Matter

Rahab (Josh. 2, 6:16–25)

The impact on performers of any theatrical production can be great. Comradery that is likened to family comes from weeks of working toward a common goal. With *Weaving Our Sisters' Voices* (2015), the impacts come from the inspirational embodying of these stories, the challenge of some of the difficult material and themes, and in the case of the 2015 production, the use of American Sign Language (ASL) to enhance understanding.

Lines you have memorized for performance are not something you just say and move on from; they become a part of you, and part of you becomes the performance. While the rehearsal period is not a nine-month gestation like carrying a baby, incubating a production with a cast is similar to a set of new parents adjusting over time to the transformation of their lives. The resonances and meanings of a production come to the performers in the months and even years after the fact.

The stage manager from the 2006 tour of *Weaving Our Sisters' Voices* (2015) recounted the experience this way:

It's fun to read through the old script. The most profound thing for me, though, was how the voices of the women who first performed it echoed so clearly in my mind as I revisited it 10 years later. . . . I don't remember a lot of the movement—even with the notes in my script, I couldn't begin to recreate the choreography. But the words and the women speaking them still resonate so clearly. I feel like that alone perfectly encapsulates what we were trying to do when we first created this show—there's a power in women's voices, when we're given the chance to speak, and that power echoes and sustains, even with time and distance and life changes."

—Kathryn Witherington (Bassier), stage manager, 2006 production

Director's Reflection by Suzanne Ostersmith

Weaving Our Sisters' Voices (2015) is full of powerful and empowering language affecting not only the audience but also the performers who live with it. Yes, we were putting on a production, but it was so much more. It prompted the question, can we consider the rehearsal and performance process as a form of meditation? We were telling many narratives that became a single story—our story—and you could feel that through the development of the work. We began the touring performance in 2006 by developing the prologue and creating an ensemble. One of the reasons I am so drawn to the profession of directing performing arts is because I become totally immersed in the experience. Again, I was reminded to trust that the outcome is what it is supposed to be. In the long run, students expressed that the process did have a healing effect on them. One student told me this:

You brought out great moments in everyone: You helped Amelia gain confidence with dance and movement; Kaitlin became a powerful and emotional actress; Dorothy found her "regal" presence; Mary and I both found healing and acceptance for our fractures.

—Heather-Nicole Seybold, cast, 2010 production

In the postshow discussions for the 2015 performance, the audience always wanted to ask about the choice to use ASL in the movement. I chose to use it as inspiration for the movement vocabulary. Caley Edwards spoke of the logistics of teaching it to this company. But it was the students talking about how it affected them in their performance that was the most moving. They spoke of the day when Caley taught them that it wasn't enough to just do the gestures right—that engaging the face and the whole body in the communication was part of ASL. There was a single moment during the "Daughters of Zelophehad" scene when the line is, "Now daughters could inherit in Israel, not uncles, not male cousins, but daughters" (Schearing 2015). The gesture for "but" is two pointer fingers moving away from each other in an arch. Just making the gesture wasn't enough, she said. They needed to engage their faces. This fed into all of the acting with the sign. The students said it was even more visceral for them to say the words with the signing because it was a true embodiment. The actor playing Job's wife was challenged with a monologue for the 2015 production; I chose to have her tell the story on her own. Usually, I felt the stories were strengthened by having all the actors engaged and embodying part of the story. For the first two productions, I knew this to be a challenging monologue, so I selected one of my strongest actors for the 2015 show. She admitted that it was difficult to get into the story at first and in particular because it was a true monologue. She chose to incorporate a lot of sign into her monologue, and the meaning grew in her performance. At a **talkback** (postshow discussion between the audience and members of the producing company), she spoke eloquently about how the gesture for "angry" was powerful and how saying the words "I was angry" was powerful, but that the two together made the most impact.

Conclusion

After all this work creating, developing, rehearsing, and performing, it is important to celebrate your efforts and all that you learned. But do remember that in art there is often more than one right answer. For example, *Weaving Our Sisters' Voices* was produced multiple times with the same director, and each time the poetry took on new meaning and was physicalized in new ways. What new things could be learned about the same poem if your efforts were opposite of what you developed? For instance, if you chose punch as your primary effort and flick and glide as your secondary, what if now you use float as your primary and wring and slash as your secondary? This is a very challenging exercise that can at first seem impossible, but by opening yourself to new creative possibilities you can learn a lot. You are encouraged to use the same blocking and scoring and just insert the new efforts to see how it might change the meaning or intention of the poem for you.

Combining theatre and dance is a natural process as mentioned at the beginning of the chapter, which you will experience through these assignments. You will see how your knowledge and tools for one art form such as theatre can inspire new ways of thinking in dance, creating a new work and stretching your knowledge about both.

DISCUSSION QUESTIONS

1. How does the poem performance combine the aspects of dance and theatre, specifically Laban's efforts and blocking?

2. Discuss the importance of feedback, and provide examples of helpful and unhelpful feedback.

3. What step of this process did you find most challenging, and why?

4. How can using elements of dance and theatre enrich a simple speech?

CHAPTER 6

Visual Arts and Dance

The fields of visual arts and dance have always had close ties to each other. Elements of artistry that bring additional meaning to movement include lighting, costumes, and garments designed for performance. Contextual art such as scenery and installations can transport the viewer to another world. Dance is a **kinesthetic** art that is perceived by the body and received through all of the human senses, but perhaps the primary mode of receiving dance is through the eyes. Watching dance can also touch on the other senses through music, and the audience can experience the dancers' rhythm through their bodies. Other elements that meet the audience's eyes alongside the dance, such as what the dancer wears, touches, and interacts with during the dance, are all important to the overall experience. Costume, scenic design, and lighting are some of the visual arts allied to performing arts, including dance. Using concepts from visual arts and dance, this chapter offers you the opportunity to integrate what you have learned and create your own piece of performance art.

Integrating Visual Arts With Dance: Wearable or Scenic Art

Students will work in small groups to create a piece of wearable art or a scenic element that will serve as a costume, prop, backdrop, installation piece, or interactive scenery for an original dance piece. The concepts of time, weight, and space explored in previous chapters will be at the center of creating an interdisciplinary work of art. Objectives for the performances include demonstrating full commitment, clear preparation, choices to develop each moment, and collaborative partnership. By the time of the presentation, you will have completed a one- to two-page position paper as well as a copy of the scored song clearly showing artistic choices and beats. Collaboration skills are important for interdisciplinary artists, and in this exercise, you will work with your collaborators to create a rubric to assess the success of the piece in reflecting your values and style.

Overview of the Process

Integrating concepts from visual arts and dance requires attention to detail and embodiment of the ideas described in chapters 3 and 4 in order to bring those concepts to life. You will have opportunities to create written and visual reflections throughout the process, encouraging you to integrate what you are learning into your own practice. Written reflections take place in your journal or sketchbook, and visual reflections can be multimedia or collage or done with markers, paints, or on the computer. The goal is to go through the steps in this independent and collaborative process in order to refine them in your own way as you emerge as an interdisciplinary artist.

KEY TERMS

art nouveau
direct
gas lighting
gels
heavy
high-level movements
indirect
kinesthetic
light
low-level movements
medium-level movements
performance art
screen dance
sudden
sustained
vaudeville

LÖIE FULLER

Löie Fuller (1862-1928) was born in Chicago and performed on **vaudeville** stages from the beginning of her career. Her early work, beginning with a theatrical piece called *Quack M.D.*, enthralled audiences with the use of her voluminous whirling skirt and her use of **gas lighting** and innovative fabric to create an ethereal effect. Her skirt dances were a sensation, and she traveled to New York, London, and Paris. In Paris, she performed with the famous Folies Bergère, and her dances were very popular. Fuller was a modern dance pioneer, setting the stage in the late 1800s with her unique lack of corsets and use of classical ballet silk fabric. Her work was abstract, what we would call **performance art**: part dance, part sculpture. She used classical ballet steps and choreography, but the silk fabric brought her dances to a new level. She pushed the elements of what had been done before in theatre lighting. She innovated by darkening and silencing the house to a degree that was unusual for solo performances at the time. She used new lighting angles and colored **gels**, like a "jewel in a jewel box" instead of the typical painted garden scenes more common to female performers. She was also a costume designer, working with her friend Marie Curie to use radioactive crystals to make her dresses glow. Her connections in the field of visual arts included Henri de Toulouse-Lautrec, Briton Rivière, and Auguste Rodin, and she was part of the movement known as **art nouveau**. Fuller performed at the World's Fair in Paris 1900, where she had her own theatre. She was also a connector of people. She met Queen Marie of Romania and Sam Hill, a wealthy businessman. Unfortunately, the chemicals she used to create her spectacular effects were discovered later to be dangerous, and might have poisoned her. The work and legacy of Löie Fuller continues to inspire interdisciplinary creators to push the boundaries of dance and visual arts (see figure 6.1).

FIGURE 6.1 Helen Shantz performing in Löie Fuller dance work at Gonzaga University.

By the end of this chapter, you will have completed the four steps of this process:

1. *Research:* In your journal or sketchbook, collect notes and make drawings from brainstorming sessions; choose a piece of music and score it.
2. *Assimilation of feedback, development, and rehearsal:* Show clear development of the work from peer and instructor feedback; track your progress in your journal and with visual reflections.
3. *Presentation:* The presentation is well-rehearsed and clearly memorized, using each moment effectively; incorporates the fabric element; and creates community.
4. *Reflection:* Why does this work matter to you? How have the research steps informed the final performance? What did you learn? How did you learn it?

These steps were developed further in the assignment in chapter 5 and can also be referenced there. These steps provide an embodied experience of specific terms from the fields of visual arts and dance. Let's take a deeper look at the specific areas covered over the course of the process.

Overview of the Concepts Used in the Project

In this chapter, you will integrate concepts of visual arts and dance through another presentation assignment: investigating a complex problem. While your dance and theatre project was a solo, this time you will work with a small group of peers. Preparing your performance, each moment must earn its right to be in the piece. You will look for full commitment from every member of your group, develop your own confidence, demonstrate clear preparation, and make choices. Clear communication within the group fosters a sense of trusting partnership. Your group will focus on the following goals:

Dance	Time, weight, and space (including levels) were used creatively.
	Visual arts elements in the dance were used thoughtfully.
	Transitions were clean and clear.
	The entire group used full-body expression and variety of movement.
Visual Arts	Fabric piece was creatively and carefully constructed.
	Choices supported the complex problem and the dance.
	All of the material was used.
	All clothing and costumes and the context were taken into consideration.

Discern Your Values as Collaborators

Brainstorm first: What aspects of communication are important to you as individuals? How will you ensure that everyone's ideas will be heard and thoughtfully considered? Do group members have differing communication style preferences? (For instance, do some of you prefer to contribute ideas in writing, while others like to think through ideas by talking through them?) You might find that some folks are more comfortable with one or more of the art forms and perhaps less comfortable with another, but this makes each member important in a collaboration. Even though someone in your group might identify as a dancer, it is very important to remember that you all are movers and can contribute to this project in physical ways, at any level of training or experience, without any previous experience in dance. You have all engaged as visual artists throughout this course so far and so can contribute to the visual elements as well, with any level of arts experience your members bring to the group.

Everyone learns from each other. Acknowledging the uniqueness of your partners and getting to know their interests, skills, and communication styles are essential parts of learning to communicate clearly.

VISUAL REFLECTION

Create a visual image of successful collaboration. This can be quite abstract. Title it *Collaboration*. Remember you can use a variety of media: colored pencils, pens, paint, crayons, or collage.

JOURNAL REFLECTION

What are the most important elements in a successful collaborative project? What have been positive experiences for you in the past? How can this collaboration succeed? Underline the ideas that are at the center of what collaboration means to you. Be ready to share some of your key concepts with your group as you build your rubric together.

EXERCISE Collaboration Rubric

Create your own collaboration rubric with your small group (see figure 6.2 for an example). Draw a grid together that includes your values for collaboration and communication. Include everyone in this process, and agree to hold each other to these criteria. You are learning both to create and to communicate, and you might have more skills in one area and a development opportunity in another. It is

important to address communication issues separately from the success of your art and performance; they link, but they are not the same thing. At the end of the chapter, you will fill out your rubric and assess the success of the collaboration based on these criteria.

Skill area	Excellent 5	Good 4	Progressing 3	Needs improvement 2	Lacking 1	Total
Technique	The dancer demonstrates a clear sense of alignment, center control, flexibility, and strength. They have a strong sense of musicality and the ability to assimilate corrections.	The dancer demonstrates awareness of alignment, center control, flexibility, and strength. Advancement in level only if recommended by instructor.	The dancer demonstrates an adequate understanding of alignment and center control, but lacks in flexibility and strength. Student should remain at current level.	The dancer is underdeveloped in alignment, center control, and flexibility. Further work is needed at current level.	The dancer lacks an understanding of alignment and center control. They lack flexibility, musicality, and the ability to pick up combinations.	
Presentation	The dancer demonstrates a high level of concentration, energy, and confidence when executing movement in class.	The dancer demonstrates a good level of concentration, energy, and confidence when executing movement in class.	The dancer demonstrates an adequate level of concentration, energy, and confidence when executing movement in class.	The dancer demonstrates a low level of concentration, energy, and confidence when executing movement in class.	The dancer demonstrates a poor level of concentration, energy, and confidence when executing movement in class.	
Attitude	The dancer demonstrates a high effort of professionalism by arriving to class on time, dressing properly, and being prepared to dance.	The dancer demonstrates a good effort of professionalism by arriving to class on time, dressing properly, and being prepared to dance.	The dancer demonstrates some effort of professionalism by arriving to class on time, dressing properly, and being prepared to dance.	The dancer lacks in effort of professionalism by arriving to class tardy, dressing improperly, and not being prepared to dance.	The dancer lacks in effort of professionalism by constantly arriving to class tardy, dressing improperly, and not being prepared to dance.	

| **FIGURE 6.2** Example rubric.

Adapted from a rubric by Sarah Glesk, used by permission.

Research

Remember that you have now all become experts in your own movement through explorations in the previous chapters. Employing the ideas of Bartenieff and Laban, you have many tools in your movement tool kit for physical expression. The research phase for this project might take place largely within your own kinesphere. Be sure to apply the terms you have learned to use your body as your research source. Use notions of time, weight, and space to begin.

Time

Begin your investigation of how you respond to different notions of time. A way of thinking about time is to divide it into effort elements correlating to perceptions of suddenness or effort that is sustained (see figure 6.3), as conceptualized by Laban (Laban 1960; Newlove 1993).

Sudden consists of quick speed and of the sensation of movement for a short span of time, or a feeling of momentariness.

Sustained consists of slow speed and the sensation of movement for a long span of time, or a feeling of endlessness.

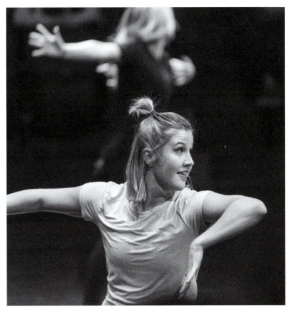

The words *momentariness* and *endlessness* describe two of the art forms used in this project. One could use the term *momentariness* to describe dance because it takes place in the moment and then is gone. One could say that a piece of visual art is endless because it is fixed in space and time, captured, and held forever. The momentary aspects of dance have a dynamic quality; one's creative effort goes into the work, choreographing, rehearsing, editing, and presenting, but is ephemeral. Visual artwork often has a solid form with an endless quality that is attractive in its permanence.

FIGURE 6.3 Sudden versus sustained.

EXERCISE Sudden Versus Sustained, Momentary Versus Endless (www)

Explore your own response to these terms on paper as you continue (see figure 6.4). One strategy is to turn these ideas 180 degrees and ask yourself, what happens when dance is endless and visual artwork is momentary? In your journal or in your sketchbook, write or draw an image of endless movement. Follow this with a drawing that is ephemeral, temporary. Capture sustained movement and sudden imagery. What creative juxtapositions emerge?

FIGURE 6.4 Time, sudden and sustained.

Next, engage in movement that expresses these same ideas. As a group but working independently in your own spaces in the room, create individual movements that give each of you a sense of endlessness. Follow this with movements that seem momentary to you, that flit away after you finish them, never to be seen or experienced again. It is all movement, but can you sense a difference in the quality when you frame it in these terms? Write about these differences in your journal, then come together and discuss them as a group.

Weight

To contrast different ways of moving, it is helpful to contrast the light feeling of gliding through space or the lightness of a flick of the wrist, as opposed to heaviness as though pushing your way through peanut butter or the effort it takes to move against a strong wind. This is the difference between movement that is light versus that which is heavy.

> **Light** movement indulges effortlessly in the moment and has a "delicate or fine touch" (Adrian 2002, 75).

> **Heavy** movement has a strong resistance, as though fighting against gravity or an outside force (Newlove 1993, 66).

EXERCISE **Light and Heavy, Effortless and Resistant** ⓦⓦⓦ

Take a moment to add in the qualities of lightness and heaviness to your work in the previous exercise. Look in your sketchbook at the drawings you made of momentariness and endlessness. Where do you see lightness and heaviness in your strokes? Make two more drawings, or layer on to the existing two. Building on your work with strokes that were sustained and sudden, now add in the qualities of lightness and heaviness. How does this change your attitude as you are drawing? Does a firm stroke evoke a different emotional response in you than does a touch on the page that is light as a feather (see figure 6.5)?

Translate these drawings into movement. In your own space, feel where your body connects to the ground, to the floor. Vary your connectedness to the earth by lying down, sitting, and standing, first with lightness, then with heaviness. Create a short sequence in which you change from one of those positions (lying, sitting, or standing) to another, going from lightness to heaviness or the reverse. For example, start by lying on the ground in an attitude of heavy connectedness, feeling the earth's gravitational pull, and move to an attitude of lightness, feeling energy and light fill each space in your hands, arms, feet, legs, core, and head, until you are sitting or standing as lightly as you can. Vary the positions and sensations until you have a set sequence, then try your movement in reverse, so that you go from lightness to heaviness, from effortlessness to resistance (see figure 6.6). Move from an upright

| **FIGURE 6.5** Example of a sketch for weight: heavy and light.

position to one that is recumbent. What emotional changes do you undergo as your body makes these shifts in its relationship to weight? Make a note of these progressions in your journal or in your sketchbook.

| **FIGURE 6.7** Direct and indirect.

Space

In dance, theatre, and visual arts, ideas are expressed through the movement and shapes created by the body, in their own nonverbal language (see figure 6.7). Applying these ideas to the concept of space as used by dancers helps the artist to think in interdisciplinary terms.

Within the area of space, movement is direct or indirect.

Direct movement travels toward a target, like an arrow (Newlove 1993, 53).

Indirect movement is flexible, expansive, without one point of focus (Adrian 2002, 75).

Sometimes similar terms are used in theatre, dance, and visual arts in different ways, such as *intention*, *objective*, *needs*, and *desires*. How are these used across all three art forms? You can start to explore how your own needs and wants are manifested in the body and how that expression can create a visual remnant of the lived dance experience (see figure 6.8). You might find this exploration of time, weight, and space makes you think about the way movement is analyzed using Laban's efforts. As you move a writing implement across the paper you may be aware of your own desires manifesting on the page, or you might depict the intention of a subject in a painting. But we will take this further in the following exploration of how these terms intersect, and how other terms can be used in interdisciplinary contexts.

| **FIGURE 6.6** Light and heavy.

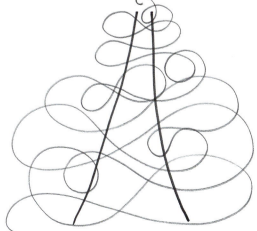

FIGURE 6.8 Example of a sketch for space: two direct and one long indirect.

LEVELS Recall from our discussion of levels in the chapter on dance and movement that it is common to think of three general levels on which movement happens:

Low-level movements (see figure 6.9*a*) emphasize a connection to the earth, moving close to the ground, but also from a standing position with lunges and pliés that bring the legs and body closer to the ground.

Medium-level movements (see figure 6.9*b*) include standing upright and moving on a plane that is more or less a conventional standing position; much of the traditional postures of classical ballet include the dancer with their torso on the medium plane.

High-level movements (see figure 6.9*c*) include lifts, jumps, and reaching the arms and legs far above the head or up and outward from the body.

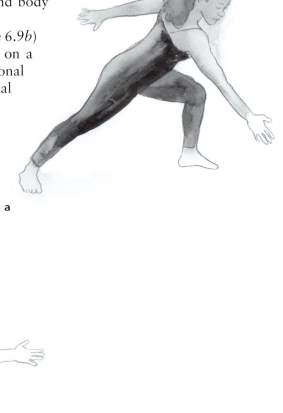

a

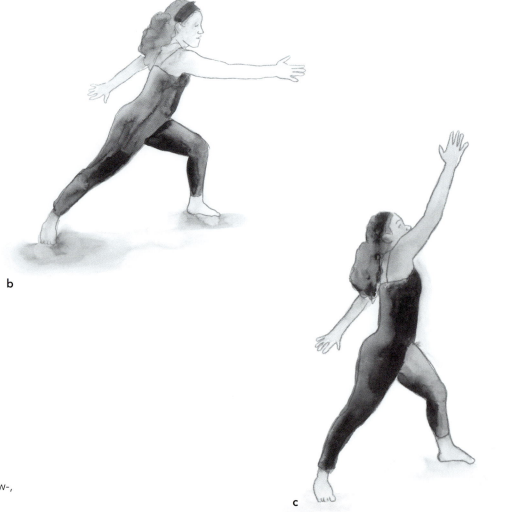

b

c

FIGURE 6.9 *(a)* Low-, *(b)* medium-, *(c)* and high-level movement.

EXERCISE Direct Versus Indirect, Need Versus Want
With Levels, Individual Needs and Wants

Movement helps us communicate these ideas in a different language from the use of mere words. Imagine that the concept of need is a gnawing focus that comes from your physical core. In exploring movement for *need*, reach toward those needs initiating from a central desire based in your core (near the belly button). Visualize the movement for the concept of want manifesting from a much higher-level point in your body, from the chest or sternum. Exploring moving with want, you might experience a sense of craving for a filling of the chest so that it puffs up with a sense of fullness or expansion. Experiment with different levels as you vary the sensations.

EXERCISE Group Needs and Wants

As a group, discuss the way contemporary American society assigns value and priority. What do we need as people? What do we need as a society? What do we merely want? Is there any difference? Start by developing a definition together of need versus want as individuals and as a society. For example, some see need as imperative and want as merely desire, but if you discuss this with others you will quickly see that it is different for each person.

Temporal Desires Film

Watch the film *Temporal Desires* (Ostersmith 2012), available at the link given in the case study at the end of this chapter. Continue your research into your own response to these terms.

Reflect with your group about what you saw, felt, and wondered.

JOURNAL REFLECTION

Respond to the film in the terms below. Where did you see expressions of these ideas?

1. Time

 Sudden versus sustained, momentary versus endless

2. Weight

 Light or heavy, effortless or resistant

3. Space

 Indirect versus direct, need versus want, levels

Thinking about marks made in works of visual art, you might notice more indirect and curving in want and more direct in need in the film, for example. Also, the dancers show these concepts intersecting with parallel and opposite moves. These elements add to the concepts available to an artist and, while they will not necessarily be noticed by the audience, they are important for all of the collaborating artists to understand when working on a project that engages with these terms. In addition to these physical explorations, the richness of this work comes from the parallels that exist in need and want as well as where the concepts intersect.

Development

Begin the next phase of the project by gathering around a large piece of paper on the floor. Using colored markers, create a visual representation as your group discusses a range of complex problems. At this point keep it to just a brainstorming session, and as you talk, doodle. You can write words, draw images, be specific or be abstract, but the goal is to keep pen to paper the whole time you are chatting so that at the end of the session you have a paper full of ideas.

Complex Problem

What is a complex problem? A complex problem is an issue that cannot be solved with one simple answer. Each person approaches this issue in a different way based on their own lived experiences. There is no right way to approach a complex problem. Examples of complex problems used by students for this activity in the past include religious tolerance, mental health, and racism in America. What is a pressing issue for you and your group today?

Once you have filled your paper with ideas and representations of your discussion, it is time to go on to the next step.

As a group, select two complex problems to research. Narrow it down to two of them and then spend some time away from each other gathering information about the topics along with visual images that connect to your research. Once you are together again, share your research openly and without judgment. Once everything is shared discuss the two problems and see which one has more energy for this assignment. From this selection, you will work together to develop a dance and visual arts presentation. You will use a large blank sheet of paper or fabric (a large bedsheet is ideal) to paint, rip, and construct a visual arts element used in the performance to help communicate your work. Students of the past have used the fabric as a costume, prop, dancing surface, backdrop, tool, another character, and often multiple or even all of the above (see figure 6.10).

Some powerful examples include the following:

• *Religious tolerance:* Students discussed they wanted to find a way of honoring religious perspectives. The students studied three religions and created beautiful, colorful, wearable fabric capes representing the religions. They each wore one to begin

FIGURE 6.10 Fabric can be worn as well as used as a prop; it can be used in many ways in your piece. Example from *Weaving Our Sisters' Voices.*

showing the isolation, but in time they passed around the fabric and eventually made them into a symbol of respect of the differences.

• *Mental health:* Students used the sheet as a stage, painted with three sections of the three ways the performers represented mental health suffering. What they wore on their bodies for the performance was unified with colors on each section of the fabric. These students moved on and off the fabric throughout the performance, picked it up at one point to use in a tug-of-war, wrapped themselves up by rolling on it, and in the end stepped away from it, giving the audience a sense of hope as they embodied learning to find a way of living with it.

• *Racism in America:* The students chose to paint on their fabric an American flag with powerful quotations in each of the stars and stripes. They then spoke the quotations at different times with the movement. The fabric was used to indicate silencing another by placing it over one student and holding them down, hiding under it. Once the performance introduced how they were using the fabric, then seeing it as a weapon made a powerful statement. The fabric could cover another, be used in a tug-of-war, or even be used to bind the wrists or feet.

To get started, look closely at your drawing, notes, and doodles that you made during your brainstorming session. Zero in on two ideas.

What complex problem would be good for you to explore in this presentation? It might be that one of you is more of a content specialist if you are studying the subject in a class right now, but this is a collaborative project, so everyone will need to be invested enough in the subject to be equal contributors. It might be helpful to think about how you could perform this complex problem. While it will not be a fully developed piece yet, thinking about it through this lens might help you narrow your list.

Do some research on the subjects that your group chooses. Get some facts and figures, but also see if you can find some stories. This can help with emotional connections. Also, do some image-based research. Connect with your group with three images related to your complex problem. All of this can contribute to your understanding of the issue from multiple angles and aid the construction of your performance.

EXERCISE Group Silent Paint

In your groups, listening to some instrumental music, gather around one large piece of paper and a set of shared paints. Do not talk; just paint together. This is about listening to your body and the moment, trusting yourself and trusting your teammates. By now you have chosen your complex problem, so see how it comes out with color and paint. It can be scary to paint near or even on someone else's work, or to have someone paint onto yours, but trust the process. Discover how what each of you does can inspire something else. Each of you might create very different images and ideas, but see how they can all contribute to a whole.

JOURNAL REFLECTION

Reflect on the group paint and what you learned about the complex problem, your peers, and yourself through the process. It is important to reflect on moments of joyful flow, moments of awkwardness, and questions the experience brought up in you. How did that process deepen your understanding and creative inquiry about your complex problem? How did the process relate to your understanding of collaboration?

VISUAL REFLECTION

Create a rich visual composition of this new assignment—further develop your thinking and be ready to share. A rich visual composition includes an image in which you have fully thought out all the elements of the assignment. Color, texture, theme, tone, mood, and how it makes you feel are some considerations. Use visual arts concepts, referring to chapter 4, to make those feelings come to life.

The next time you are together, discuss your group painting and reflect together about what that process was like as a group. Then talk about what inspiration you can take from the group painting. Employ the strategy of using a frame to isolate just a portion of the painting or to discuss what it would be like to move sections of the painting.

EXERCISE Craft a Visual Score

A visual score is a visual representation of the movement in a dance. This usually corresponds with music, with annotations for the movements corresponding to the beats and sections of the music, but it can be as abstract or literal as the artist or creator wants (see figure 6.11). The score usually depicts the mood or feeling of the choreography and can be a good starting point for choreographers to decide what they are trying to make the audience feel before choreographing a single step.

ZagDance Concepts Dance 2017–2018
Verge (Owl City feat. Aloe Blacc) 3:33

	:22			:52	1:06	1:32
1 \| \| 2 \| \| \| \|	3 \| \| \| \|	\| \| \| \|	3 \| \| \| \|	5 \| \|	6 \| \|	7 \| \|

1:33	2:02 (on top)	2:22	2:41 (on top)
8 \| \|	\| \| \| \|	\| \| \| \|	\| \| \| \| \| \|

Space	1	general space (8) self space (8)
Level	2	low^2 mid^2 high2 mid^2 fingers
Size		small rolls4 big jumps opening turn 2x
Direction	3	(forward back) (chasse RL) (up^2 down2 rollup2)
		diagonal plié 2nd arms out 2x
Pathway	4	curvy front straight scoop up stage zigzag DS 6x hit
Focus	5	indirect arrows direct arrow (8)
Speed		high jazz fast melt down (8)
Rhythm	6	slap grand 2x clap 2x (rollup) grand 1 clap 1
Energy	7	whistle - sharp (8) smooth (8)
Weight	8	heavy light
Body part		
Shapes		
Relationships		

FIGURE 6.11 Visual score of music for a concepts dance.

Write out a visual score for this new work. Be ready to share your ideas with your group. Try writing out multiple scores, maybe by drawing one when you have your eyes closed and are only moved by the music. Try to imagine the music in your head, and draw a score based on what you remember (see figure 6.12). Add in color to the score, and play with the weight or pressure of the pen.

| **FIGURE 6.12** Listen to the music, and let your hand be guided by it.

Work individually, and then bring together the collected texts and research.

Select Music

You can choose the song for your piece based on a visual score or choose your music first and then map out your score in relation to the music. This assignment also can be effectively done in silence with the performers creating sound on their own through claps, sighs, flapping the fabric, and so on.

JOURNAL REFLECTION

Tape your visual score into your sketchbook. With colored pencils or pens, add to this visual score your own notes, musings, and colors of how your song flows. Why is the song you selected perfect?

Develop Your Piece

Now is your time to develop the work. You have been doing this through conversation, but it is time to move from a cognitive approach to a deeper physical exploration. It is important always to be going back to the score to take notes and record ideas. You will need to set aside time to construct your fabric art, through painting, cutting, and working with the material. The time it takes to rehearse something well with a prop or scenic element cannot be underestimated. Fabric can move in very different ways depending on how it is wielded, and it is important that this element clearly supports what you are trying to communicate. If not rehearsed well, it can distract the audience from what is being said because they are worried about the fabric, and then sometimes worried for the performers, rather than focusing on the art.

> **Tips for Performance**
>
> Hold the beginning and ending.
> Have a strong introduction.
> Have a clear and concise title.

Peer Feedback

It can be helpful to show another team the work. Before you share your work, brainstorm with your group about what kind of information might be beneficial to learn from this peer feedback audience. Share this information with your audience before you present so they know what kind of feedback you are looking for. Sharing that a particular section is causing you concern can alert your peer audience to give that part special attention for feedback. Prepare to share with your audience your intentions for the piece as well. At the end, take the time to discuss your findings with the audience.

JOURNAL REFLECTION

Reflect on one of the performances you saw. What did you learn from watching them? What stood out? Did you learn anything that causes you to see your own work in a new way? Reflect on your own performance as well, noting what you learned about performing.

VISUAL REFLECTION

Look for at least five images that connect you to the subject you are going to research for your group. Ideally, put them together into a collage so that they can all be looked at together. They might be photographs and actual images of your complex problems, but they might also be more abstract and reflect your feelings about it. You can do this at any stage of the process to provide a fresh perspective on the work.

Coaching Session with Instructor

Your instructor can offer helpful suggestions and assist you in developing your presentation by asking helpful questions, such as the following:

- Is every group member contributing? Comfortable? Confident?
- Is the group integrating the fabric fully in the work?
- Is the group's intention with the work evident to the audience?

Your instructor might push you further with questions. Do not be discouraged if they ask a lot of questions. Interrogating the work brings out the best and clearest presentation from your group.

Visual Considerations

It is important that you think about what you will wear for this presentation. Consider your costume choices. How does what you wear affect the communication of the work you have done? Sometimes students ask if they can leave their fabric unpainted because they feel that best represents their idea. We encourage you to brainstorm as a group how it might be painted to further communicate or comment on what you are preparing. It can be subtle or very dramatic, but it is important to use the paint in some way for this activity. Students typically paint onto the fabric with a brush, but some have also dipped it into a watered-down bucket of paint to create a light wash. Experiment with your group: are there other ways you could apply the paint?

Crafting a Great Title

When you present it will be important to have a title for your work. In many cases in the arts, the only thing the audience is privy to before watching a performance is the title—this is more the case in dance and visual arts than in theatre—so think carefully about how your title frames the audience's perspective on what they are about to see. Beginning choreographers sometimes are tempted to title the dance with the name of the song, but a dance is a different work of art that deserves the thought that goes into creating a title. Even experienced artists can find titling difficult, so give yourself some time with this. This is art-based research and presentation, not just information but also your interpretation, and the title should reflect this creative labor.

One strategy for coming up with a title is to write words down that connect you to the work, rearrange them, say them aloud, share them with your collaborators and friends. For example, rather than "Climate Crisis," look up other words that express the ideas of *climate* and *crisis*, adding to them with additional layers or metaphors. It could be "The Battle for Our Mother," "Place for Tomorrow," "What Have We Done?," or "Environmental Spaces and Degradation to Hope." The possibilities are endless.

Order of the Presentation

The order of presenting will be to give your title, get into position, pause, take a deep breath, and then begin your performance. That pause and deep breath are important for letting the community of performer and audience become present in the moment and settle into clear focus. One strategy for clarifying this focus is to use one of Laban's still forms at the beginning and end of your presentation. As a reminder, the still forms are pin, wall, ball, tetrahedron, and spiral (see chapter 3).

Once you are finished presenting this work, be certain to hold your ending once again to help the audience understand it has concluded.

You now get to explain your choices to your audience. What is the complex problem you researched? How did you represent it in your performance? What were your challenges, and how did you overcome them? It is important that this is also prepared and rehearsed and that everyone has an opportunity to explain some portion of this information. You will then perform a second time.

At the conclusion of the second presentation the class will be divided, and a group of students will join each performer. The performer will have their research and knowledge and hold a discussion about the subject matter. At the end of the discussion each student will turn in their research notes, score, and written intentions for the work.

JOURNAL REFLECTION (www)

How are you doing in this moment? Reflect on your physical expression of this moment in your life. Are there places of tension in your body? What more can you do to take care of yourself?

VISUAL REFLECTION

Create an image that represents nurturing and self-care.

Presentation: Visual Arts and Dance

Students will work in groups to create wearable art or scenic elements that will serve as costumes, props, or scenery for a dance piece they will devise. At the time of the presentation, each student will turn in a one- to two-page position paper as well as a copy of the scored song clearly showing artistic choices and beats.

Visual Reflection

☐ Create a visual expression of how your collaborators contributed.

Written Reflection

☐ Reflect on your creative spirit at this point in the semester.

☐ If you could do this project over again, what goals would you set for yourself?

☐ How will you meet those goals in future projects and beyond as a creative being?

EXERCISE **Formal Reflection**

Discuss the process of choosing and developing the concept for the performance of the complex problem. Discuss the process of creating the visual arts fabric piece and editing and developing the performance together. What did you learn from collaborating, presenting, and sharing with a group of peers about your knowledge of the subject? While you might never have the pleasure of creating a work of art with these same parameters again, you will use again the various skills you employed for this assignment. Making that transfer of knowledge will lead you to more creative and innovative thinking.

REFLECTION PAPER GUIDING QUESTIONS

1. Discuss the process of choosing and developing the concept for the performance of the complex problem.
2. Why does the complex problem matter to you?
3. Describe how the various research steps informed the final performance.
4. Describe the process of creating the visual arts fabric piece and of editing and developing the performance together.
5. How did the comments from your instructor inform the development of your piece?
6. How did the comments from your peers inform the development of your piece?

CASE STUDY

Temporal Desires www

Temporal Desires (Ostersmith 2012; www.youtube.com/watch?v=-qelxYNnNEU, or search on YouTube "Temporal Desires Ostersmith") is an installation by Suzanne Ostersmith that used dance, visual arts, and video to explore the time-based qualities of art. It was shown in a juried exhibition at the Museum of Arts and Culture in Spokane, Washington. The original music was created by Jeff Rosick.

The creating of visual artwork is inherently theatrical. When I began working on *Temporal Desires*, I knew it was important to show the actual process of art making, and that in turn was how I decided to begin the video. The first step was to find a solution to an ethical struggle with the waste that was to be created from experimenting with huge sheets of paper required to explore this on a larger scale. I found a local newspaper company that was happy for me to use the ends of newsprint that would normally just be pulled off the roll and recycled. This discovery freed me to experiment because when I was finished, the paper would eventually make it to recycling, newly adorned with my arts research.

The research problem for me to solve was how to embody the spirit of dance in my visual artwork. I taped sheets on the studio mirror and danced against the wall with drawing tools in my hands. The results were unsatisfactory because typically I am not moving my body against a vertical surface. I put the paper on the floor to dance on, but immediately the functionality of how to dance with paint on my feet and not mark up my expensive dance floor concerned me and placed boundaries in the exploration.

Taking the experiments from the dancing-on-paper image and connecting to the temporal aspects of these two art forms led to a new line of exploration. Dance happens in the moment; we rehearse, we perform, it is gone. Where visual arts are more often permanent, whatever happens in the studio is rarely seen. Rehearsal is so often very private, but the visual result can live forever. I have been curious as to how to make visual arts for the moment, and dance forever.

The next step in the research was to bring dancers into the space to experiment with the horizontal and vertical surfaces again with more bodies. I observed their choices and re-created their movement on the page. Some moments were successful in capturing that sense of effortlessness and freshness. The sheer size of the work made creating a challenge. Because of our light-colored dance floor and my use of messy charcoal, I was careful to lay out protective paper and devise ways of washing the feet before walking off the artwork (see figure 6.13).

The final piece was 22 feet (7 m) long, hung in a gallery 16 feet (5 m) high, so my vision was to crumple the base of the work on the plinth

FIGURE 6.13 *(a)* Our toes did not stay stained for long. *(b)* *Temporal Desires* paper taped to the dance floor.

stand much as it does in the video (see figure 6.14*a*). This detail added to the imagery of this being a temporary visual artwork contrasting with the permanent film of the dance playing beside it. The sculptural element that the suspension provided was exciting (see figure 6.14*b*).

FIGURE 6.14 *(a)* The crumpled base of the work mirrored the effect in the film of the paper falling and crumpling on the floor. *(b) Temporal Desires*, center, in the Museum of Arts and Culture (facing the entrance).

Conclusion

By the end of this presentation you will have learned new ways of looking at your complex problem by expressing it with movement and visual arts through collaboration. How did this experience change you? How did the subjects that your peers explored make you want to learn more? While reading and lecture are excellent ways to learn, how does engaging in these art forms to explore your chosen issue enhance your learning? You might have embarked on this assignment without a lot of confidence about dance, or wondering how you were going to achieve the objectives of the assignment. But you did it! You kept your mind open, creativity flowing, communicated with your collaborators, prepared, presented, and reflected on the experience. Congratulations!

EXTENSION ACTIVITY

Site-Specific Screen Dance

Step One: Choose a Location

You might find deeper meaning in your performance if you set it in a location that speaks to the message or feeling of your piece (see figure 6.15). Responding to the natural world and dancing outside with your fabric is one excellent way to bring your piece into direct contact with the environment. Would your piece benefit from taking place outside? How would the natural elements assist in connecting you to your thoughts and emotions about the complex problem you have chosen?

Come up with a list of potential sites, and ask the owners or managers of those spaces whether you can have their permission to film your piece at that location. Ensure that no other people appear in the background unless you have their written permission to be filmed.

FIGURE 6.15
Illustration based on a site-specific screen dance.

Step Two: Screen Dance

Now that technology is at our fingertips and in our pockets, it is much easier to turn your performance into a **screen dance**, or combination art form involving film (video) and dance. Using the camera and recording technology that is available to you (a mobile phone works just fine), record your performance. This way your audience does not have to follow you to your location, although you certainly could have an audience with you on the day that you record. Later, watch your performance video and ask yourself, how is the complex problem addressed differently in the filming location than it was in the classroom or the place where we conceived the idea? What thoughts and emotions are spurred in you when you watch yourself perform, something that is not always possible in a studio or classroom? Share the video with your friends, and discover if this medium prompts a discussion of the complex issue in a new way.

DISCUSSION QUESTIONS

1. Why were Löie Fuller's works considered performance art instead of dance performances?
2. Explain the difference between suspended and sustained movement.
3. What are some benefits of combining visual arts with dance in a performance?

CHAPTER 7

Theatre and Visual Arts

Theatre and visual arts are integrated in many ways. Theatre naturally works with visual images in scenic, costume, and lighting design, as well as the visual shaping of the body. All the visual elements work together to communicate the intention of a theatrical piece. Within the fine arts, there is a sense of drama that is at home in the language of visual artwork. Even when a piece of visual art is not created for a show, there is nonetheless a relationship between the artist and whoever is viewing the work. In this chapter, you will create your own work of visual art in the form of a mask and will write and perform a work of theatre in the form of a monologue that employs the mask as a unique mode of bringing your personal expression to life.

The artists and concepts you have learned about so far will be important for getting the most out of this adventure. Consider Bartenieff's inner-outer connection and expression as you begin. You have explored how inner impulses manifest themselves in our outer movements, postures, and ways in which human beings use the physical instrument of the body. Expression is bringing that which is inside to the outside, where it can be perceived by others. Recall the notion of intent in dance and objective in theatre and how needs and wants can be expressed in visual arts; these are important concepts for articulating and expressing the inner desire that lies behind what appears on the outside. Our inner-outer work explores the dynamic between the motivation behind what others can see and the desire that motivates our actions and behavior.

KEY TERMS

Kabuki Theatre (Japan)
locomotor movement
mirror work
neutral mask
Noh Theatre (Japan)
plaster-infused gauze
soliloquy
storytelling

Integrating Theatre and Visual Arts: In/Out Masks

A powerful way that human beings have expressed their inner-outer connection and expression is through the use of masks (see figure 7.1). In this chapter, you will develop a performance of a monologue integrating visual arts and theatre, using Bartenieff's concept of inner-outer connection and expression. Objectives for the performance include the creation of a quality mask, the writing and performance of a work of theatrical text in the form of a monologue, clear choices for communicating your inner intention with outer expression, and a polished presentation-performance. You also will write a one- to two-page position paper and score a monologue clearly to show body movements with your mask, intentional vocal delivery choices, and beats.

FIGURE 7.1 Neutral masks are plain, forcing the body to be more expressive.

JACQUES LECOQ ⓦ

Jacques Lecoq (1921-1999) began his career as a Parisian sportsman, with his main focus on gymnastics, which is when his fascination and passion regarding the human body and its capabilities began. He continued his studies in sport and physical education throughout World War II, specializing in rehabilitative sports therapy. Lecoq's first introduction to theatre was not until he met Jean-Marie Conty at the college they both attended. Although Lecoq was studying physical education, he quickly became fascinated with theatre after Conty introduced him to the art of theatre and mime. This inspired a newfound curiosity in Lecoq around the intersections between sports, physical expression, and theatre. Lecoq began his theatre training with the troupe Travail et Culture (TEC), where he began exploring movement choreography, influenced by his background in sports and exercise. After the war, Lecoq and some of his TEC peers formed a company named Les Compagnons de la Saint Jean, which toured France, holding large festivals where they performed portrayals of significant historical moments through song, dance, and mime. At one of these festivals, Lecoq was asked to join Jean Dasté's company, Les Comédiens de Grenoble. In his involvement in theatre, Jacques Lecoq recognized that the dramatic movements used in theatrical performances are exaggerated athletic movements, which in combination with his discovery of masked performances, led to his further interest in body movement analysis. Through Dasté, Lecoq discovered other masked performance forms, specifically Japanese **Noh Theatre**. Seeing how masks encouraged performers to rely more on larger, more dramatic movements to portray emotions captivated Lecoq and inspired much of his future teachings. In 1948 Lecoq taught in Italy and met the sculptor Amleto Sartori. Inspired by the masks used in commedia dell'arte, the two worked together to create a new mask, which later was known as the **neutral mask**, the basis of Lecoq's most famous methods (see Eldredge and Huston 1978). The idea of the neutral mask is to encourage performers to explore new ways of moving that are not dictated by social norms and expectations (see figure 7.1). The mask allows the performers to learn to express emotions through movement of the body instead of relying mostly on facial expressions and words. This is the founding principle for Lecoq's philosophy and methods—refocusing conventional theatre methods to be more centered around the melding of physical movement in theatre. Lecoq believed neutral mask-based movement exercises should be free, spontaneous, and playful, instead of serious and restrained. He also pushed his students to explore themselves as actors and as characters, teaching them to dig deeper and reflect on what they wanted to do instead of what they felt expected to do. Jacques Lecoq's teachings have been influential in inspiring a new generation of theatre, one that centers around the power of movement in expressing emotions in theatre (see HK*Propel* and Markandu 2014 for more).

Overview of the Process

The steps for integrating theatre and visual arts in this project involve the same four-stage process with which you have grown familiar within the previous two chapters. As you become more sophisticated in your integration of interdisciplinary arts concepts, you will form your own language and process for bringing visual arts and theatre together in your own unique way.

By the end of this chapter, you will have participated in four components:

1. *Arts-based research:* Thumbnail sketches, images, writings, presenting ideas
2. *Assimilation of feedback, development, and rehearsal:* Filtering feedback from peers and your instructor; developing and rehearsing your performance
3. *Presentation:* Your performance for an audience
4. *Reflection:* What did you learn? How did you learn it? How will you apply it?

Overview of the Concepts Used in the Project

Visual Arts	Creatively and carefully constructed mask
	Inner-outer connection clearly expressed
	Integration of the mask into the piece of theatre
	Deployment of visual arts terminology such as form, color, shape, line, texture, and so on

Theatre	Creatively and carefully crafted monologue
	Clear, expressive, and articulated vocal work connecting the inner intent to the outer expression
	Monologue scored with notes or colors by hand to show thoughtfulness and preparation, showing division of the piece into beats

Work toward each outcome takes place during the following sequence of activities that build on the skills in the previous chapters, leading to greater integration and deeper use of arts concepts from multiple disciplines. Each phase in the process has something different to offer as you create your unique mask, become comfortable wearing your mask and experimenting with its expressive possibilities, write your own monologue text, and bring it all together in a performance for your peers. Here are the steps we will explore in this chapter, using arts-based research.

1. Paint your ideas on paper first.
2. Reflect and write about those ideas.
3. Return to the paper, and paint some more as you continue researching those themes or concepts through artistic practices. Use all media, words, images, paint, and so on.
4. Write the monologue (see the section Developing the Monologue). Do not forget to draft, read it aloud, edit, read it to someone else to gain their feedback, and edit again.
5. Draw the shape of your mask on a piece of paper, and design the colors and shapes of the mask.
6. Paint both the inside and the outside of the mask.
7. Plan what your body will do as you interact with both sides of the mask. Choreograph your moves as you explore moving with the inside and outside of the mask.

Arts-Based Research

Before creating your own mask, it might be helpful to consider this brief historical overview of the way that masks have been used by humans to create meaning and to do your own research about masks from around the world (see figure 7.2).

FIGURE 7.2 Masks are used in a variety of cultures.

Masks in Ancient Greek Theatre

Masks that covered the whole face or head and included a protruding wig were a characteristic feature of ancient Greek drama. Masks for the protagonists were individualized and recognizable to the audience (i.e., they looked like who they were supposed to be). The singing and dancing group of chorus members also wore masks, but they were often similar to or the same as each other, representing their group identity as a society rather than an individual. The masks worn in comedy were more exaggerated than the tragic masks (see more on HK*Propel*). 🌐

Masks in Rituals and Festivals

Throughout human history, masks have been used worldwide for festival and ritual purposes, for example as parts of social occasions, rites of passage, strategies of defense, and to hide or disguise identities. Some social examples of masks include funeral rites such as Kanaga masks worn by the Dogon dancers of Mali or by certain Oceanic societies and some Native American tribes to honor ancestors (see more on HK*Propel*). 🌐 Examples of festivals around the world that engage in this kind of performativity are La fiesta de las Fallas in Valencia and Entroido in Galicia, Spain.

African Masks

Masks were, and are, traditionally worn to recognize the supernormal within rituals and festivals celebrated in Africa, such as Festima that takes place in West Africa (Zechner 2016). In Burkina Faso, music and dancing contribute to the ritual and performance aspects of the celebration (Balzani Loov 2016). The masks covered the face and sometimes the entire body (see also Diakhaté and Eyoh 2017).

Asian Masks

- *China:* Masks from ancient China showed an emotion and are now sacred pieces of art today. Many of these masks were expensive and showed admiration for certain gods (see Chan 2009).

- *Korea:* Korean masks are commonly made with many materials such as papier-mâché. One of the most popular Korean masked dance-dramas is Kamyonguk. These masks have elaborate colors that represent different types of characters and express various themes found in Korean dramas (see Saeji 2012).

- *Japanese Noh Theatre:* These masks are much smaller and delicate than other types of masks and were seen as sacred. Along with Chinese and Korean masks, these masks showed the body and ego of a performer. There are also forms of therapeutic Noh Theatre in which the forms of Noh are reinterpreted for the benefit of consciousness and health (Hiltunen 2004).

- *Southeast Asia*: Many dance-dramas incorporate masks and puppetry into their traditions, including in Indonesia, Thailand, Cambodia, Laos, and Burma. The masked theatre of Bali and Java, the *wayang topeng*, can include masks with elaborate headpieces and costumes (Brockett 2008, 638).

Masks in Europe

- *Medieval cart performance masks:* Usually these masks were made with leather and cloth and were used in commedia dell'arte and religious performances. Masks often represented other people or characters to express a certain role.

- *Plague masks:* Although these masks are most known for the black death, the masks also became an icon in Italy (see Blakemore 2020). The beak-shaped masks extended across the entire face, emblematic of the time of the plague when beaked face coverings were stuffed with scented herbs thought to protect physicians from a disease that caused terror and death for millions (see figure 7.3). These masks have very little ventilation and usually are black or have dull colors.

- *Italy:* Masks used in Venice were common attire for many people. Typically, Venetian masks are used in the carnival season when they hide and create new, mysterious identities for the wearer (see Welte 2017).

FIGURE 7.3 Masks inspired by plague masks used in *Romeo and Juliet,* Gonzaga University.

Masks in Mexico and Brazil

- *Mexico:* Masks for the Day of the Dead often look like skeletons and celebrate the lives of those who have passed away (see *National Geographic Society* 2012). Masks are decorated to express individual lives with flowers and other vibrant colors.

- *Brazil:* Brazilians commonly wear masks that depict traditions from African culture (Hufferd 2007). These masks have festive decorations that represent ideas of power and status from Brazilian history. They are commonly worn during Carnival.

This is only a tiny selection of the vast array of cultures who create and wear masks for a multitude of reasons and effects. For the process described in this chapter, you will make a neutral mask, and then you will paint it to suit your own unique performance (see figure 7.4).

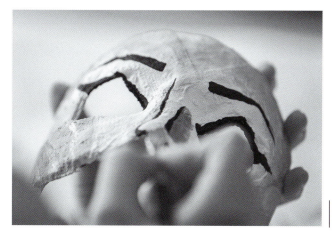

FIGURE 7.4 Painting a neutral mask.

What is arts-based research, and why is it important?

Development: Creating Your In/Out Mask

Materials List

Plaster-infused gauze

Bowl

Hot water

Scissors

Towels

Vaseline or petroleum jelly

Face wash or soap you can use on your face

Time to make the mask! Working with a partner, you will each create a mask on the other person. Here are some tips for the mask-making process:

- Before you start, cut the **plaster-infused gauze** into strips, with two longer strips on top.
- Fill an electric water kettle and boil it once, then let it cool.
- Place a paper towel under a paper bowl with about a quarter inch of warm water in it.
- Keep a towel handy.
- Bring any special facial cleaners that you need for cleaning your face at the end.
- Begin without makeup if you are comfortable, because the makeup might be left inside the mask.
- Tie back long hair, or use a cloth headband to keep hair back.
- Men's facial hair can be left.
- Decide with your partner whether you will cover the nostrils if they plan to breathe through their mouth or if you will be leaving air holes for the nose.
- Play calm music to create a relaxed atmosphere.

Preparing Your Face for the Mask

With your hair pulled back, place a layer of Vaseline or petroleum jelly along your face and hairline; this prevents any wispy hairs from being stuck on the mask. You only need Vaseline down to your upper lip and on your cheeks because this is a half mask. Be certain to put plenty of Vaseline on your eyebrows. Be brave, make it relatively goopy, and have fun!

The easiest way to make a mask on someone else's face is for them to lie down on the floor, face up (see figure 7.5). You are the artist of the mask they will wear, so proceed with respect and consideration.

| **FIGURE 7.5** Making the mask on a partner's face.

Take the two longer pieces of the gauze, and dip them in the bowl of warm water. The warm water loosens the gauze, making it more pliable. As you go, rub and work the plaster to eliminate the little holes from the gauze, making it as smooth as possible. Dab your hands on the towel to eliminate some water, then put the first cross from the upper forehead, across the bridge of the nose to the other cheek. The person lying there should relax and enjoy the process, as though they are at a spa. Remind them to keep their eyes closed at all times, even when you are talking to them. A little drip of water with plaster in it might slip into the eye, and that would be irritating. Use a soothing voice.

Get the other strip warm and soft, and cross it the other way. This will give strength to the mask. Continue to work around the outer edge of the face, folding the edge of the strip to make a clean edge to the mask. Be sure to keep all hairs out. Once you have outlined the mask, including across the upper lip, continue to fill in with more layers. Be certain not to go below the lower line of the eyebrow, ensuring that the eye has plenty of room to open. You can cover the nostrils and your partner can breathe through their mouth, or you can leave an air hole. Decide this with your partner in advance.

Continue adding strips until you reach about two or three layers thick. Your water should be warm to continue to make the plaster gauze the most pliable. If it cools too much, refresh with warm water. Continue to work the plaster to eliminate the little holes from the gauze, smoothing it as you go.

Look around the edges of the mask to be certain no hairs are caught and that the edges are folded and solid. Look at the sides by the outer corner of the eyes. These should be wide enough that you can make a hole for the elastic to hold it on your head.

It is nice to talk to your partner as you are working, but try not to make them laugh. Staying relaxed makes a big difference (see figure 7.6). Change the music if it helps.

Continue to layer and massage the gauze so that there are two to three layers. Once the mask looks complete, let your partner continue to rest as it sets. You can clean the area around them and continue to talk to them if you like. If the mask seems to be getting firm, it is good to touch the forehead part with the back of your hand to see if it is warm. The plaster will be slightly warm as it sets. When it feels cool to the touch, it is firm enough to consider taking it off.

FIGURE 7.6 Forming the mask on a partner.

The person who had the mask made on them is in charge of gently taking it off their face. The best way to do this is to encourage them to smile and frown gently while still in a resting position. As they smile and frown, they will feel it loosening from their face. When they are comfortable, ask them to sit up and bring their hands to the mask slowly. By tilting the face toward the ground and continuing to make various smile and frown faces, the mask will eventually pop off the face and into their hands. It is fun for you both to look at the mask, and then for them to peek in the mirror and see the little bits of plaster left on their face. Once you are finished looking at it, your partner can put the mask on a piece of paper towel so that it can cure completely; they should write their name on the towel. Now they can go wash their face.

Once the mask is dry, you or your instructor can drill holes in the sides and tie a strip of elastic to attach the mask to the face. Adjust the elastic to ensure a proper fit.

One of the beautiful things about this process is that the mask is never smooth on the outside. It will have little bumps and grooves that might surprise you. These can be a great source of inspiration for creative work with the mask.

EXERCISE Mirror Work

Mirror work is moving and rehearsing in front of a mirror and is helpful for developing your relationship to your own image and awareness. When you have your own mask dried and with the elastic attached, begin by standing with your mask at your feet and looking into the studio mirror (if you are not in a studio, you can do this in any mirror). Celebrate this amazing human being looking back at you. Just like when you walked around the space focusing on your own exploration, do the same here. Avoid looking to your peers through the mirror, but instead focus on your observations and discoveries.

As you look at yourself, imagine that same face but from when you were a very young age—same eyes, same heart, same breath, but much younger. Be gentle with that little person that you were and grateful for the wonder and discovery that fulfilled your life.

Now move to the other end of life and imagine that person very old. How might the wrinkles form around your eyes as your skin softens, yet you still look through the same eyes, the same heart beats in your chest, the same lungs are filled with breath. What a wonderful human you have the chance to be. All your experiences make up who you are, and you will have so many other wonderful experiences by then!

Pick up your mask, and look at the inside of it. Run your finger along the nose, cheekbones, and the outline of the eyes. Give a little thought of gratitude to your partner, the artist who created it on your face. Remember that moment of trepidation when they placed the first X across your nose and brow. Turn it over, and look at the outside of the mask. Notice the various bumps, hills, and valleys. Pause and feel gratitude for each piece of the mask. Which elements of this mask inspire you with thoughts about inner connection and outer expression from the concepts of Bartenieff? Placing your mask on your face, slow your breathing so that you can feel it become a part of your face.

In the mirror, look at the mask on your face and use that sense of wonder you used to have as a little child. What do you think about as you see yourself? What imperfection in the mask inspires you? Select a part of the mask and think about a character or feeling. Let that physically express and show forth in the rest of your body. Take a couple steps back so that you can take in your whole physical instrument in the mirror. Create a shape with your body that expresses that idea.

Can you make that shape any more exaggerated? Bigger? Such that someone from far away might get the impression of what you are intending with that body shape? Now move into a neutral stance, and look back at yourself in the mask. Select another part of the mask that inspires you in another way. Let that impulse from the mask move into the rest of your body to create a shape—bigger, larger still, using the breath to help you to grow your shape from within. Again, a third time.

Practice moving in and out of those shapes, creating them into characters (see figure 7.7). Move in and out of the characters. Beginning at neutral, take eight counts to get into the first shape, hold it, and then take eight counts back into

neutral. Notice how you can use the body to express without relying on the face. When you look in the mirror, your expression is static with the mask, giving you a greater opportunity to see what your body can communicate.

| **FIGURE 7.7** Physical exploration with the mask.

Do this exercise backing away from the mirror and toward the mirror. **Locomotor movement** is moving across the floor, through space, as opposed to moving in one location. Starting from a fixed position, notice how the body shapes you create change or evolve as you move closer to and farther from the mirror. How do the postures or shapes you are making with your body help define an emerging sense of a character as you push forward and back in locomotor movement?

As you move away from and toward the mirror, revisit all the various ways we have studied to use the body to express. Walk, keeping your upper body very still or in body half, using Bartenieff concepts. Walk indirectly or directly, heavy or light, quick or slow using the efforts of Laban. All of this is physical artistic research to help you think about what you might want to explore with this presentation.

VISUAL REFLECTION

Check in with yourself about how it is going so far. Create a rich visual reflection piece about how you are feeling about the work on this project. If you want to, comment on what is working well for you and what is not.

At this point, it is time to transition to the verbal portion of this project. Put the mask to one side for the moment, and focus on the process of creating an original text to use in your performance.

Developing the Monologue

For the purposes of this interdisciplinary arts project, you might not be writing a dramatic monologue like you would hear in a play, but it is important to understand the various forms of writing for solo performance that are sometimes used. There are two main terms to keep in mind: monologue (see chapter 2) and **soliloquy** (thinking aloud, or a character's conversation with themself). Because both a monologue and a

soliloquy involve one person speaking, often alone, the terms are sometimes confused. But it is easy to remember that a monologue is addressed to another listener, whether to an on- or offstage character or to the audience, whereas a true soliloquy is an internal dialogue that the audience witnesses, but it is not addressed to them or to anyone else. Hamlet's "To be or not to be" speech is a soliloquy, whereas Marc Antony, in his monologue in *Julius Caesar*, addresses his "Friends, Romans, countrymen," asking that they listen or "lend me your ears." In either case, the speaker normally has a reason for speaking, something that they wish to attain or convey with the words they speak. For the rest of this chapter, we will refer to your solo piece as a monologue, regardless of to whom you direct it. That desire behind the text is the most important aspect for us here: *what* you have to say is driven by *why* you want to say it.

Take a moment to think about what you might like to use this opportunity to express. If you are not sure what to write about, take a moment to write out a linear timeline of your own life. Consider events from your own life that have involved emotions that others might connect to, such as moments that were funny, embarrassing, difficult, tragic, disgusting, or extreme in a way that is important, interesting, or evocative to who you are.

Sometimes, the purpose of a monologue is to tell a story. If you choose to use this as an opportunity for **storytelling**, look for a clear beginning, middle, and end, with the aspects of drama written right into your tale, even though it might be very short. A good story has a central conflict that might or might not be resolved. The most interesting part of a story is how the people or subjects in it pursue what they want, and when forces both external and internal to the individual either prevent or assist them in attaining their desires. An emotional connection between the audience and the speaker is best brought about by the speaker desiring more than to tell a story, but that they have a reason or need to tell the tale.

Arts-based research can be appropriate here; as you think about what you might want to write about, take the perspective of a researcher who is learning about your life from the position of an observer. If you step outside of yourself and look at a timeline of your major life events, are there moments in between those milestones that could be the small, subtle building blocks of your life?

Try other ways of generating ideas that involve other art forms. Could you use paint to develop the monologue? Rather than composing the words as text, allow your hands and body to put color on paper as you remember and consider the moments that make up your past. How would you draw or paint the feelings of your first day of school? What shapes and forms come to your expression when you think about the pets or animals you have loved? Are you inspired to use certain colors when you think about relationships with friends, family, and past romances? The words may come to you after the images in this case.

A digital medium might suit this kind of personal investigation as well. Can you create a collage of open-source images that gets at the root of a particular time in your life?

EXERCISE **Three Good Stories**

1. Identify a situation or event from your own life that could help you write a monologue. In one paragraph, summarize the plot of the event, including the potential beginning and ending. Identify the central conflict in this event. Who else was there? Who were you talking to at the time?

2. Find an historical account of an event about which you have read but for which you were not present. In one paragraph, summarize the plot of the event, including the potential beginning and ending. Identify the central conflict in this event. Who else was there? To whom might a person recounting or dramatizing this event be talking?

3. Imagine a fictitious situation or event that could be good material for a monologue. In one paragraph, summarize the plot of the event, including the potential beginning and ending. Identify the central conflict in this event. Who else was there? To whom might you as the speaker be talking?

4. Write out your ideas, using any of the above processes to generate ideas. It doesn't have to be perfect at first, just get some lines down on paper. Read it to yourself multiple times; editing it until it sounds right to you. It can help to leave it for a while and come back to it. Writing is rewriting!

5. Once you have written your monologue and read it over to yourself a few times, it is time to come back to the mask and start generating ideas for how to paint it. Think about colors and other visual aspects that will express the themes in your monologue and support you in the performance.

EXERCISE Thumbnail Sketch

Just as with other art processes, perhaps it will be helpful for you to explore ideas for connecting your monologue to your mask by creating several thumbnail sketches first. On a sheet of paper, draw four boxes by dividing the paper into four equal quarters. Beginning with the top left box, quickly make marks that represent the inside of your mask. Use color, shapes, fast and slow strokes, specific symbols and imagery to record your thoughts, keeping in mind concepts from Bartenieff and Laban's efforts as you experiment. The key thing is to keep moving as you explore. Thumbnail sketches and paintings are for moving quickly and getting ideas on the page. So do not stop and judge; let the ideas flow through your body and onto the paper. Now in the upper right box do the same thing, reflecting on what the outer represents. Repeat this exercise in the lower two boxes. Each square represents a different articulation of inner and outer.

Requiring yourself to fill each box with ways to explore a single idea frees you up because you keep coming up with ideas. Then at the end, you can step back and see which idea feels strongest and use it as a jumping-off point (see figure 7.8). This encourages the idea that in creating and art there can be more than one right answer.

Another way to use this technique is to engage your whole body. You can imagine two boxes on the floor and create a different shape as a "thumbnail sketch" with the movement of your body. The left might be the inner

FIGURE 7.8 Dividing your paper into sections is a great way to explore. The painter is using the idea from the top right quadrant of her work hanging above the one she is working on.

mask as a different body posture and the right as the outer. The mask itself is for supporting your performance as part of your own artistic exploration. Remember, you are the one who gets to create the meaning. Do not get caught up in a right and wrong way to express these concepts. Abstraction is your friend!

JOURNAL REFLECTION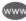

Check in with the connections you are making between your monologue and the sketches you have done so far. Write out a brief preliminary plan for what you are thinking for taking this project forward, how you might paint the mask, and how it connects to your monologue. Be ready to share these ideas. Explore themes using the language of inner and outer.

VISUAL REFLECTION

Create a visual representation of the imagery, colors, or ideas you have or with which you are deciding to paint your mask. One idea is to take a photo of your thumbnail sketches, zoom in on one section or an area that inspires you most, and make a sketch of that section in your sketchbook. Changing media from painting to sketching can unlock new ideas.

Painting the Mask

Draw and paint the mask on paper first. Divide a piece of paper in half: One side is inside of the mask; one side is outside. As you dream about how to create your mask, explore different ways you can divide your paper in half. For instance, could you divide it diagonally to free your imagination? This allows you to not see the inside as lower or lesser than the outside; both are important, and a diagonally split paper can assist you in not privileging one side over the other.

It is now time to put paint to the mask (see figure 7.9). Take it slowly, working from your sketches, drawings, and paintings you have made on paper. Tempera paint is perfect for painting the mask, but some students have also found that watercolor or acrylic paint can be successful. Paint one side first, let it dry, then paint the other side. As you have discovered, layering color can be challenging, so go slowly and allow for drying time in between layers. A light base color is a great place to start. If you start with black, it is difficult to add color on top of that. Starting with a lighter color, paint the images or shapes, and then you could add black as a night sky or background around those images and shapes. You will need less water than you think.

Paint the inside of the mask too (see figure 7.10). Many students immediately think about how they will wear the mask, but many options exist for taking it off or performing with it in ways other than wearing it on your face. Think about how you will put the mask on, when you might want to take it off or put it down, how you might reference it or even speak directly to it, making it part of

| **FIGURE 7.9** Painting the mask.

the performance (see figure 7.11). Remember that you need to find a way to let the audience see what is on the inside of the mask since that is part of the work. As you plan, reflect on everything you have learned so far. Think about Laban: As you paint, do you flick? Dab? Press? How does the body feel as you paint even something as small as the mask? This textbook is full of ideas for the monologue and the movement too.

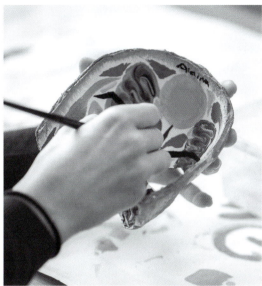

FIGURE 7.10 The inside of the mask is just as important as the outside.

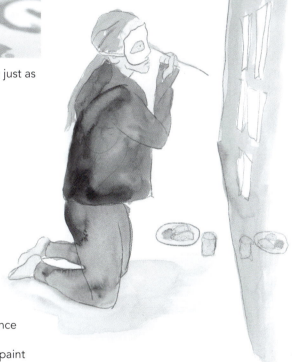

FIGURE 7.11 This was a final performance in which the student used the mask as a metaphor for how society expects us to paint ourselves with makeup.

EXERCISE **Formal Reflection**

The reflection for this project is a self-challenge: did you put thought and effort into this assignment? Did you incorporate theatre and your visual arts pieces in dynamic and theatrical ways to support this performance? Did you challenge yourself? How? Why?

CASE STUDY

The Crane Wife www

Barbara Carlisle's version of *The Crane Wife: A Folktale From Japan* (1994) was performed at Gonzaga University (see more on HK*Propel*). In the story, a man finds an injured crane, nurses it back to health, and lets it go. Soon after, he falls in love with a woman who suddenly appears at his door, and they are married. The woman weaves beautiful silk clothes for them to sell, on the condition that her husband will never watch her weave the cloth. They enjoy great success for a time, but the man grows greedy and demands that she weave more and more, and she weakens. When he can no longer contain his greed, he comes to observe her working and finds a crane in her place using its own feathers to make the fabric. When she notices him there, she flies away, and he is left alone.

Director's Reflection by Suzanne Ostersmith

Japanese cranes are not only a symbol of peace but also represent honor and loyalty. We were indeed honored to present this beloved Japanese folk tale in Gonzaga University's production of *The Crane Wife*. As director and choreographer, I was immediately drawn to the story because of its haunting beauty and clear struggle between greed, compassion, and love. Barbara Carlisle's script was particularly interesting to me because of the opportunity to use puppetry, dance, and ensemble work to tell the story. I have always had a fascination with Japanese theatre and culture. The students and I enjoyed visiting the Japanese Cultural Center at Mukogawa in Spokane, Washington, and receiving support and guidance from Seiko Katsushima, then a professor at Gonzaga University. Additionally, it was a blessing to get to immerse myself in research about **Kabuki** and Noh theatre and then pull elements that I found served this story best with my decidedly Western directional perspective. It was our hope that this ancient tale, artistic rendering, and original score composed by recent Gonzaga University theatre arts graduate, Jeff Rosick, would touch all audience members, young and old. The work of the ensemble showcased the power of the judgment that can come from one's community. The style was to physicalize the words, without prioritizing facial expressions to communicate meaning. Puppetry was an interdisciplinary approach to this production in that we used puppets as additional characters. In the end of the story, when the man checks on his wife and she is a crane that flies away, we created this massive crane that would be used by many dancers to represent flying. We also had several scenes where the villagers were an important part of the storytelling, and having many villagers had an impact on the section of the script. When she was a woman it was just her, but whenever she was the crane she was joined by the other dancers. We used puppets to make it feel like many people. Notice how the costumes are an interdisciplinary part of this design. When they expand their arms (see figure 7.12*a*) their costumes are reminiscent of a Japanese kimono and give the sense of wings. By using four dancers to represent the crane wife we were able to gracefully represent flying (see figure 7.12*b*). Each actor held a mask on the stick so that they each represented two people. They animated the masks, sometimes talking to the face or "listening" to it and reacting with their body (see figure 7.12*c*).

FIGURE 7.12 *(a)* The start of the story. You can see the storyteller in the pagoda, and the villagers are responding to the moment the crane wife is revealed. Then the performance moves back in time to tell the entire story. *(b)* Alyssa Harvey in the front portrayed the crane wife. *(c)* Masks were used in *The Crane Wife*.

Performer's Reflection
by Alyssa Harvey

"What an honor it was to play the crane wife at Gonzaga University. I remember the experience of creating the show to be collaborative, detail-oriented, and generous. We went on site visits to local Japanese gardens, a shrine; we ate together; and we rehearsed puppetry, dancing, and acting individually, and as a group.

Rehearsals required us to be open and active listeners, because the crane was composed of four individuals. Three dancers and I formed a cohesive unit, puppeteering the huge (and heavy!) crane puppet, making costume changes on stage (see figure 7.13), and dancing together. Our movement was grounded in text and informed by research, and performing was an emotional and moving experience for me. The first time we flew the crane onto the stage with an audience, I remember hearing an audible gasp from our audience. The crane was expansive and beautiful—unexpected and, of course, perfect for the show.

Including puppetry and dance made the play immersive not only for us as artists but also for the audience. Whether we were acting, dancing, or puppeteering, most importantly we were storytelling. The crane wife gave of herself in order to transform the life of her husband. The actors, crew, and creators gave of themselves to transform the audience. And the creator, director, and choreographer gave of herself to build a transformative experience for us. I'll never forget it!"

| **FIGURE 7.13** Costumes used in *The Crane Wife.*

Composer's Reflection
by Jeff Rosick

"Composing music for *The Crane Wife* was an exciting opportunity. It was one of the first creative processes I was able to have with a professor and senior storyteller in a way I hadn't before: it never felt like an assignment; it was a collaboration. After reading *The Crane Wife*, Professor Ostersmith introduced me to the rich celebration that is Japanese storytelling (e.g., Kabuki, folk tales) and guided me through her vision and feeling of the story, which quickly became a discussion. While dance and movement most often rely on a rhythm of some kind, we spoke of various story elements like themes, arcs, pacing, tone, and so on more with fluid words of emotion, color, and abstraction than with the rigid lexicon of music theory.

After researching and listening to some Japanese music and stage play cues that shared the tone for which Professor Ostersmith was aiming, I noticed in them and learned that the often-obvious and staple rhythms of Western music were far more sparse, if not completely absent. Again: Feeling. Emotion. Abstract. Natural. Silence was and is even its own instrument. It was also an exciting opportunity for me to put into practice many sounds and instruments (real and virtual) that I had gathered up until then. A simple wood recorder I had purchased at a Pike Place Market tourist shop in Seattle served as the score's main element. While it was not, unfortunately, specifically Japanese, it paved the way for my appreciation of the world's wondrous palette of music and its vast library of unique instruments.

Just as with collaboration, in general, developing the music for *The Crane Wife* was its own dance. Together, with Professor Ostersmith and her cast and crew, and through multiple rehearsals, music was added, subtracted, filled in, thinned out, and more. *Trying* to answer this question served as my guide: How do we create a score that supports the story structurally (e.g., scene transitions, specific scene underscore, etc.), while ensuring we celebrate the sounds, tone, musicality, and spirit of the story and its culture at the same time? It was a great learning experience—even to this day, by having been asked to reflect on it, years later—for which I'm grateful."

EXTENSION ACTIVITY

Visual Reflection

Attend a theatre performance, and watch how they use their facial expressions to convey meaning to the audience.

Journal Reflection

1. After attending a theatre performance, what did you notice about how visual arts and theatre can work together?

2. How do actors use their facial expressions to convey meaning to the audience? Discuss specific moments when you noticed that facial expressions really added to the performance.

3. How can you take this experience and apply it to your mask work?

Visual Reflection

Create a visual piece that relates to the show you saw and what you learned from it that you could add to your mask.

Journal Reflection

1. Reflect on the arts-based research you put into this project. What research did you use? Why did you do that research? Where did you find it? Did you just grab the first thing?

2. Reflect on the feedback you received. How did the feedback you received help shape the piece further?

3. How did making the inner and outer expression change the way you thought about your mask? Do you think you could do the same exercise with different art forms? What would that look like?

4. Write up another score with more detail with how the piece is shaping up. Detail how the show influenced this new score, or if it didn't at all.

Visual Reflection

Paint another version that expands on what you did in class. Paint about how you experience empathy with your family members, friends, professors, and so on.

Journal Reflection

1. How has this project changed your thinking about visual arts? How has this project changed your thinking about theatre?

2. Reflect on your performance. What did you learn from the performance as opposed to from the preparation? How did you learn it? How will you apply it to the next presentation and other parts of your life?

DISCUSSION QUESTIONS

1. Describe some reasons masks have been used throughout history.

2. Describe some reasons for using masks in theatre, including the neutral mask.

3. What other ways are visual arts incorporated into theatre?

4. Define the term *locomotor movement*.

CHAPTER 8

All Three Art Forms

After learning about all of the previous art forms and how they can work together to become interdisciplinary, it seems inevitable for you as a reader to wonder, *so what? I'm not going to be a student forever. How can I apply what I have learned in this course to my future career path? How can these ideas fit into the corporate world? The world of medicine? The nonprofit sphere?* No matter which career path you choose to take following graduation, or even other courses you take after this one, you can apply what you have learned in this course to all fields of study. One such student, Miranda Heckman (Senf), did just that as you will see in the case study.

This book was designed to help students think creatively, a skill desperately needed in order to be successful following graduation. Interdisciplinary arts emphasizes the importance of working within other fields to grow and push yourself to try new things and to think in new ways. If you were to apply interdisciplinary thinking to the world of medicine, you might realize how interconnected each form of medicine is with the others. A neurosurgeon might rely on an oncologist's knowledge to know when the best time is to go into someone's brain to extract a tumor after it has been shrunk with chemotherapy. A teacher might rely on a school counselor to know how to work with a student who has family issues at home that are affecting their schoolwork. An athlete might hire a nutritionist to find out how many calories and what type of nutrients they need to consume in order to train for an upcoming event. All these examples are interdisciplinary.

We are interdisciplinary people. Thus, the ways of thinking you developed while taking this course can be applied long after the course has been completed. In fact, you might use these ideas for the rest of your life.

Making Art Using the Human Intelligences

Throughout this book, you have encountered many ways that the activities, exercises, and concepts of interdisciplinary arts engage many of the human capacities, also referred to as **multiple intelligences** by Howard Gardner (1993). This is a potentially powerful part of interdisciplinary studies in that in engaging so many aspects of human expression, the arts can be leveraged by a wide variety of people across cultures and places where various intelligences are valued and prioritized in different ways.

Gardner's book *Frames of Mind: The Theory of Multiple Intelligences*, first published in 1983, changed the way modern psychologists and sociologists thought about intelligence. Rather than the intelligence quotient (IQ) measures that had grown in popularity up to that point and had come to be accepted as the standard way of expressing cognitive capacity in the West, Gardner put forth a more holistic view of human intelligence that involved multiple categories. After a time, he added the naturalistic intelligence to capture the human mode of engagement with the natural world.

Mainstream academia and schooling rely heavily on the first two intelligences listed below, so the study of interdisciplinary arts offers unique ways to engage with the other intelligences. Whichever capacities play to your strengths and those of your community, there are ways to use and extend your intelligences to solve problems and make meaningful art.

KEY TERMS

bodily–kinesthetic intelligence
Happenings
interpersonal intelligence
intrapersonal intelligence
linguistic intelligence
logical–mathematical intelligence
multiple intelligences
musical intelligence
naturalistic intelligence
spatial intelligence

ARTIST SPOTLIGHT: MERCE CUNNINGHAM

Merce Cunningham (1919-2009) was an inspirational dancer, choreographer, and interdisciplinary artist who pushed the boundaries of movement, music, visual arts, and theatre. Born in Centralia, Washington, he was educated at Cornish, where he experienced the power of studying multiple art forms. He innovated constantly and is best known for his collaboration with life partner and composer John Cage, whose music interacted with his dance and performance artistry throughout his life. Cunningham danced in Cage's work *Theater Piece No. 1*, a mix of piano, poetry, paintings hung on the ceiling, and recorded music, which is referred to as one of the first **Happenings**, a form of theatre performance art in which unpredictable, unscripted performance can take place. He developed the Cunningham technique, which is a form of movement training that engages the mind and body. The Merce Cunningham Dance Company, which he started in 1953, is an incredibly prolific company with a rich and varied history of physical performances and works that brought together visual artists, musicians, and artists in the realm of design. The Merce Cunningham Trust continues to stage and license his work and offer daily classes in the Cunningham technique. His ideas about the use of chance in art allowed movement to happen for movement's sake and pushed the boundaries of traditional dance, music, visual arts, and theatre. See www.mercecunningham.org.

Many of the activities so far in this book meet or engage with the multiple intelligences below, and examples from this book are included:

- **Logical–mathematical intelligence**: Scoring a dramatic text or poem; logical, step-by-step artmaking processes; theories such as color theory
- **Linguistic intelligence**: Working with dramatic language in a script; lyrical text such as poems; symbols in Bartenieff
- **Spatial intelligence**: Movement in theatre such as blocking, dance, and choreography; use of space in visual arts
- **Musical intelligence**: Use of music in rehearsal and performance processes for theatre and dance; rhythm in visual arts
- **Bodily–kinesthetic intelligence**: Movement in the theatre; dance and creative movement; physical aspects of visual arts such as painting and sculpture
- **Intrapersonal intelligence**: Journaling and reflection assignments throughout this book
- **Interpersonal intelligence**: Creating a collaborative team; generating a collaboration rubric; communication and meeting everyone's needs on a team
- **Naturalistic intelligence**: Responding to the natural world such as choosing an outdoor location for a performing arts project; using natural forms in visual arts; categorizing natural forces and phenomena

Logical–Mathematical Intelligence

This capacity begins in infants as they relate to the objects and physical world around them. As they explore and probe the items within their grasp and perceive their environment, young children begin to make connections and develop a sense of cause and effect (Gardner 1993, 129). Drawing from the work of the Swiss psychologist Jean Piaget, Gardner asserted that children's abilities to connect material objects with nonmaterial concepts is key to the adult capacity to show logical sequences and predict consequences in the mathematical and physical world. As young folks grow into adults, Piaget observed that they can map their concrete experiences of objects onto abstract expressions such as equations. Gardner also explored the "delights" of mathematicians, such as discovering new areas of the field or making connections and new analogies between types of information: "It seems evident mathematical talent requires the ability to discover a promising idea and then to draw out its implications." He also wrote, "At the center of mathematical prowess lies the ability to recognize significant problems and then to solve them" (Gardner 1993, 143). This work is at the heart of many activities in this book, including scoring a poem, using the mathematical aspects of music to score movement and text, observing the logical pro-

CASE STUDY

Dancing Spokane River, **Miranda Heckman, Biology Major** www

Dancing Spokane River: Teaching Science Through the Language of Dance and Theatre (see the video on HK*Propel*) was a project conceptualized by Miranda Heckman (Senf) '16, a biology major and dance minor. Miranda used dance, visual arts, and theatre to explore and communicate issues affecting the Spokane River Habitat to elementary-aged children. The project toured around Spokane, Washington–area schools and presented at the Opus Prize Awards Ceremony at the Fox Theatre in Spokane on April 16, 2014.

At first, Miranda wondered how combining her love of biology and the arts could be integrated into a performance that could educate children. This was a massive undertaking, but using the skills from this book, she dove in. First, she drew on concepts from each art form—visual arts, theatre, and dance. She engaged with theatre as a performer, knowing that embodying a story through acting can bring it to life. She studied renewable energy, dams, and the many ways organisms in the Spokane River are affected by humans. She began writing a monologue to reflect her findings. She developed her dance technique, including studies of performance and history. She asked how one can dance like a river and express the unhealthy elements of the habitat.

It was then time for her to take her findings and develop them further. She studied choreography to learn to create dances, developing this idea of teaching river science through dance and theatre. Her investigations took her next into theatre history and asking what different methods of storytelling have been used in theatre that could apply to a work about the Spokane River.

As the project was beginning to take shape, she then learned about stage management and what elements come together to create a successful production, and she asked how that correlates to the health of habitats. Pulling it all together with a script that complemented choreography and engaged an elementary-aged audience was the final stage. She and her team also did visual research to find out the colors and markings of the fish that she talked about in her script that are affected by pollution in the water. These colors and markings were then painted onto the fabric that was used as a costume element when they danced like the fish.

Miranda held auditions, cast the touring company, rehearsed, and finally toured to elementary schools and presented at various community events, including the Opus Prize Awards (see figure 8.1) and a research symposium on the Gonzaga University campus, where she articulated the experience and connections between her biology major and dance minor.

FIGURE 8.1 Heckman's *Dancing River* project at the Opus Prize Award Ceremony, 2014.

To further the experience of the elementary students, Miranda created lesson plans that met standards for the science curriculum and aligned with the performance for elementary school teachers to use in classes before and after the visits. Miranda is now a high school science teacher in western Washington.

gression of the Bartenieff developmental stages and their exercises, observing Laban's still forms in relation to the body, and the logical interrelations between the concepts of time, weight, and space.

Looking deeper into an example, figure 8.2 is an example of a scored song that exemplifies aspects of the logical–mathematical intelligence. Here we see how rhythm and movement are used in a mathematical sequence that follows the logic of the music.

ZagDance Concepts "The Sound of Sunshine" 3:45

One+ :23 woke why :52 sound 1:12 ch 1:23 vrs 1:35 <u>sound</u>

1 |||| 2 |||| || 3 |||| 4 || - 5 |||| 6 ||||

2:00 wanna go 2:28 sound 2:45 your 3:07 sound eh-

|||| | |||| |||| - |||| ||

1	General space	Place wave, clap hands on hips	2(8)
	Self-space	High knee run	(8)
	Size	4 ct. wiggle **small**, 4 ct. blow up **big**	(8)
2	Levels	Step-tog-step RL **middle high middle low**	(8)
	Direction	**Forward** swing up **back right left**	4 ct.
		up wave **down** squat (repeat)	(8)
3	Chorus	Open walk right diag, close back to start	(8)
		Point wiggle to ground, roll up (repeat)	(8)
4	Pathways	Curvy course left and upstage	(8)
		3 zigzag side together (RLR)	(8)
5	Focus and speed	Chaine left, clap and chaine, right clap	(8)
		Multi-focus **4ct.** multi-focus FAST **4ct.**	(8)
		Reach up and melt slow	(8)
	Rhythm	Slap ground twice, clap twice	(8)
		RL stomp clap twice RL clap twice	
6	Chorus	Repeat 3 chorus	

| **FIGURE 8.2** Scoring a song employs logical–mathematical intelligence.

In "Exclusion Score—Immigration," we see how the flow of movement using Laban's efforts is laid out by a student in order to show how each movement leads to the next one.

"Exclusion Score—Immigration"

She appears into a new place and surroundings, **pressing** away "curtains" into somewhere she has never seen

She gazes around, eyes **floating** until she sees the flag, and they **punch**

towards its direction—her head also **punches**

She jumps forward to grab it, arms **slashing** to try and gather it, but she cannot and stumbles back

She **glides** a leg back and walks heavily, then stops. Her head **punches** over her right shoulder as the flag holders **tap** her, then the same happens on the left

She **presses** her hands to her head and **glides** it around, before turning around quickly to grasp the flag, bringing her arms up into her and dropping to the ground with a **punch**

She stands up slowly, her hands **glide** to touch the "walls" of the box she is in, **pressing** against the front wall so she can go out the back

She steps back with her left foot, but her right foot is stuck—she struggles and yanks it out, then guiding it with her hands **glides** to spell "free," falling into a standing pose

Then, in a circular pattern, she **slashes** her arms to grasp the flag finally giving up when she comes to face front again

Then, the others with the flag put it down and pick her up by either arm, dragging her away as she kicks and **flicks**

EXERCISE **Layered Symbol Painting**

Paint a variety of numbers, equations, and symbols. Fill the canvas using a variety of colors, brush sizes, and shapes of the marks. Turn the canvas around so that there is not an up or down. Now add another layer and another. Allow it to dry fully, and spend some time stepping away and looking at the painting. How does all that information become a single image? It might look like a mess, but take a moment to think about how it can inspire a whole new image. Now with very watered-down paint (glaze), flow over the symbols capturing this new idea. Perhaps it is a landscape, a favorite symbol, or something more abstract.

Linguistic Intelligence

Gardner used the poet T.S. Eliot as the quintessential example of a person with advanced linguistic intelligence. Poetry and a facility with prose, narrative, or verbal expressions are easily identifiable as belonging to this category. Within interdisciplinary arts, the linguistic mode is often supported by other intelligences such as the support of the whole body in relation to using the voice. However, the words themselves are often not the whole story within a work of interdisciplinary art; they are just an important puzzle piece in a wider landscape of signifying modes. For example, poem analysis, position papers, reflection journals, and other writing assignments are great opportunities to express linguistic intelligence. The meaning of the words in a poem, and sensitivity to the way that the words in our reflections help to shape the way we remember our experiences, are also ways that language informs creative acts.

A creative example of expressing linguistic intelligence in interdisciplinary arts is in the writing of expressive, individual monologues. Here is an example of a student-written monologue that exemplifies linguistic intelligence in order to express personal emotions:

> Inside, my mind is racing; running through the steps. A kick, a step, make sure to point my toes on the leap, another step. I quickly tell the butterflies to stop fluttering up my throat, then I run through the beginning of the dance for the ninth time since I have been standing in the wings. I subconsciously wiggle my toes and stretch my calves while the worry if I put on enough lipstick is sandwiched between the wonder of who is in the audience and the reminder to keep a smile plastered on my face. I focus on visualizing myself hitting every move at exactly the right time. I am in warrior mode: determined to shine harder than any of my last performances.

> As the lights blackout and the finished dancers exit stage left, I still myself and my thoughts for a millisecond before I shift my face from warrior princess to outright princess. I walk on the stage, and my face shows calm. I emulate joy. I am having the time of my life on the floor. My dancing is effortless, and I am not even getting tired.

> Ow, my calves hurt; obviously, I didn't stretch them quite enough. Keep that smile going. Look at the audience here, and a head tilt here, and keep the core strong for the balance. The sweat dripping down my back is really obnoxious. Is my bra showing a little? Oh God, it is. It's okay, pretend like nothing is wrong and that the only thought in your mind is how happy you are to be dancing. Smile.

Spatial Intelligence

Gardner wrote, "Central to spatial intelligence are the capacities to perceive the visual world accurately, to perform transformations and modifications upon one's initial perceptions, and to be able to re-create aspects of one's visual experience" (1993, 173). Many of the activities in this book ask that you perceive your body as situated in a particular space and to think of visual and spatial aspects such as form, shape, line, and angle as inherent to the expressive movement of the body. Other examples from this book include making and manipulating masks, reframing paintings and using a frame to isolate portions of paintings, using fabric to create unique shapes, and the idea of creating pathways and shapes in choreography.

One key example of visual and spatial intelligence is the work on Laban's still forms. As part of preparing the movement pieces, you were encouraged to hold still at the beginning and end of the presentation.

Another fine example of spatial intelligence common to this work is the practice of yoga. As you have seen, Laban's still forms relate to various yoga poses. Spatial intelligence is required to cognitively map the forms onto the human body and then to translate this into movement you can do. For example, creating "swirls and shapes" and spatial forms in mask work (see figure 8.3). As you are able, experiment with spatial intelligence by holding the still forms in your mind as you engage your body in the poses, such as figure 3.2 in chapter 3.

A final example involves taking a concept such as "the thread that holds people together" and applying it to a physical object such as a colorfully dyed sheet. Here is a student's reflection that employs spatial intelligence (see figure 8.3):

Thursday's performances were all well done, but of the three (excluding my own) I felt that Erin, Madison, and Gracie's piece really stuck out to me. Their representation of the concept they chose and their use of the sheet to further that representation was inspiring. Depicting a slightly altered version of the Red Thread of Fate, Erin, Madison, and Gracie braided multiple strips of the fabric and tied themselves to each end so all three were connected to each other. The ancient concept depicts that whoever is at each end of the red thread are meant to meet and are destined to marry. Altering that theory, the group chose to represent friendships in place of marriage. I thoroughly enjoyed their piece because it was so relatable; anyone in any situation could relate to their story and understand the struggle of being connected to a group or even one person, losing that person(s), but never truly forgetting them. With the dyed, braided strands of the sheet the girls brought to life the theoretical thread that holds people together. By literally being tied together the group was able to accurately portray the ties of friendship, the ties of love and devotion to other people that can either strengthen over time, solidifying that bond, or hold people back from moving on. The group's story, however, showed that although friends can break away from the ones with which they spend time and become lost trying to discover who they are, no one is really alone; everyone always has a tie to someone else who is willing to reach out and accept them for who they are.

FIGURE 8.3 Melina's journal entry about her mask.

EXERCISE Positive and Negative Space Dance

Choose a movement partner. Face each other and decide who goes first. Warm up by mirroring each other's movement, taking a minute each to lead and eventually just letting the leadership flow from one to the other. Now take this spatial exercise further: one partner creates a shape and holds it. The other partner looks at the shape, thinking about the space the body takes up as well as the space the body does not take up. The shape of the body is thought of as positive space and the space around it as negative space. The partner then creates their own shape in the negative space, not touching the partner but creating their shape around them. The first partner carefully moves away from their partner to look at the new shape they have created. Now they can create their own new shape in their partner's negative space. Continue taking turns. Be careful not to rush this exercise, but take time observing and then creating a new shape. This can be a beautiful exercise to observe.

Musical Intelligence

Many individuals with highly developed musical intelligence discover or display their talents at an early age (Gardner 1993, 99). Musical intelligence can be expressed in creating or composing, appreciating, or performing music. The principal aspects of music and its appreciation are pitch or melody, rhythm, and timbre (the quality of a tone) (Gardner 1993, 104-105). The connections between music and the emotions, and also between music and mathematics, are nuanced. You might have noticed that when you listen to a certain kind of music, it can affect or change your mood; consider what happens to your body when you hear your favorite music versus being subjected to a type of music that makes you feel uneasy. The differences can be profound. In the case of musicians who are mathematically talented, that facility with numbers and patterns can aid in the composition and appreciation of highly complex music. In this book the opportunities to express musical intelligence have included the Bartenieff- and movement-based warm-up, choosing music for the dance and visual arts presentation and the theatre and visual arts presentation, and the experience of moving your body to music in the screen dances and less structured movement opportunities.

One thing to keep in mind when planning performances is to consider royalty-free music. You can make music yourself or research sources online that offer music that can be used without seeking the musician's permission. Rhythm can be used in many ways, such as creating your own recorded sounds and rhythms; strike the floor in as many ways as you can! Find natural sound sources and ways to incorporate sound that are freely available in your environment.

Creating music is a great representation of musical intelligence. This student created a music piece for one of the presentations, and it showed how aspects of tempo and rhythm can be employed (see figure 8.4).

FIGURE 8.4 *The Mask You Wear* updated score.

EXERCISE Rhythmic Poem Performance

Go back to your performance poem from chapter 5 or choose a new one and underline juicy words. Select five words on which to focus. Now take those words and repeat each word many times, exploring different levels of projection, saying them in a high voice or low voice, and playing with the tempo and intention of each word. Use repetition and different ways of saying the words to express the poem either with your original meaning or perhaps creating a new musical and rhythmic performance with new meaning.

Bodily–Kinesthetic Intelligence

This intelligence has a wide variety of uses and examples in the performing arts, particularly in dance, acting, musicianship, and the body when playing an instrument. In thinking about the fine arts, it is important not to neglect the bodily aspects—fine and gross motor skills—of painting and sculpting. Gardner identified two core aspects of bodily–kinesthetic intelligence: "control of one's bodily motions and capacity to

handle objects skillfully" (1993, 206). Every chapter of this book has engaged the body: dance, choreography, warm-ups, yoga poses, Laban's efforts and still forms, movement in the theatre and visual arts presentation, the dance and visual arts presentation, and the theatre and dance presentation. The poem project merged linguistic and logical intelligence with bodily–kinesthetic manipulation, and the screen dances offered a chance to move in ways that related to both the body and the inclusion of manipulable, and sometimes wearable, objects (see figure 8.5).

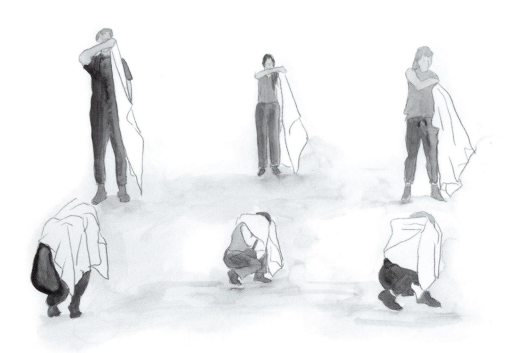

FIGURE 8.5 The inclusion of fabric can unlock new movements for performers. Illustration based on a screen dance.

EXERCISE **Travel Embodiment**

Decide on a country with which most in the class or group are familiar. Reimagine the room as the country, and discuss which direction is north, south, east, and west. Decide on a mode of transportation for your journey, and take a trip together. Visit various cities throughout the space, and create physical shapes of various activities one might do in that city. For example, together you could travel to Los Angeles and create shapes representing surfing; then another student could encourage everyone to go to museums in Washington, DC, and point in all directions to the amazing paintings on the wall; and then the group could continue on to Seattle where everyone learns to make a latte and they drink them together.

Intrapersonal Intelligence

Knowledge of the self, in terms of one's own feelings and sense of pleasure and pain, is key to the intrapersonal intelligence: "The core capacity at work here is *access to one's own feeling life—*one's range of affects or emotions" (Gardner 1993, 239). This is one of the main goals of any interdisciplinary arts endeavor; as we solve complex problems and express deeply felt emotions, we get to fully know ourselves. Through the process of choosing poems that speak to you, painting realities of body and soul, bringing out feelings and painting them onto a mask, planning the visual aspects of projects based on emotions, and delving into the connections between the inner and

outer expression of the self in the Bartenieff exercises, you have done research into the self in many modes and varieties of art.

The prime example of activities that express intrapersonal or self-intelligence are the journal reflection assignments peppered throughout this book. As you progress, you have had opportunities to stop and reflect, to see where your imagination has taken flight and also where you have struggled. Here is an example of a journal entry reflecting on a performance project.

> This project was an interesting mix of imagination and reality. When we decided to use our poems and integrate two different texts into them, I was unsure how I would make this work. I had become very attached to my poem and how I had performed it in the weeks prior. The story of someone being intoxicated and taking over a bar performance was ingrained into every word I was saying. We decided to change the efforts, and that changed the whole piece.

> I altered my Laban efforts to be slash, dab, and press. Making the primary effort be slash made me rethink my motives and the objective of the piece. I decided to focus on the internal emotions that a person would feel if they were dealing with a divorce or some major life change. I also thought about how or if they would express those emotions. I used my life and how I tend to work emotionally to guide me through this process. I found a poem that talked about fear and how it can rule your life. This felt right to me because fear is often why people do not express their emotions. Will people understand? Will I look silly? The other work I found was a written opinion piece. This work talked about the indifference that comes after a relationship ends and how to push through that.

> *1. Reflect on what you learned from your performance. What did you learn about using Laban's efforts in communicating? What did you learn about performing? What did you learn about the poem? What did you learn about yourself?*

> I think the Laban efforts are a great way of connecting intentions to actions. I think the efforts don't even necessarily need to be applied to dance, but also in art, speaking, or a person's disposition. I thought it was really interesting in class when we paired up with someone and said what we thought they'd be if there was a Laban effort that described them. During my performance, I think I made it not just a dance, but also like a monologue. The Laban efforts weren't just used in my movements, but in how my "character" acted and spoke.

> I think one thing I definitely learned about performing (at least for myself as a performer) is the importance of being in the right mental state before going out on stage. When I went up the first time, all I could think about was ,"What if I mess up my lines?" or "What if my dance isn't good enough?," which made me second-guess myself, and my mind kept blanking even though I knew the words and movements. When I stepped out in the hallway, I put on the music that had inspired me for this piece, breathed, and focused on what I wanted to convey. When I performed again, I tried my best to physically and mentally embody the person that I saw in this poem.

> Having a personal connection with your poem is huge, and I think that this poem spoke to my own flaws a lot. During some parts I didn't neces-

sarily need to act; instead I just let myself loose. For example, at the end of my performance when I held up my hands, I let them shake with nervousness instead of holding back.

2. Choose two of the performances we saw in class on Friday. Critically reflect on the performance. What did you see? What did you feel? What did you wonder?

The first performance I wanted to reflect on was *Sword*, done by Alaysia. Since I had also done this poem, it was interesting to see someone else's take on it. I saw a lot of quick movements like slashes and punches. In addition to just having elements of speed, directness, and weight, I felt like her moves told a story. I felt a sense of chaos and desperateness. It's interesting because these were things I wanted to convey in my performance too, but she seemed to take a different approach. In mine I think I was more of a heavy, somber desperateness, whereas hers was more frantic. For me, I felt like I was really able to connect with this poem and really became the person who was saying the poem. I wonder how Alaysia connected with this poem and what she thinks the person is saying. It also seemed like at the end she was a little more hopeful; I wonder if this was intentional and what the story behind that is.

Another performance I wanted to reflect on was *Clockwork Doll* done by Alexa. I saw a variety of different movements such as gliding/floating as well as punching. I thought she did a good job of highlighting the important moments by having a contrast between high emotion and low emotion. I felt the anger the speaker of the poem was trying to convey, especially when she used a long pause after "smashed me to bits." I wondered about what the meaning behind the poem was for Alexa; after she presented, she said she felt that the poem was about feminism and the expectation for girls to look put together and pretty. After hearing that, I thought about the poem differently and understood the emotions behind it.

EXERCISE **Doodle Worlds**

Begin with a blank canvas and a pen or paint. Close your eyes, and tune in to your body, mind, and heart and how you are feeling. Now begin a line, and don't take it off the paper or canvas, allowing it to move all over the space, crossing over itself. You can do big looping movements or sharp zig-zag lines, but just let what you are feeling create this pathway on the paper. When you feel like it, stop and look at the journey of the line in a new way. Look at the unusual shapes and spaces that are created. Think of each of those spaces as their own canvas. You can now paint or color each space in solid, create patterns within, or even capture a feeling or landscape. Do not pressure yourself to find a way for them to interrelate; allow them to each be what they are calling you to make them. Enjoy creating new worlds within this one drawing.

Interpersonal Intelligence

The second of the two "personal" intelligences "turns outward, to other individuals. The core capacity here is *the ability to notice and make distinctions among other*

individuals and, in particular, among their moods, temperaments, motivations, and intentions" (Gardner 1993, 239). A child who is adept at noticing their friends' feelings or an adult who is able to influence the behavior of a group might be displaying interpersonal intelligence (Gardner 1993, 239). Working with your peers, viewing and responding to peer performances, taking part in discussions and assimilating feedback all engage your ability to detect and respond to others' feelings. When you and your group created the collaboration rubric in chapter 6, you were planning to listen to one another carefully and to gauge how well you could interact with them. You might have been sensitive to another's emotions when you created a mask on another person's face; as you laid the strips of gauze on them, taking care to avoid the eyes and keep them comfortable, you not only made a mask, you made a connection with another human being. Anytime you work in a group, you have an opportunity to engage interpersonally, and the dance, theatre, and visual arts presentations invited you into a relationship with others that was itself an expression of the give-and-take of interpersonal intelligence.

EXAMPLE **Collaboration Rubric**

An example of the interpersonal intelligence is a collaboration rubric. Figure 8.6 shows how students planned and listened to one another throughout their project. The collaboration rubric also shows how students worked with one another, which is a key aspect to the interpersonal intelligence.

Rubric for Evaluating Collaboration and Communication

Because I am only observing your process from the outside, I am not in the best position to evaluate your leadership and communication skills. Therefore, you will be evaluating each other according to the rubric below.

Instructions: Fill out a separate rubric for each collaborator in your small group. (Do not fill one out for yourself.) In each row, circle the description that *you* feel is most appropriate. **When filled out, return this rubric directly to me. I will keep the results confidential.**

Person completing the evaluation:_____ Student A_____

Person being evaluated: _____ Student B_____

4	3	2	1
Routinely provides useful ideas. A definite leader who contributes a very strong effort.	Usually provides useful ideas. A strong group member who contributes a good effort.	Sometimes provides useful ideas. A satisfactory group member who does what is required.	Rarely provides useful ideas. Might refuse to participate.
Shares ideas effectively, clearly, and without being prompted. Communicates before taking action that will affect group decisions.	Can usually share ideas effectively and clearly; sometimes needs to be prompted. Communicates before taking action that will affect group decisions.	Has difficulty articulating ideas or does so only when prompted. Sometimes takes action without first communicating with the group.	Does not share ideas. Takes action impulsively without seeking input from the group, or does not participate.

> continued

> continued

4	3	2	1
Takes an active role in being sure that all group members understand the discussion. Frequently restates ideas in alternate ways.	Makes an effort to ensure that their own contributions to the group dialogue are understood. Can restate their own ideas if necessary.	Demonstrates an awareness of others' level of understanding but struggles with knowing how to help. Might have difficulty restating ideas in a different way.	Does not take a role in helping others follow the group dialogue.
Provides work of the highest quality.	Provides high-quality work.	Provides work that occasionally needs to be checked or redone by other group members to ensure quality.	Provides work that usually needs to be checked or redone by others to ensure quality.
Uses time well throughout the project to ensure things get done on time. Group does not have to adjust deadlines or work responsibilities because of this person's procrastination.	Usually uses time well but might procrastinate occasionally. Group does not have to adjust deadlines or work responsibilities because of this person's procrastination.	Tends to procrastinate but usually gets things done by the deadlines. Group does not have to adjust deadlines but might occasionally shift work responsibilities because of this person's procrastination.	Rarely gets things done by the deadlines *and* group has to adjust deadlines or work responsibilities because of this person's inadequate time management.
Listens to and supports the efforts of others. Gives constructive feedback that is mindful of others' feelings.	Usually listens to and supports the efforts of others. Gives feedback but sometimes tries to take over or "solutioneer."	Sometimes listens to and supports the efforts of others. Might provide some generalized feedback but does not offer constructive or specific comments.	Rarely listens to or supports the efforts of others. Does not comment or only comments negatively on others' work.
Takes an active role as a mediator or facilitator when conflict arises within the group.	Will listen to all sides when there is conflict; encourages peers to listen to each other.	Stays out of the conflicts of others. Is willing to accept mediation when involved in a conflict.	Is passive in the face of conflict; might initiate or encourage conflict between others.
Routinely monitors the effectiveness of the group and takes an active role in making it more effective.	Sometimes monitors the effectiveness of the group. Will accept suggestions and work to make the group more effective.	Occasionally monitors the effectiveness of the group and passively goes along with efforts to make the group more effective.	Rarely monitors the effectiveness of the group and does not work to make it more effective.

Is there anything else you would like me to know about the communication or collaboration skills of the person you're evaluating?

| **FIGURE 8.6** Sample rubric.

Adapted from a rubric by Deanna L. Zibello, used by permission.

EXERCISE **Movement Conversation**

Partner with someone, and have a conversation—not with words but with movement. Allow one to begin the conversation by moving while the partner observes carefully. Then respond physically by saying something with your body. A conversation can be held in lots of ways. For example, you might want to repeat what your partner physically said before adding on something new, or you might ask a question with your movement. See what happens if you disagree physically, get into an "argument," or when you physically let them know that you like them and appreciate them. Explore doing this with different-sized groups.

Naturalistic Intelligence

Responding to the natural environment is a skill some people express as a keen sensitivity to the flora, fauna, and processes of the earth. Gardner identified this intelligence later; it does not form part of his initial categories in *Frames of Mind*. You might have friends who are particularly good with animals or who have a green thumb and are great with plants. Naturalistic intelligence, sometimes called *nature intelligence*, is defined as "the ability to make consequential distinctions in the world of nature as, for example, between one plant and another, or one cloud formation and another (e.g., taxonomist)" (MI Oasis). Making distinctions is critical to the practice of interdisciplinary arts, because the artist is fundamentally one who makes choices among possible media, forms, colors, and modes of expression in order to refine the visual, verbal, and corporeal piece they are creating.

The site-specific dance film created in the visual arts and dance chapter is an ideal expression of interacting with the environment (indoor or outdoor) in order to respond to what is there (see figure 6.15). Another example from your work in this book is your investigations into color theory and visual thinking strategies, because these opportunities require making careful distinctions and identifying distinguishing features.

EXERCISE **Outdoor Inspiration Dance**

Go outside and take a moment to stand in one place and observe all the elements of nature around you. Even in the middle of a city you can respond to the air, sounds, smells, and what you are standing on. Begin to move, responding to the various stimuli around you. Embody the sounds of leaves, texture of grass, shape of trees, and so on. Create a movement sequence from these inspirations. Go inside or to a new place, and repeat the movement sequence, seeing if you can continue to capture the outdoor elements through your movement and expression.

EXERCISE **Sort Your Own Experiences** www

Using the multiple intelligences described above and your own experiences throughout your work in this book, respond in your journal (see figure 8.7 for an example).

Intelligence	In what assignments, projects, or exercises were these intelligences used in this course?
Logical–mathematical intelligence (sees patterns; logical reasoning)	
Linguistic intelligence (facility with language and meaning; learns languages easily; good with verbal communication)	
Spatial intelligence (strong spatial relations skills; able to relate physical objects and movements)	
Musical intelligence (facility with musical instruments and/or singing; can keep rhythm and perceive pitch and tone)	
Bodily–kinesthetic intelligence (strong motor control; able to connect concepts to physical forms)	
Intrapersonal intelligence (can access, name, and interpret personal emotions in a positive fashion)	
Interpersonal intelligence (perceives other people's affective signals; able to work productively with others and help them reach their goals and those of the group)	
Naturalistic intelligence (responsive to nature and the environment)	

| **FIGURE 8.7** Gardner's multiple intelligences adapted for this interdisciplinary arts course.

Multiple Intelligences Synthesis Assignment

The study of interdisciplinary arts expands a student's problem solving, critical reflection, and innovative thinking by combining the strengths that theatre, dance, visual arts, and music provide. The work you have done up to this point in the book provides you with a solid foundational knowledge of these art forms. This synthesis assignment, in which you will develop your own creative process and carry out a multistep project, will allow you to integrate valuable arts-based research experience into your own skill set, increasing your creative capacity and expressiveness. If you are a STEM (science, technology, engineering, or mathematics) major and you choose to integrate research from that area of interest into this project, you will be incorporating the arts (the letter A), transforming STEM into STEAM.

An interdisciplinary approach provides the flexibility many students need to craft their arts education, combining multiple fields in the arts and synthesizing their expe-

rience. The main learning outcome for this project is for students to see themselves as creative and capable of expressive and empathetic inquiry. This project provides the opportunity for students to synthesize the work done in interdisciplinary arts with another field of study, perhaps in your major or minor or another subject that interests you. You will have the chance to reflect on connections to the other subject or your chosen field of study.

In this project, you will engage in the four-step process you have implemented in previous chapters of this book, with a few additional components as you synthesize three art forms (theatre, dance, and visual arts) with the human intelligences. The process follows:

1. *Arts-based research:* Create thumbnail sketches, conduct visual research or imagery, develop a concept and create an abstract, present early ideas
2. *Assimilation of feedback, development, and rehearsal:* Draft a production schedule; set benchmarks; document conversations with an expert in the other field such as a professor or advisor from your major or another area of interest; rehearse and produce the piece, filtering feedback from peers and your instructor as you develop and refine your performance
3. *Presentation:* Gather an audience; present and perform
4. *Postperformance reflection:* What did you learn? How did you learn it? How will you apply it?

This final synthesis could result in many different types of synthesis projects. Please refer to the case study at the end of this chapter for an in-depth example. For now, here are a few examples of what might be possible:

- Touring production using the art form of dance to teach about the science of the Spokane River
- Visual arts installation of anatomy
- Interdisciplinary performance on your campus or venue in your community
- Presentation in major department (some students might fulfill requirements in their other major or degree program with elements of this assignment)
- Book of images presented through a rotating slideshow in a public setting

EXERCISE **Arts-Based Research**

Get into groups to brainstorm how you can combine aspects of your previous projects to create this synthesis. Discuss the theatre and dance project, the dance and visual arts project, and the theatre and visual arts project. Then, look at the chart you filled out about the multiple intelligences (see figure 8.7). How might you leverage your areas of strength to produce a new project that combines and synthesizes your experiences with your chosen intelligences you would like to explore further or develop? After your discussion, complete the written reflection.

JOURNAL REFLECTION (www)

1. Explain the different aspects of each unit you want to bring into this final project.
2. Start a rough idea of what you think this project could look like to you.

VISUAL REFLECTION

1. Start a new visual score with your first thoughts about how you see this project flowing.
2. Talk about what kind of music you want to incorporate into this project. What are some visuals and sounds that inspire you for this project? Draw or score aspects of the music or sounds you might like to use.

EXERCISE Assimilation of Feedback, Development, and Rehearsal

OUTLINE YOUR PROJECT PLAN

If possible, participate in a coaching session to go over the outline of the project with your instructor or a mentor whom you trust. After sharing your ideas, complete the following writing assignment.

JOURNAL REFLECTION www

How did the coaching session help you? What are you changing or keeping the same after the coaching session?

VISUAL REFLECTION

Create a new visual score to finalize your piece and where you see it going.

JOURNAL REFLECTION www

1. What have been the hardest challenges of this assignment? What have you loved about this assignment?
2. Why did you decide to do this project either by yourself or with others?

EXERCISE Presentation

You will need to gather an audience. Perhaps you are presenting as part of a course or inviting peers or members of your community to see your work. It is possible that the first audience for this piece will be your instructor and your class. In that case, it will be helpful to think about information the audience might need to help them appreciate the work to the fullest extent possible. What might be helpful for your audience to learn about your work before they see it? Are there any ways you can incorporate necessary information into the work itself so that explanations of any kind are not needed? Finally, it might be possible to invite people whose feedback or perspective you value, even if they are not part of your regular group or class. Check with your instructor about whether it would be allowed to invite others to your presentation or whether you could show this work in a location more friendly to an outside audience such as a community center in your area. Expanding your

reach and gathering your audience is often done by using a live-streaming service or recording your work on a mobile device to show to those whose opinion you value. Think about who the audience is for your piece, and make appropriate arrangements. Remember that if you are going to record your work or if it will appear online, you must secure everyone's permission first and ensure that the music and material you are using is appropriately handled regarding copyright.

EXERCISE Postperformance Reflection

Reflect on each group or person's piece and how they balanced all the concepts in their final piece.

JOURNAL REFLECTION

Which one of your classmate's pieces was your favorite? How did it make you feel? What did you learn from their project that you might not have thought about before?

VISUAL REFLECTION

Create a visual reflection of yourself and how you have grown this semester with performance as evidence.

JOURNAL REFLECTION

1. Write about what grade you would give yourself on this project if you were grading yourself.
2. Reread your early development writings. What was your goal with this project? Did you achieve what you set out to do, or did you achieve something else? Why?
3. *Suggestion:* Include two typed pages reflecting on your process and one page of the score of your text, music, and movement.

CASE STUDY

Beautiful Weapons

In the spring of 2018, dance and interdisciplinary arts director Suzanne Ostersmith and biology professor Brook Swanson toured the Gonzaga Repertory Company with *Beautiful Weapons*, a 45-minute dance and spoken-word piece about how biology and dance could come together to teach the audience about science in a new way. Ostersmith and Swanson employed the art forms of dance and visual arts to express research on biodiversity and weaponry in animals including fiddler crabs (see figure 8.8). Narrated by a biology professor and performed by six Gonzaga University dance students to music composed by a student, the costumes mimicked the colors and function of fiddler crab claws. The silk skirts and large claw props were made of hand-painted silk. The inspiration for the project came from team teaching a first-year seminar called the Art and Science of Dance (see Swanson and Ostersmith 2021).

FIGURE 8.8 Dancers showing the art and science of fiddler crab anatomy in *Beautiful Weapons.*

In the final assignment, students were placed into small groups, chose a scientific topic to research, and then articulated their findings in a dance they choreographed and performed. The success of this assignment came from using research and creative inquiry. Some challenges of this project included its touring performance at biology seminars to biology professors, students, and performing arts professors and students. Touring to a variety of universities and performing on a variety of stages were welcome challenges. The choreography needed to express the animals and characteristics without becoming characters, and the narration and movement needed to be true to biology. Ostersmith is incredibly proud that their work succeeded. The postshow discussions were rich, and the general response of the work was very positive. She was also very proud of the way the Gonzaga community responded with great enthusiasm, and the work was even invited to present as part of a Dean's Forum.

Some of the students provided feedback about being part of the tour, saying, "I plan to tour every other year with the Gonzaga Repertory Dance Company now that I fully understand the benefit to the students, the audiences, and my creative inquiry. This is a manifestation of my beliefs in the power of interdisciplinary work."

The entire tour was about promoting interdisciplinary work and showing how science and dance can work together to teach students and audiences in new ways. The dancers here are showing animal anatomy interpreted in dance, while Swanson gives a performance-lecture about the physiology at work (see figure 8.9).

FIGURE 8.9 Brook Swanson (center) and students in *Beautiful Weapons*, Gonzaga University.

DISCUSSION QUESTIONS

1. Describe three achievements of Merce Cunningham, using online sources. Which human intelligences did he display in each achievement?

2. Give an example of the logical–mathematical intelligence used in the field of dance.

3. What is the difference between intrapersonal and interpersonal intelligences? Describe a scenario in which each would be helpful.

4. Before the exercise in this chapter, had you ever danced outdoors? How does being outside change your energy?

CHAPTER 9

Make Art, but Also, Go See Art!

KEY TERMS

critical reflection
horizons of expectation
New Criticism
phenomenology
reader-response criticism
semiotics

Daily life provides many opportunities to make art. How you arrange food on a plate can be an artistic act. How many brilliant ideas have been sketched out on a paper napkin? But even as you continue to make art and engage in creativity in your life, seeing the art that others have made offers many benefits.

Part of developing your skills as an interdisciplinary artist is to practice **critical reflection**. After reading this book, you now have skills you can engage in performance criticism and critical thinking. In this chapter, you will observe the work of other practitioners. Afterward, you will reflect on questions such as the following: How did an actor employ Laban's efforts to make a character more dynamic? (Even if the artist is not aware of Laban's terminology, you can still observe the efforts at play in any artwork.) How are Bartenieff's Fundamentals at play in a choreographic work? In looking at a painting, before you focus on the details, ask yourself the big overarching questions, such as, What do I see? What do I feel? What do I wonder? And as you have studied in this book, you can use these sample methods for each of the art forms with questions such as the following: How did that artist use various Laban's efforts in their mark-making or paint strokes? How did the actor engage Bartenieff's developmental progression? Were they just performing in upper-lower? When looking at a dance work you can ask yourself, What is going on in this dance? What do I see that makes me say that? What more can I find? (www.vtshome.org) Each of these methods of critically reflecting or engaging is applicable to each art form.

Theorists and practitioners of critical reflection have structured the work of critical response in many ways. In this chapter, you will learn to employ practices drawn from many sources, including Patrice Pavis ("Theatre Analysis: Some Questions and a Questionnaire"), Liz Lerman (https://lizlerman.com/critical-response-process/), and Visual Thinking Strategies. As an audience member, you have an active role in deciding how to structure and communicate your own response. What you see, feel, and wonder during and after a performance or viewing of an artwork might be in response to the work alone, or you can endeavor to learn more about the artist's intentions by reading program notes, attending pre- and postshow discussions, reading statements by the artists, and sometimes even asking the artist directly.

Theatre Criticism

Starting with critical response for theatre, it is important to touch briefly on some terminology from the field of **semiotics**. Building on the work of formalist linguistics of Ferdinand de Saussure, semioticians interpret "signs" (units of meaning) as comprised of two parts: a "signifier" such as a word (e.g., the word *tree*) and what is "signified" (i.e., what it means or stands for, such as the tree itself). This kind of work is applied to theatre when the observer or critic looks for the "signs" (e.g., the text, gestures, design elements) and interprets what they mean, what is "signified" by them. Patrice Pavis developed a questionnaire, published in *New Theatre Quarterly* in 1985, that divides the theatre experience into sections (general, scenography, lighting, props, costumes, actors' performances, music and sound, pace, story, text, audience,

notation, "what cannot be put into signs," and others). This questionnaire is very helpful for organizing your thoughts after seeing a production. It might remind you of the ancient Greek philosopher Aristotle's *Poetics*, in which he divides the elements of performance into the six areas of plot, characters, theme, diction, music, and spectacle, defined in chapter 2. These make great structuring areas for a review. In any critical reflection about a work of performance or visual art, you might find it helpful to develop your own categories for what you saw and address or reflect on each area one by one, coming at the end to a synthesis or holistic statement of what the combination of elements means to you (see figure 9.1).

FIGURE 9.1 Signs are everywhere. Meaning is all around us, and we take these meanings into the theatre with us as spectators and critics.

EXERCISE **Applying Theatre Theory to Visual Arts**

Find a painting online or in a museum (or on a museum's website) that engages you. Critically reflect on how it engages you in terms of Aristotle's *Poetics*: what can you see in the painting that shows elements of plot, characters, theme, diction, music, and spectacle? Rephrase these concepts if it helps you to be specific in how you view the work.

EXERCISE **Attend Theatre**

The theatre is everywhere, from big-city professional to community productions. Be broad in your definition, expansive in what you might consider theatrical performance. Consider the work of technicians and designers as well as that of the performers (see figure 9.2). Whether it is a professional or volunteer theatre production, much can be gained from attending and thereby supporting the work. The empathetic response an audience feels from being in the same room as the actor going through the experience on stage is different from watching on a screen. When the actor breathes, the audience breathes with them.

FIGURE 9.2 Technicians and designers create the experience for the audience in unseen ways. What can you perceive of their work?

JOURNAL REFLECTION

As discussed in chapter 2, theatre is made up of many different art forms, from acting to costume to scenic to lighting design. You can develop your own system of categorizing what you experience; use Aristotle or Pavis's lists of elements as a guide, adapting it for the performance you saw. Consider taking notes surreptitiously during the performance and solidifying your thoughts by discussing with your seatmate at intermission. Consider asking yourself or a fellow audience member these questions as you reflect:

1. What did you see? What did you feel? What did you wonder?
2. What about specific characters did you find particularly interesting or gripping?
3. What did the actors do to embody their character?
4. Which of Laban's efforts might you see in the work?
5. What about Bartenieff's Fundamentals?
6. How did the integration of theatre, dance, and visual arts tell the story?
7. How did the production succeed in synthesizing the various art forms into an effective whole? Or not? How might you improve the production?
8. With any critical review of a performance, it is important to articulate your feelings (subjective responses) and support for your perspective (objective analysis).

Visual Art Criticism

Since early civilization, human beings have been making marks and interpreting them, from cave hieroglyphics to masterpieces in the Louvre. The development of visual language, of translating our experience of our world and environment into forms, is ancient and a part of who we are as a species. We use pictures to communicate

with those who share our experiences, and we leave them for future generations. As an interdisciplinary artist, developing your own language for observing and interpreting visual arts is an important way of integrating new ideas that you might want to use in your own work. Many modes of talking about art have already been established. One that might be of use to you is Visual Thinking Strategies (VTS) as developed by Abigail Housen and Philip Yenawine (https://vtshome.org/founders/). These practitioners have been foundational for how artworks, primarily paintings but also others, are viewed and discussed in educational settings around the world. When viewing a painting or work of art (and in VTS workshops specific images that suit the process best are carefully chosen), challenge yourself to answer these questions: "What is going on in this picture? What do you see that makes you say . . . ? What more can you find?" (https://vtshome.org/daily-image/). Typically, these questions are asked in a group setting by a trained VTS facilitator, but you can certainly ask yourself these questions as you ponder a work and develop your thoughts for a written critique. This is about slowing down, putting your eyes on the canvas or artwork for a longer period, diving deeper as you look within the work. This kind of reflection is linked to **reader-response criticism** in literary studies, an approach that includes the observer or reader in the creating of meaning (as opposed to **New Criticism**, a viewpoint that holds that meaning is held within the work independent of a viewer). Meaning is therefore tied up with the context in which it is viewed, the process of reading or observing, and what happens in the observer when the artwork and the observer interact or transact (Bressler 1999, 68). This is also interpreted as being related to **phenomenology**, a field of philosophical inquiry that emphasizes the receiver of a work in directly constructing its existence. The writings of Hans Robert Jauss and Wolfgang Iser are helpful here, Jauss for his view that a reader or viewer will create their own **horizons of expectation** based on their historical context. What is your horizon of expectation, or your unique situation from which you view a work of art? What do you bring with you into the museum or gallery that forms the lens through which you see the work? For Iser, the work is inextricable from the mind that interprets it, from the consciousness or worldview that the person brings with them (Bressler 1999, 72). As you view a work, you "concretize" it by filling in the gaps between your own experience, knowledge, and the work itself (see figure 9.3). As you view a work of art, you create its meaning. What do you see?

FIGURE 9.3 Looking at a work brings both the artist and the viewer into connection.

EXERCISE Visit Galleries and Art Museums

Seeing pictures of art in books or online can be inspiring, but no matter how high the duplicate image quality is, there is nothing quite like being in the presence of an original. By being able to move side to side, light catches on color and brushstrokes in ways only possible to view in person. Sculptures become the three-dimensional pieces they are designed to be when observed by taking them in from all angles, moving around the piece so that its true texture, shine, and color become apparent. But perhaps the most striking aspect of viewing art in person is its scale. While reproductions typically list the actual size of a work of art, seeing things in their full scale changes your physical orientation to the piece and creates a visceral response.

For example, take a look at the Art Institute of Chicago's website to see Georges Seurat's painting *A Sunday Afternoon on the Island of La Grande Jatte* (www.artic.edu/artworks/27992/a-sunday-on-la-grande-jatte-1884). It might be familiar to you, because this image appears on countless gift cards and mugs in circulation. A quintessential example of interdisciplinary arts, this painting was used as inspiration for a piece of musical theatre, *Sunday in the Park With George* by Stephen Sondheim. The musical is about the artist himself (fictionalized for the story) and how he gets into the mindset and physically paints this glorious piece of art. The piece won the Pulitzer Prize for Drama in 1985 and other honors such as Tony Awards for its design aspects. You can find excerpts from performances online, which will give you a sense of the interrelation between visual arts, music, theatre, and movement that come together. If you take the museum's video tour (https://artic.edu/videos/19/georges-seurats-a-sunday-on-la-grande-jatte-art-institute-essentials-tour) you can see museumgoers in front of the painting and have a sense of its true size and scale. If you imagine standing before something of that size, you might empathize with how the artist's body would have reached and extended to make it. Or perhaps you find yourself standing straighter as you look at the woman with the black parasol.

Observe what you have learned about movement through space and how that language can be applied to what you see in this painting. What are the pathways that people engage in as they enjoy the beautiful day in the park? Think about the gallery experience of viewing this painting as well: What are the pathways that people engage in as they enter and navigate a gallery space? Look at (or imagine) the ways the space is organized and how the art is hung and placed.

If you are in the museum, try to avoid looking at the label until you have spent some significant time looking at the work and making your own observations. Can you only look at the art and avoid looking at the label altogether? Look at the images that are next to each other or in the same room, and imagine how they could be connected. Once you are able to reflect after taking the image in, imagine further (see figure 9.4). If you were asked to create a narrative tying together a number of images, what stories or relationships come to your imagination?

FIGURE 9.4 Making connections and relationships between observations that seem distinct can open new pathways in your imagination.

Dance and Movement Criticism

The artist and practitioner Liz Lerman created a critical response process that is helpful for both responders and creators in developing effective feedback. The book she published with John Borstel, *Liz Lerman's Critical Response Process: A Method for Getting Useful Feedback on Anything You Make, From Dance to Dessert*, guides the reader in establishing their role in the observation process and provides four steps for giving feedback. This is normally conceived as a verbal process done in person with the collaborators and observers sharing together, but as a student of interdisciplinary arts you might find it helpful to draw on these steps when responding to your peers' work or when working with partners. First, the observers share their experience and what was meaningful in what they just saw. Then the artist asks questions about areas in which they would like feedback, followed by neutral questions from the responders. Finally, the artist may grant permission for the observers to give their opinions on certain aspects of the work, or may say they do not want feedback on some areas. See https://lizlerman.com/critical-response-process/ and Liz Lerman's book for more detailed information to guide you in the nuanced process of delivering and receiving effective audience response. Attending dance and responding to it engages your mind and body (see figure 9.5)

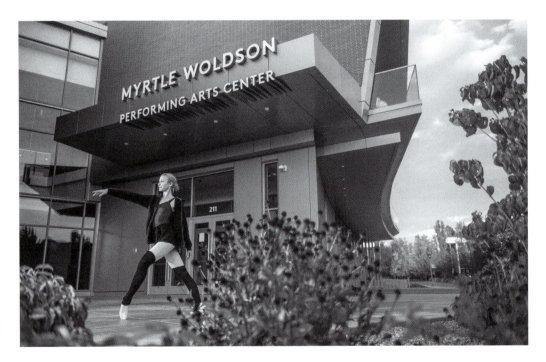

FIGURE 9.5 Attending dance develops your ability to give and receive feedback.

EXERCISE Attend Dance

Search your area's arts sites and cultural centers for works by dance companies or studios in any style of dance. Scour the websites for both the major and minor venues in your area for works of dance. If you live in a large metro area, you might have many professional dance companies to choose from, including contemporary, modern, classical, or world dance companies. Touring companies often visit from out of town, and you can find performance dates by looking at the local performing arts centers' websites and publications.

However, if you live in a place where live dance is not readily available, you could watch a smaller studio's culminating performance. There are many end-of-the year recitals for dance studios, which could be a great opportunity for you to see a local, live dance performance.

No matter where you live, there are many options available to view on the Internet, but live dance offers you so much more. If you are somewhere where dance performance is very difficult to find, it might also be helpful to broaden your thoughts about dance performance. What is dance? Movement? What if you went to a busy park or airport and watched the dance of humanity engaging in life? You could learn and reflect on the timing of the people, the weight they carry, and how they are oriented in space (see figure 9.6). While this is not a dance performance in a specifically structured way, it is a dance of sorts that you can use to employ the various theories in this book.

FIGURE 9.6 Dance that takes place in unconventional spaces can help us understand space, such as the use of verticality in this image.

JOURNAL REFLECTION

First things first: Do not bother wasting your time trying to "get" something. Large historic story ballets are designed to use dance to tell a story, much like theatre but without the words. Pantomime is used to physically express the narrative. But that is only one approach to the art form. Some companies and dance pieces are athletic feats and can be enjoyed for just respecting what the human body is capable of. Others are perhaps abstractions of an intention, feeling, or idea. Others yet might truly be movement for movement's sake. All have a place in our human experience, and if you are able to enter the dance performance with an open heart and mind, rich narratives can grow for you that are totally different from the intention of the choreographer. That is okay. The key thing is, again, the empathetic response and inspiration that comes from witnessing the creative act. Ask yourself these questions:

1. What did you see? What did you feel? What did you wonder?
2. What kind of training might it take to be able to dance like that?
3. Which of Laban's efforts did you see at work, and did you see contrasting dynamics?
4. What did you observe about the use of Bartenieff's developmental stages or fundamentals?
5. What does the title of the work tell you, or what questions does it bring up?
6. What is going on? What do you see that makes you say that? What more can you find?
7. How did you feel as you watched and after? What is going on with your breath, your muscles, your forehead?

EXERCISE **Concepts From Interdisciplinary Arts**

Go back through this book and find 10 concepts or vocabulary words that intrigue you. Draw from the various chapters to come up with a list that is truly varied and interdisciplinary. Then, looking back on your notes and reflections from attending theatre, dance, and visual arts, apply the concepts in a sentence for each term, trying to be as interdisciplinary as possible (i.e., use visual arts terms to describe theatre, dance terms to describe what you saw in the gallery, theatre terms to describe dance, and so on). What new connections does this allow you to make?

EXERCISE **Seeing Like an Interdisciplinary Artist**

Visit a museum that has a collection with which you can spend some time. Move around the space until you find a work that connects to a piece you have created during your interdisciplinary arts journey in any way you sense the connection; it could be the way the brushstrokes move on the page, or the subject in the image. Select a painting that connects to your work somehow. Spend time in front of the painting with your journal. First, just write what you see and the connections you are making with your own work. Do not stop to judge or improve this part; just write. Then, take a break and just look at the image again. At that point, complete written and visual reflections using the following prompts:

JOURNAL REFLECTION

Answer the following questions in relation to the piece of your choosing:

1. What is going on in the image?
2. What do you see that makes you say that?
3. What more can you find as it relates to your final presentation?

VISUAL REFLECTION

Sketch the image. Then, on top of the image, add strokes that invoke the past work you have been thinking about. Can you augment your sketch to include elements of that prior work? For instance, can you add strokes that invoke a sense of lightness or heaviness, or that are sudden or sustained, matching your work to the

qualities of weight and time you perceive in the image? Use terminology from this book and from your past work to inspire you as you sketch (see figure 9.7). What are the strengths of this new image? Write in your journal about what you would do to take this forward into a new work of art if you were to pursue this project.

| **FIGURE 9.7** Sketching frees the imagination to make new connections.

JOURNAL REFLECTION

1. Have you ever visited an art museum before? When and why or why not?
2. What was it like visiting the museum?
3. How did sketching the piece at the museum change the way you saw it?
4. Write notes on the back of the page about what aspect of the image drew you in.

VISUAL REFLECTION

Insert your sketch from the museum visit. Add to it, continuing to develop the image as you sketch. Feel free to go back and visit it again to add to what you started before. How does the passage of time change how you see both images, the one from the museum and your own work?

Conclusion: Interdisciplinary Arts as a Way of Life

Engaging in interdisciplinary arts to develop creative acts and innovative thinking certainly applies to most fields and are some of the greatest qualities sought out by employers today. Engaging in interdisciplinary arts is also an opportunity to create a life well lived by being more observant, leaning into wonder, color, and movement.

Laban's efforts, when employed in theatre, create more dynamic characters, in dance allow the body to be used more fully for expression, and in visual arts can loosen the hands and give a freedom to the mark-making. As people mature, it is easy to become more directly focused rather than using indirect focus. Take driving, for example: as a driver, it is necessary to scan the area around you to be a defensive driver and be open to all that is going on around, not just on the road. If you are not paying attention to the task at hand, that is not good either. Life and art require a prioritization of focus but also an ability to blur the eye and take in many perspectives.

Taking the driving analogy further, you can keep life interesting by breaking up habits. Perhaps you always go to school or work on the same pathway. But what happens when you take a new route? You see things differently, and you are perhaps more present, maybe even arriving at your destination more refreshed and ready for what life has to offer. Interdisciplinary arts teach this as well. While one person might be comfortable with theatre, another might prefer painting or dancing to express themselves, and taking the time to explore in an art form that is less comfortable to you can be like driving a new way to work.

These skills of perception and observation as a performer can also help you become more attuned to body language and thereby perhaps make for more satisfying relationships.

Seeing the world through the eyes of an artist helps you to appreciate form, color, and light, bringing back a sense of wonder like a child.

Getting out of our comfort zone and taking artistic risks fosters healthy creative risk taking in other ways.

Listen, speak, sing, wiggle, dance, move, doodle, observe, smile, frown, breathe, be present. Rather than pooh-pooing the arts, celebrate, engage, encourage, and support. The world will be a better place, and *your* world will be a better place.

APPLICATION ACTIVITY

Review a Performing Arts Production

Performance Review Guidelines

Students are required to attend a performing arts production and write a review of the integration of concepts from theatre, dance, and visual arts.

Note-Taking

Take notes surreptitiously (please) during the performance but mainly directly following the production. Write down your impressions, observations, and feelings about the elements of theatre, dance, and visual arts; successes; failures; ways to improve; specific performers; specific numbers; specific movements; connections to class; and so on.

Content of Paper

This paper will be a combination of your feelings (subjective responses) and support for your perspective (objective analysis). A successful paper will select some aspect of the show and analyze how theatre, dance, and visual arts influenced that aspect, moment, or section. The paper must make clear connections with the performance and the theories and practices studied in class. How did the production succeed in synthesizing the various art forms into an effective whole? (Or did it not succeed?) How might you improve this interdisciplinary artistic production? What did you observe from Laban, Bartenieff, color theory, and so on?

Structure

This review should accomplish the following:

_____ /10	Be at least two to three pages long, typed, double spaced, free of grammar and spelling errors with a catchy title
_____ /10	Have a clear *beginning*, where you state your point of view and what elements you are going to focus on
_____ /20	Articulate the *middle*, where you show the evidence of your perspective
_____ /10	Have a strong *end* to reiterate your point of view and leave me with a clear sense of your impressions and connections to class

EXTENSION ACTIVITY

Interdisciplinary Arts Study Guide and Application to Your Own Life

On HK*Propel*, you will find a list of terms for this activity. Apply them to the table also provided on HK*Propel*. Be creative in how you write about what these concepts have meant to you in the class and how you can employ them in your own life. The experiences you have had in this course and the learning you have undergone will mean so much more, and you will remember it so much more vividly, if you apply what you have learned to your own life.

DISCUSSION QUESTIONS

1. What are the two components of a sign in semiotics? Provide an example of each. Give an example from something you can see from where you are right now as you answer this question. Signs are all around you.

2. Describe the influences on your current horizons of expectation. What is your unique situation from which you see the world?

3. Who are Liz Lerman and Patrice Pavis, and what system of observing performance did they each develop? Give an example of how each system might be used to give feedback to artists.

4. You have had many opportunities to observe artists and their work. What are the skills needed for making good observations when critiquing art?

GLOSSARY

acting—The act of portraying and performing a character.

actions—How the characters physically carry out their objective.

aerial/atmospheric perspective—Using light and colors to create haziness or making distant objects indistinct.

Alexander Technique—A process of unlearning physical habits that are detrimental to the body in favor of good use; developed by Frederick Matthias Alexander.

art nouveau—A style of art that focuses on expressive organic lines; defined as a fusion of structure and ornament.

asanas—Postures and positions of the body in the practice of yoga.

aside—Text directed away from the normal flow of a conversation to a specific hearer or to the audience.

Bartenieff fundamentals—Movement concepts developed in the 1960s and 1970s by Irmgard Bartenieff (1900-1981), deriving from the developmental stages of human beings in utero through adulthood.

bits—Term for a small section of a script; interchangeable with "unit."

blocking—The movement of performers on the stage.

bodily–kinesthetic intelligence— In Gardner's terminology of multiple intelligences, the ability to employ the body as a whole or as individual members to achieve particular goals (https://multipleintelligencesoasis.org/the-components-of-mi). Examples include movement in the theatre, dance, and creative movement; physical aspects of visual arts such as painting and sculpture.

body half—Connecting the left side of the body to the right side.

body shape—In dance, the shape of the body is used to convey the intent behind the dance and express the emotions and ideas behind the movement.

breath—Respiration; the taking of air in and out of the lungs, processing oxygen and releasing carbon dioxide to sustain life; an important foundation for the spoken word and the moving body.

cast—The group of actors in a theatre production.

characters—One of Aristotle's six elements of drama; the people or figures who appear or are important in a play.

chiaroscuro—Technique that contrasts light and dark.

choreographer—The collaborator on an artistic process involving movement who is responsible for crafting the specific movements of the performers.

color palette—The combination of hues and values to develop the visual look of the piece, the emotions it is intended to evoke, and the ideas it stimulates.

complementary colors—Colors that are opposite each other on the art wheel: red and green, blue and orange, and yellow and purple.

compositional form—A key part of choreography; any method of composing movement.

contrast—The juxtaposition of seemingly disparate elements within movement in order to provide visual and emotional interest; the visual opposition of elements in art.

core—The center of the body; the muscles around or just below the belly button.

core–distal—The relationship between the center of the body (the muscles around or just below the belly button) and the body's extremities (fingertips and toes).

costume designer—Responsible for imagining and creating the costumes for performers.

costumes—Clothing and accessories that actors wear in order to take on the character in the appropriate period.

critical reflection—The ability to look back at your experiences, analyze them, and combine the new acquired knowledge with previous knowledge to create meaning to use in the future.

cross-lateral—The connection diagonally across the body, from the left upper side to the right lower side, or the right upper side to the left lower side.

dance—Dance styles are systems of organized movement. These words (*dance* and *movement*) are sometimes used to differentiate the field of dance with its subgroups of genres (e.g., ballet, tap, jazz, modern, folk, social)

dance theatre—Works that employ movement techniques from formal dance in order to tell a story or engage with a social issue.

developmental progression—Describes basic movement patterns that are developed at a young age in humans and continue into adulthood. The developmental progression that leads to the most complex pattern are: breath, core–distal, head–tail, upper–lower, body–half, and cross-lateral connectivity.

diaphragm—The muscles at the bottom of the chest cavity and top of the abdominal cavity that assist with breathing.

diction—Pronunciation and verbal articulation; also, one of Aristotle's six elements of drama, the style of a play, whether it is verse or prose, and use of rhythm and type of speech.

direct—Movement that travels toward a target, like an arrow.

direct address—When an actor speaks to the audience.

director—The person typically at the helm of a production, serving as the decision maker and lead conceptual artist for each production's distinct take on the play or story. The director interprets the work of the author or playwright.

distal ends—The fingertips and tips of the toes that are the extremities of the limbs.

dramaturg—Theatre research assistant.

dress rehearsal—One of the final steps before an opening show and includes all elements, such as costumes, makeup, lighting, and sound being rehearsed all together.

dry brush painting—A technique that uses a dry brush dipped in paint to create a broken line effect rather than a pure line of paint.

dynamics—The relationship between time elapsed and the level of energy.

effort—One of the key concepts found within Laban's other foundational ideas on the body, shape, and space. Efforts are impulses to move that are expressed as attitudes and behaviors within the following factors: time, weight, space, and flow. The effort factors of time, weight, and space combine and can be expressed in eight actions, called the eight efforts, which are punch, slash, flick, dab (or tap), press, wring, float, and glide.

ensemble—The group of performers involved in a performing arts production; a group of performers that can include actors, dancers, singers, musicians, and other types of artists with special skills depending on the requirements of the production.

exertion-recuperation—The natural cycle of the body, and when either is ignored, the body can become out of balance.

feedback—Information from others about how they perceive your work.

form—The structure of the elements that comprise an image or object and the way they are configured.

found art—Using materials from your environment to create art.

frame—The border around an art piece.

function-expression—One of Bartenieff's (2002) fundamental principles, which holds that a strong, functioning, articulate body is more capable of expressing itself.

gas lighting—A lighting style that uses burning gas as a fuel source.

gels—Colored plastic sheets placed over a light fixture to create different-colored lighting effects.

given circumstances—The situation in which the production is taking place; outside influences that the performer does not control.

glaze—A transparent or light use of paint to create a thin film on the canvas or paper. Glazes are great for creating atmosphere, the sky, or soft variations in skin tone.

Happenings—A form of theatre performance art in which unpredictable, unscripted performance can take place.

head–tail—The connectedness of the head to the base of the spine, and the fundamental connection of the spine to the rest of the body.

heavy—Movement that has a strong resistance, as though fighting against gravity or an outside force.

high-level movements—Include lifts, jumps, and reaching the arms and legs far above the head or up and outward from the body.

horizons of expectation—Your unique situation, perspective, and lived experiences that influence how you view art.

hues—The term used to describe colors.

impasto—The thick layering of paint onto a canvas. Sometimes artists even use palate knives to scoop up dollops of paint onto the "knife" and smear it in thick plops on the canvas.

impulse—A drive from within; an idea or feeling that compels one to move, act, or create.

indirect—Movement that is flexible, expansive, without one point of focus.

informance—An educational performance.

inner-outer—Bartenieff's (2002) principle that our inner impulses manifest themselves in our outer movements, postures, and ways with which we use our physical instrument.

intent—Similar to the concept of *objective* in theatre, intent is the desires that motivate and drive the movements of the body.

interdisciplinary—An adjective describing the deliberate inclusion of practices from more than one subject area simultaneously; it is a way of knowing and of seeing the world from more than one perspective.

interpersonal intelligence—In Gardner's terminology of interpersonal intelligence, the ability to fully communicate with others (sometimes called social intelligence). Examples include creating a collaborative team; generating a collaboration rubric; communication and meeting everyone's needs on a team.

intrapersonal intelligence—Knowledge of the self, in terms of one's own emotions and sense of pleasure in pain. In Gardner's terminology, "access to one's own feeling life" (1993).

intuitive painting—A field of visual art making that prioritizes the process over the product.

isolation—Using one area or part of the body at a time, either with stillness or with movement.

Kabuki Theatre (Japan)—Plays and dance-dramas that began as early as 1603 by a female dancer, Okuni, who popularized the form; it continues to this day.

kinesphere—The area directly around the body.

kinesthetic—Movement or sensory experience relating to the world through the body and the senses.

Laban/Bartenieff Movement Analysis—A way of looking at human movement using the elements of body, effort, shape, and space. Bartenieff built upon Laban's work with effort and space and infused his ideas with her holistic view of movement, creating a system of perception that went through several iterations, including Labanalysis and Laban Movement Analysis.

Labanotation—A system of dance notation developed by Laban (1960) that features a musical staff and a complex system of markings to denote the movements of the body in a dance or other sequence.

level—A movement term to denote whether the mover's position is low, medium, or high in three-dimensional space.

light—Movement that indulges effortlessly in the moment; has a delicate or fine touch.

line—A continuous strip of color, ink, or marking that can be straight or curved or take any number of shapes.

linear perspective—The technique of bringing converging lines together in the distance (background) of a painting.

linguistic intelligence—In Gardner's terminology of linguistic intelligence, the sensitivity of the meaning of words, such as sound, rhythms, and inflections. Examples include working with dramatic language in a script; lyrical text such as poems; symbols in Bartenieff.

locomotor movement—Moving from place to place, such as walking, running, crawling, and so on, moving the body from one location to another.

logical–mathematical intelligence—In Gardner's terminology of logical-mathematical intelligence, the capacity to conceptualize the logical relations among actions or symbols. Examples include scoring a dramatic text or poem; logical, step-by-step artmaking processes; theories such as color theory.

low-level movements—Emphasize a connection to the earth, moving close to the ground, but also from a standing position with lunges and pliés that bring the legs and body closer to the ground.

medium-level movements—Include standing upright and moving on a plane that is more or less a conventional standing position; much of the traditional postures of classical ballet include the dancer with their torso on the medium plane.

method of physical actions—A theory and method of performing created by Kostantin Stanislavski regarding analysis of the physical movement in performance.

mirror work—Rehearsing in front of a mirror; helpful for developing your relationship to your own image and awareness.

mise en scène—Creating the illusion of locations other than where the movement is taking place can involve multiple art forms. The making of a look for a performance is the mise en scène.

monochromatic—A variation of one hue used in art.

monologue—Longer speech by a character, often directed at the audience.

movement—A function of the human body necessary to survival and expression, which includes dance but also a range of somatic (*soma* means "body") and therapeutic practices designed to maximize the human physical experience.

multiple intelligences—A term used by Howard Gardner in his book *Frames of Mind* and elsewhere to talk about human capacities.

musical intelligence—In Gardner's terminology of musical intelligence, the sensitivity to rhythm, pitch, meter, tone, melody, and timbre. Examples include use of music in rehearsal and performance processes for theatre and dance; rhythm in visual arts.

musical theatre dance—Training of dancers within theatre studies, including movement for performers and the study of dance for musical theatre.

naturalistic intelligence—In Gardner's terminology of naturalistic intelligence, ability to make consequential distinctions in the world of nature. Examples include responding to the natural world such as choosing an outdoor location for a performing arts project; using natural forms in visual arts; categorizing natural forces and phenomena.

neutral mask—Developed by Jacques Lecoq, plain face covering that allows performers to learn to express emotions through movement of the body instead of relying mostly on facial expressions and words, developed by Jacques Lecoq.

New Criticism—Viewpoint that holds that meaning is held within the work independent of a viewer.

Noh Theatre (Japan)—A stylized and refined performance form rooted in Zen Buddhism, with characters such as ghosts, demons, or humans who find no peace from being drawn too much to the physical world.

notation—Also known as scoring, a written progression of the sounds, musical notes, and movement, as used in music.

objective—The character's desires.

palette—A flat board, typically in a round or oval shape, that artists use to place and mix paint.

pathways—A term used in dance to describe the way the artist makes their way across the floor and through space. If you were to paint a dancer's feet before they start, the tracks along the floor would show the paths, or pathways, taken by the dancer, and the choreographer plans these routes as part of the choreographic process.

performance art—An artistic practice that can take many forms, including aspects of theatre, dance, visual and sculptural elements, location-based work, and audience participation.

personal uniqueness—Individual touches and self-expressions that bring richness into movement.

perspective—The way artists give a sense of distance, of forms being near to and far away from each other.

phenomenology—A field of philosophical inquiry that emphasizes the receiver of a work in directly constructing its existence.

plaster-infused gauze—Rolls of flexible fabric net wrapping that contains plaster that can be formed when wet and dries hard; used in creating crafts, masks, and for bandages.

playwright—The author or creative artist who has written, developed, or curated the script.

plot—One of Aristotle's six elements of drama; the events and actions of a play.

presentation—Sharing your ideas and your work with others in an organized, prepared fashion.

production manager—The person who works with the stage manager, director, technicians, and designers to ensure all elements needed are completed on time, within the given budget, and safely.

projection—The art of ensuring your voice fills the performance space and that you can be heard even in the back rows. This comes from proper understanding of voice and control over your breath and diaphragm.

proprioception—Body awareness; for instance, knowledge of the position of your head in relation to your spine, awareness of your shoulders and how they connect to your fingertips, and so on.

props—Short for "properties," this refers to all the things that are laid out in front of the actors that help bring the world to life, such as a tea set or specific furniture.

reader-response criticism—An approach that includes the observer or reader in the creating of meaning.

reflection—Looking back on the strengths and weaknesses of your work.

rehearsal—Practice run-throughs before the official production.

rhythm—The number of beats within a certain division, such as a measure.

scenic designer—Artistic designer responsible for creating the sets, or the physical world of the play.

score—Breaking a script or piece of work into more manageable chunks.

screen dance—A combination art form involving film (video) and dance.

semiotics—Based on the work of formalist linguistics of Ferdinand de Saussure, semioticians interpret "signs" (units of meaning) as comprised of two parts: a "signifier" such as a word (e.g., the word *tree*) and what is "signified" (i.e., what it means or stands for, such as the tree itself).

sfumato—A way of painting that blends tones and colors together instead of using harsh, defined outlines or boundaries.

soliloquy—An internal dialogue that the audience witnesses, but it is not addressed to them or to anyone else.

space—We interact with space by making contact with the floor and changing the position of the body within the air.

spatial intelligence—In Gardner's terminology of spatial intelligence, ability to conceptualize and manipulate large-scale spatial arrays. Examples include movement in theatre such as blocking, dance, and choreography; use of space in visual arts.

stability-mobility—During any one movement, the elements of stabilization (equilibrium and balance) and mobilization (activity and motion) occur.

stage business—The activity the actor engages in while portraying a character.

stage electrician—The person in charge of the lighting and other electrical duties needed for a production.

stage manager—The person in charge of the physical aspects of a production, who helps the director and is in charge during the production.

stipple—A dab or tap of paint onto a canvas.

storytelling—A method of human communication that can take many forms, usually comprised of a beginning, middle, and end, and often containing a conflict and resolution.

sudden—Movement consisting of slow speed and a sensation of a short span of time, or a feeling of momentariness.

sustained—Movement consisting of slow speed and a sensation of a long span of time, or a feeling of endlessness.

talkback—Postshow discussion between the audience and members of the producing company.

technical director—The person responsible for overseeing the technical elements of a production.

tempera paint—A type of paint historically made by mixing a pigment with an egg yolk or oil; now a cheap, water-soluble paint option popular for crafters and beginner artists.

texture—The physical feeling or appearance of paint on a canvas (e.g., smooth, thick, raised).

theme—One of Aristotle's six elements of drama; what a play or work of art is about, or its main concepts or messages.

time—How long a movement lasts.

total-body connectivity—Bartenieff's (2002) principle that all parts are connected and react to each other.

transdisciplinary—*Trans* means "across"; transdisciplinary knowledge is created by both academic and nonacademic practitioners working side by side.

trunk show—A production that is scaled down to travel with a small amount of scenery, costumes, and props.

upper–lower—The connection between the top and bottom halves of the body, divided at the core.

value—How light or dark a color is.

vaudeville—A style of theatre originating in France involving the use of mime, dialogue, dance, and song; typically comedic.

voice—Important tool for an actor in order to tell a story and portray a character.

warm-up—A process to engage the mind and body that can be repeated before creative work begins.

yoga—A somatic and spiritual practice with roots in spiritual and physical training of the mind and body. There are many different forms including hatha yoga, which is popular in Western cultures as a form of physical wellness and exercise, and pranayama, breathing exercises that purify the mind and spirit.

REFERENCES

PREFACE

Boostrom, R. 1998. Quoted by Arao, Brian, and Kristine Clemens. 2013. "From Safe Spaces to Brave Spaces: A New Way to Frame Dialogue Around Diversity and Social Justice." In *The Art of Effective Facilitation*, edited by Lisa M. Landreman, 135-150. Sterling, VA: Stylus Publishing.

Frodeman, R., Thompson Klein, J., and Pacheco, R.C.S., eds. 2017. *The Oxford Handbook of Interdisciplinarity*. 2nd ed. Oxford: Oxford University Press.

Gardner, Howard. 1993. *Frames of Mind: The Theory of Multiple Intelligences*. 10th anniversary ed. New York: Basic Books.

Housen, Abigail, and Philip Yenawine. "Our Founders." Visual Thinking Strategies. Accessed July 14, 2021. https://vtshome.org/founders.

Sternberg, R. 2008. "Interdisciplinary Problem-Based Learning: An Alternative to Traditional Majors and Minors." *Liberal Education* 94 (1). www.aacu.org/publications-research/periodicals/interdisciplinary-problem-based-learning-alternative-traditional.

Ulbricht, J. 2005. "Toward Transdisciplinary Programming in Higher Education." In *Interdisciplinary Art Education: Building Bridges to Connect Disciplines and Cultures*, edited by M. Stokrocki, 17-30. Reston, VA: National Art Education Association.

CHAPTER 1

Frodeman, Robert. 2017. "The Future of Interdisciplinarity." In *The Oxford Handbook of Interdisciplinarity*, edited by Robert Frodeman, Julie Thompson Klein, and Roberto C.S. Pacheco, 3-8. 2nd ed. Oxford: Oxford University Press.

Hackney, Peggy. 2002. *Making Connections: Total Body Integration Through Bartenieff Fundamentals*. New York: Routledge.

Haynes, Deborah. "A Proposition." *M/E/A/N/I/N/G* 17 (1995): 50-54.

Lee, Teresa. 2002. "Alexander Technique and the Integrated Actor: Applying the Principles of the Alexander Technique to Actor Preparation." In *Movement for Actors*, edited by Nicole Potter, 65-72. New York: Allworth Press.

Park, Glen. 1998. *A New Approach to the Alexander Technique: Moving Toward a More Balanced Expression of the Whole Self*. Freedom, CA: The Crossing Press.

Wahl, Colleen. 2019. *Laban/Bartenieff Movement Studies: Contemporary Applications*. Champaign, IL: Human Kinetics.

CHAPTER 2

Bain, Terry. 2017. "Tell Me About the Trees." In *WA129: Poems Selected by Tod Marshall: State Poet Laureate, 2016-2018*, 10-11. Spokane, Washington: Sage Hill Press.

Berry, C. 1992. *The Actor and the Text*. London: Virgin Books.

Castro, Guillén de. 2019. *The Force of Habit*. Translated by Kathleen Jeffs. Liverpool: Liverpool University Press.

Hackney, P. 2002. *Making Connections: Total Body Integration Through Bartenieff Fundamentals*. New York: Routledge.

McGaw, C., Stilson, K.L., and Clark, L.D. 2007. *Acting Is Believing: A Basic Method for Beginners*. 11th ed. Boston: Wadsworth.

Merlin, B. 2007. *The Complete Stanislavski Toolkit*. London: Nick Hern.

Ostersmith, S. 2018. *A New Season*. Unpublished performance script for performance. Spokane, Washington.

Pepiton, C.M. 2019. *Romeo ∞ Juliet Redux*. Unpublished typescript. Canton, NY.

Stanislavski, C. 1989a. *An Actor Prepares*. New York: Routledge and Theatre Arts Books.

Stanislavski, C. 1989b. *Creating a Role*. New York: Routledge and Theatre Arts Books.

Thomas, C. 2002. "Breathe Before You Act." In *Movement for Actors*, edited by N. Potter, 85-95. New York: Allworth Press.

CHAPTER 3

Adrian, B. 2002. "An Introduction to Laban Movement Analysis for Actors: A Historical, Theoretical, and Practical Perspective." In *Movement for Actors*, edited by N. Potter, 73-84. New York: Allworth Press.

Ambrosio, N. 2016. *Learning About Dance: Dance as an Art Form and Entertainment*. 7th ed. Dubuque, IA: Kendall Hunt.

Bartenieff, I. 2002. *Body Movement: Coping With the Environment*. New York: Routledge.

Hackney, P. 2002. *Making Connections*. New York: Routledge.

Hall, D. n.d. "Graphic Notation: The Art of Visualising Music." David Hall. Accessed June 1, 2020. http://davidhall.io/visualising-music-graphic-scores/.

Laban, R. 1960. *The Mastery of Movement*. London: MacDonald and Evans.

Lerman, L. 2014. *Hiking the Horizontal: Field Notes From a Choreographer*. Middletown, CT: Wesleyan University Press.

Newlove, J. 1993. *Laban for Actors and Dancers*. London: Nick Hern and New York, NY: Routledge.

Sofras, P. Anderson. 2020. *Dance Composition Basics*. 2nd ed. Champaign, IL: Human Kinetics.

Stamoolis, Leslie. 2019. "The Fabric of 'A New Season.'" Gonzaga University News, Events & Stories. www.gonzaga.edu/news-events/stories/2019/4/5/stamoolis-costume-design-a-new-season.

Wahl, C. 2019. *Laban/Bartenieff Movement Studies: Contemporary Applications*. Champaign, IL: Human Kinetics.

CHAPTER 4

Bowley, F. 2016. "Mini Lesson With Flora Bowley: 5 Ways to Begin a Painting." YouTube video, 3:44. www.youtube.com/watch?v=aNojnc4x78I.

Capitolo, R., and K. Schwab. 2005. *Drawing Course 101*. New York: Sterling Publishing.

Cassou, M. 2010. "Point Zero Insights and Images." YouTube video, 0:58. www.youtube.com/watch?v=aMG1YeTpmOw.

Gelb, M.J. 1998. *How to Think Like Leonardo da Vinci: Seven Steps to Genius Every Day*. New York: Random House.

Hurley, D. n.d. "Your Guide to Intuitive Painting in 5 Easy Steps." Dominique Hurley Intuitive Art & Inspiration. www.dominiquehurley.com/guide-to-intuitive-painting/.

Shakespeare, W. 2007. *Macbeth*. In *William Shakespeare: Complete Works*, edited by Jonathan Bate and Eric Rasmussen. Basingstoke, UK: Macmillan and The Royal Shakespeare Company.

Sporre, D.J. 1996. *The Creative Impulse: An Introduction to the Arts*. 4th ed. Upper Saddle River, NJ: Prentice Hall.

CHAPTER 5

Barone, T., and Eisner, E. W. 2012. *Arts-Based Research*. Thousand Oakes, CA: SAGE Publications.

"Biography." n.d. Pina Bausch. www.pina-bausch.de/en/pina/biography.

Lerman, L. 2014. *Hiking the Horizontal: Field Notes From a Choreographer*. Middletown, CT: Wesleyan University Press.

Marshall, T. 2009. *The Tangled Line*. Marfa, TX: Canarium Books.

Schearing, Linda. 2015. *Weaving Our Sisters' Voices*. Unpublished script for performance. Spokane, WA: Gonzaga University.

"Talking About People Through Dance—Pina Bausch Biography." n.d. Pina Bausch Foundation. Accessed November 6, 2020. www.pinabausch.org/en/pina/biography.

CHAPTER 6

Adrian, B. 2002. "An Introduction to Laban Movement Analysis for Actors: A Historical, Theoretical, and Practical Perspective." In *Movement for Actors*, edited by N. Potter, 73-84. New York: Allworth Press.

Newlove, J. 1993. *Laban for Actors and Dancers. Putting Laban's Movement Theory into Practice: A Step-by-Step Guide*. London: Nick Hern.

Laban, R., and Ullmann, L. 1960. *The Mastery of Movement*. London: MacDonald and Evans.

Ostersmith, S. 2012. "Temporal Desires." YouTube video, 3:41. www.youtube.com/watch?v=-qelxYN-nNEU.

CHAPTER 7

Balzani Loov, Jacob. "In Burkina Faso: FESTIMA, a Festival of African Masks." *Al Jazeera*, March 13, 2016. https://aljazeera.com/gallery/2016/3/13/in-burkina-faso-festima-a-festival-of-african-masks/.

Blakemore, E. 2020. "Why Plague Doctors Wore Those Strange Beaked Masks." *National Geographic*, March 31, 2020. www.nationalgeographic.com/history/reference/european-history/plague-doctors-beaked-masks-coronavirus/.

Brockett, O.G., and F.J. Hildy. 2008. *History of the Theatre*, 10th edition. Boston: Pearson Education, Allyn and Bacon.

Carlisle, B. 1994. *The Crane Wife: A Folktale From Japan*. Woodstock, IL: Dramatic Publishing.

Chan, M. 2009. "The Magic of Chinese Theatre: Theatre as a Ritual of Sacral Transmogrification." *Change and Innovation in Chinese Opera: A Post Conference Publication*, edited by Cai Shupeng, 144-164. Singapore: National Heritage Board.

Diakhaté, O., and H.N. Eyoh. 2017. "The Roots of African Theatre Ritual and Orality in the Pre-Colonial Period." *Critical Stages/Scènes critiques*, July 6, 2017. www.critical-stages.org/15/the-roots-of-african-theatre-ritual-and-orality-in-the-pre-colonial-period/.

École internationale de théâtre Jacques Lecoq. Accessed October 8, 2021. www.ecole-jacqueslecoq.com/.

Eldredge, S.A., and H.W. Huston. 1978. "Actor Training in the Neutral Mask." *The Drama Review* 22 (4): 19-28. https://doi.org/10.2307/3181722.

Hiltunen, S.M.S. 2004. "Transpersonal Functions of Masks in Nohkido." *International Journal of Transpersonal Studies* 23 (1): 51-64. http://dx.doi.org/10.24972/ ijts.2004.23.1.50

Hufferd, M.L. 2007. "Carnaval in Brazil, Samba Schools and African Culture: A Study of Samba Schools Through Their African Heritage." Master's thesis, Iowa State University, 2007. https://lib.dr.iastate.edu/rtd/15406.

Markandu, S. 2014. "Jacques Lecoq." *Facciocose*, January 23, 2014. www.facciocose.co.uk/blog-articles/jacques-lecoq.

National Geographic Society. "Dia De Los Muertos." *National Geographic*, November 9, 2012. www.nationalgeographic.org/media/dia-de-los-muertos/.

Saeji, C.B. 2012. "The Bawdy, Brawling, Boisterous World of Korean Mask Dance Dramas: A Brief Essay to Accompany Photographs." In *Cross-Currents: East Asian History Culture Review* 2 (2): 439-468. Berkeley: University of California Berkley.

Welte, S. 2017. *Masked Venice Unveiled: The Venetian Art of Identity Construction*. Studien aus dem Münchner Institut für Ethnologie [Working Papers in Social and Cultural Anthropology]. Munich: Institut für Ethnologie, Ludwig-Maximilians-Universität München.

Zechner, S. 2016. "10 Fascinating Cultural Masks From Around the World". *Western Union*, July 19, 2016. Accessed November 4, 2021. https://www.westernunion.com/blog/cultural-masks-of-the-world/.

CHAPTER 8

"The Components of MI." n.d. MI Oasis. Accessed October 11, 2021. www.multipleintelligencesoasis.org/the-components-of-mi.

Gardner, H. 1993. *Frames of Mind: The Theory of Multiple Intelligences*. 10th anniversary ed. New York: Basic Books.

Swanson, B., and S. Ostersmith. 2021. "Moving Toward Engagement: Teaching Collaborative Dance and Science Classes to First-Year College Students." *Journal of Dance Education*, published online February 19, 2021. https://doi.org/10.1080/15290824.2021.1876237.

CHAPTER 9

Bressler, C. 1999. *Literary Criticism: An Introduction to Theory and Practice*, 2nd edition. Upper Saddle River, NJ: Prentice Hall.

Ladenheim, K., ed. 2021. "Critical Response Process: A Method for Giving and Getting Feedback." Liz Lerman. May 28, 2021. https://lizlerman.com/critical-response-process/.

Lerman, L. "Liz Lerman's Critical Response Process." In *Contact Quarterly*, 16-20. Vol. 33. Northampton, Mass: Contact Quarterly, 2008.

Lerman, L. and J. Borstel. 2003. *Liz Lerman's Critical Response Process: A Method for Getting Useful Feedback on Anything You Make, From Dance to Dessert*. Takoma Park, MD: Dance Exchange, Inc.

Pavis, P. 1985. "Theatre Analysis: Some Questions and a Questionnaire." *New Theatre Quarterly* ½, 208-12. Reprinted in *Performance Analysis: An Introductory Coursebook*, ed. Colin Counsell and Laurie Wolf, 229-32. London: Routledge, 2001.

Smith Media, J. n.d. "What's Going on in This Picture?" Visual Thinking Strategies. Accessed November 3, 2021. https://vtshome.org/.

INDEX

Note: The italicized *f* following page numbers refers to figures.

ABOUT THE AUTHORS

Suzanne Ostersmith (MFA, Goddard College) is the founding director of the dance and interdisciplinary arts programs and an associate professor of theatre and dance at Gonzaga University. As a professor and scholar of dance, theatre, and visual arts, Ostersmith develops opportunities for students to grow and learn about themselves and the world around them through community, collaboration, and creativity. Ostersmith's areas of research and creative inquiry are in the intersection of the art forms of theatre, dance, and visual arts.

Kathleen Jeffs (DPhil, University of Oxford) is core director and an associate professor of theatre and dance at Gonzaga University. Publications include her translation of the 17th-century Spanish play *The Force of Habit* (Guillén de Castro's *La fuerza de la costumbre*) and *Staging the Spanish Golden Age: Translation and Performance*, which is based on her time as rehearsal dramaturg with the Royal Shakespeare Company. Kathleen teaches performance studies, playwriting, acting, and directing using classroom and studio methods.